"If you're a professional photographer, you must own this book. It's as much a basic and valuable tool as your light meter. Leonard D. DuBoff's *The Law (in Plain English)® for Photographers* will help you avoid some legal pitfalls, answer many legal questions about your business, and intelligently inform you how to deal with your own legal counsel (something hard to avoid these days)."

—David Hume Kennerly, Pulitzer Prize winner, former White House photographer, University of Arizona presidential scholar

"*The Law (in Plain English)® for Photographers* is a must-own and must-read for anyone considering a career as a professional photographer or for one with a career already underway. Authors Leonard D. DuBoff and Sarah J. Tugman have used their experience as lawyers to provide a survey of the key areas of law that are most relevant to photographers. Drawing on individual cases, and writing in clear, vivid language, they connect examples of key matters of law and legal decisions so readers can better understand how the law works and why it matters to working professional photographers. Their sweep of topics is very valuable, ranging from intellectual property protection to all the things one must do for business formation, legally, as well as the contracts and releases necessary to effectively run a business. As such, they produce a very clear roadmap to follow for understanding the key legal issues likely to be impactful to a photographer. "

—Tom Kennedy, executive director, American Society of Media Photographers

"A must read for any photographer! *The Law (in Plain English)® for Photographers* provides photographers with the guidance and necessary tools to protect their copyrights and manage a photo business in this Wild West digital age."

—Carr Clifton, nature photographer, winner of the International Color Awards and Theodore Roosevelt Association Founders Medal

"Through the lens of photography, Leonard DuBoff's sweeping overview of legal issues that concern all artists is a great resource for anyone who takes photographs (which is practically everyone these days), as well as professional photographers and attorneys who are often asked about intellectual property, regardless of their particular practice."

—Alma Robinson, executive director, California Lawyers for the Arts

"Leonard DuBoff is a master at demystifying the legal issues faced daily by professional photographers. From setting up a business to drafting licenses, analyzing agreements, registering your work, the rights of privacy and publicity, work made-for hire, and much more, *The Law (in Plain English)® for Photographers* is an essential reference and should be on the desk of every photographer."

—Jeff Sedlik, advocacy committee, American Photographic Artists

"Because everyone is stealing images off the internet today and seems completely ignorant of copyright law, it is more important than ever for photographers to understand copyright issues. This book covers all of that, as well the legal essentials for photographers to protect themselves and their businesses, and should be in every photographer's library."

—Peter Bussian, photographer, filmmaker,
media consultant, and author of *Passage to Afghanistan*

"A few years ago Leonard DuBoff represented me and my photography firm when I had a copyright case with a large casino conglomerate. We were able to settle the case in my favor and I am forever grateful to Leonard and his team. This book of his, *The Law (in Plain English)® for Photographers*, has been a valuable resource ever since. The content and information within the book has served as a way to educate my clients in the laws regarding copyright issues and has allowed me to pave a smooth path in resolving conflict and disagreements about photographers' rights regarding ownership of original works. I highly recommend this book as a way to save time and money—and peace of mind—when discussing copyright law."

—Jeff Dow, commercial photographer

The **Law**

(in Plain English)®

for

Photographers

FOURTH EDITION

Leonard D. DuBoff *and* **Sarah J. Tugman**

Attorneys-at-Law

Foreword by Marybeth Peters

ALLWORTH PRESS
NEW YORK

Allworth Press books may be purchased in bulk at special discounts for sales promotion, corporate gifts, fund-raising, or educational purposes. Special editions can also be created to specifications. For details, contact the Special Sales Department, Allworth Press, 307 West 36th Street, 11th Floor, New York, NY 10018 or info@skyhorsepublishing.com.

24 23 22 21 20 5 4 3 2 1

Published by Allworth Press, an imprint of Skyhorse Publishing, Inc. 307 West 36th Street, 11th Floor, New York, NY 10018. Allworth Press® is a registered trademark of Skyhorse Publishing, Inc.®, a Delaware corporation.

www.allworth.com

Cover design by Mary Belibasakis

Library of Congress Cataloging-in-Publication Data

Names: DuBoff, Leonard D., author. | Tugman, Sarah J., author.
Title: The law (in plain English) for photographers / Leonard D. DuBoff and
 Sarah J. Tugman, Attorneys-at-Law.
Description: Fourth edition. | New York, New York: Allworth Press, an
 imprint of Skyhorse Publishing, Inc., [2020] | Includes bibliographical
 references and index.
Identifiers: LCCN 2019009819 (print) | LCCN 2019012363 (ebook) | ISBN
 9781621536819 (eBook) | ISBN 9781621536772 (pbk.: alk. paper)
Subjects: LCSH: Photography—Law and legislation—United States. |
 Photographers—United States—Handbooks, manuals, etc.
Classification: LCC KF2042.P45 (ebook) | LCC KF2042.P45 D75 2020 (print) |
 DDC 343.7307/877—dc23
LC record available at https://lccn.loc.gov/2019009819

Print ISBN: 978-1-62153-677-2
eBook ISBN: 978-1-62153-681-9

Printed in the United States of America

Table of Contents

Dedication

To photography professionals who creatively freeze time for posterity. To my mother, Millicent, and my father, Rubin, who provided me with the gift of life and the desire to use that gift effectively. To my mother-in-law, Cumi Elena Crawford, for her faith, trust, and inspiration; and to my wife, Mary Ann, for her enduring love and continuing support.

—Leonard D. DuBoff

To my husband, Greg, without any doubt the love of my life; my father (a lawyer), who instilled a sense of justice in me from my earliest years; my mother, who always set a good example with respect to the English language; both my brothers Bill, and my son, Bill.

—Sarah J. Tugman

Acknowledgments

The process of surveying photography professionals, collecting relevant material, processing it, analyzing it, and putting it in an understandable, useful form could not have been completed without the help of a number of friends, colleagues, and associates. Their contributions to this book are truly appreciated and worthy of note. While it is not possible to identify all of the individuals who have contributed in some way to this volume, we thank all of you who aided in preparing this edition of *The Law (in Plain English)® for Photographers*. Further, I would like to thank my coauthor, Sarah Tugman, for her contributions to the information that appears in the pages that follow. Her knowledge, research, analysis, and writing skills are unsurpassed.

Thanks to Rudolph Lopez III, Esq., as associate with the DuBoff Law Group, for his help with research; to Sara Cain, for her skill in converting my scraps of paper, incomprehensible interlineations, and cryptic notes into readable form; and to Megan Randall, who has devoted many hours assisting me with this project. My brother Michael DuBoff, an attorney with the law firm of Ballon Stoll Bader & Nadler P.C., contributed valuable recommendations and suggestions. Gregory Roer, a Seattle, Washington, CPA; Greg Rogers, of the accounting firm Rogers Financial Services; and Justin Jones, of the law firm Thornton Byron LLP have been kind enough to review the tax material in this book. Their skilled analysis and their thoughtful recommendations add a great deal to the quality of this work.

We would also like to thank the world-class photographers and other professionals who were kind enough to review versions of the manuscript and provide comments, recommendations, and the very flattering statements that appear in the work, or have been used in connection with it or former versions of it, including Victor Perlman, former general counsel of ASMP; the Honorable Marybeth Peters, former United States Register of Copyrights; photographer Jeff Dow for his kind words about the book; and David Hume Kennerly, former White House photographer for Gerald Ford, with whom I was able to travel to China when foreigners were again able to travel to that country, for reviewing an earlier version of this book and for the words that appear here.

On behalf of Team DuBoff and the others whose handiwork contributed to this edition, we hope you enjoy and benefit from this book.

—Leonard D. DuBoff

Foreword

Copyright protection is very important to photographers; however, copyright law is complicated and perceived by many as difficult to comprehend. Leonard DuBoff and his coauthor, however, demystify it, along with many other essential topics. Photographers, lawyers, and the public are the beneficiaries. The authors explain the basics of the copyright law: what it is; who it protects; who is considered the author and owner of a photograph, with an explanation of work made for hire; what rights are granted to authors and what limitations are placed on those rights, for example, fair use and library exceptions; and how long copyright protection lasts. Additionally, they cover copyright law from the business point of view, explaining the effect of transfers of copyright ownership (along with the legal requirements) and the termination provisions concerning termination of assignments and exclusive licenses made by photographers. Significant court decisions, including recent opinions, are included with explanations that everyone can understand.

On the practical side, they include information about the benefits of registration of copyright claims with the United States Copyright Office (www.copyright.gov), as well as practical advice on how to apply for registration. They describe what constitutes infringement of a photographer's copyright and spell out the available remedies, including an explanation of actual and statutory damages. Criminal enforcement, that is, prosecution by the United States government, is also covered.

The Law (in Plain English)® for Photographers contains much more than information on copyright, the subject that I am most familiar with, for example, trademark law, the law of defamation and libel, the rights of privacy, and publicity. Many important business topics, such as organization, tax consequences, and insurance, are laid out. This book includes not only the law, but also practical advice and timely observations. DuBoff is a well-respected expert. Photographers, and those who deal with them or care about them, will value and appreciate this book.

—Marybeth Peters
Register of Copyrights
US Copyright Office
Library of Congress

Introduction

For years, I had been asked by the many photographers I represented to provide them with the title of a text that could help them understand the myriad legal issues present in the world of photography. At that time, I was unable to locate such a book, and therefore, I wrote this text. It was my hope that this fifth book in my *In Plain English*® series would fill the void.

As a law professor for almost a quarter of a century, I realized the benefit in preproblem counseling, and, therefore, much of the material in this volume is intended to enlighten photographers so that legal problems can be avoided. Unfortunately, even the most prudent individual may become entangled in the web of complex legal issues, and a good deal of attention has been devoted to that possibility, as well. There is no substitute for the skills of an experienced and knowledgeable attorney. This book is not intended to replace your lawyer. Rather, it is hoped that with the information contained in these pages, you will be in a better position to communicate with your attorney in order to maximize the benefits you can expect from effective representation.

Throughout the years, since the first edition of this book was published in 1995, I have been actively involved in photography law. Through feedback from clients and colleagues and through independent research, I have continued to update and revise this book so that it can remain current and relevant.

When it became clear that there had been significant changes in the law since the last edition of this book, I enlisted the aid of Sarah Tugman, an attorney I first met in the classroom and with whom I later had the privilege of associating with in my law firm, to assist with this update. We have devoted a great deal of time and energy in updating and reworking the material that now appears in this edition of *The Law (in Plain English)*® *for Photographers*.

I am also indebted to my wife, Mary Ann Crawford DuBoff, my partner in law and in life, for everything she does and for her aid in preparing this work for publication. It is impossible to list all of the work she has undertaken in connection with this book, my other writings, and my work in general.

It is my hope that this, the fourth edition of *The Law (in Plain English)*® *for Photographers*, will continue to serve the needs of the photography community and provide you with a readable text covering the many legal issues you encounter in your chosen profession.

—Leonard D. DuBoff
Portland, Oregon, November 2019

Intellectual Property

COPYRIGHT LAW

A professional photographer is not likely to have an in-house lawyer. So, in addition to becoming skilled at your work and getting word out to the rest of the world about your skills, you need to be aware of the potential legal problems that may be lurking in your business dealings. Once you are armed with the knowledge of what to look for, you can usually avoid potentially serious headaches.

Copyright protection is a good topic for starting this book, because it is a subject about which most photographers have many questions. While it is always recommended that an attorney be retained to assist with copyright issues, this chapter will aid you in effectively working with your lawyer.

Copyright law in the United States has its foundations in the Constitution, which, in Article I, Section 8, provides that Congress shall have the power "To promote the Progress of Science and the useful Arts, by securing for limited Times to Authors and Inventors the exclusive Right to their respective Writings and Discoveries." The First Congress exercised this power and enacted a copyright law, which has been periodically revised by later Congresses.

The Copyright Act expressly provides for the registration of photographs. Furthermore, courts have held that photography is eligible for copyright protection because photography is a form of creative expression and each photograph involves artistic choices. According to the US Supreme Court, a photograph "must be deemed a work of art and its maker an author, inventor or designer of it, within the meaning and protection of the copyright statute." The Copyright Act of 1909 remained in effect for nearly three quarters of a century despite periodic complaints that it no longer reflected contemporary

technology. At the time the 1909 Act was passed, the printing press was still the primary means of disseminating information, but new technology, such as improved printing processes, radio, television, videotape, computer software, and microfilm, created the need for a revision that would provide specific statutory copyright protection for newer information systems.

The 1909 act was substantially revised in 1976. The Copyright Revision Act of 1976 became effective on January 1, 1978, and covers works created or published on or after that date. The creation of copyright in all works published prior to January 1, 1978, is governed by the 1909 act. Rights other than creation, such as duration of copyright, infringement penalties, and infringement remedies, are governed by the revised law. It is important to be aware of the basic differences in the two laws and which law applies to a given work.

In 1988, Congress once again amended the statute so that the United States could become a party to an international copyright treaty known as the Berne Convention.

Federal Preemption of State Copyright Law

One of the problems with the 1909 act was that it was not the exclusive source of copyright law. Copyright protection (or its equivalent) was also provided by common law (that body of law developed by the courts independent of statutes), as well as by various state laws. This caused considerable confusion, since securing copyright protection or avoiding copyright infringement required careful examination of a smorgasbord of different laws.

The 1976 act largely resolved this problem by preempting and nullifying all other copyright laws. In other words, it is now the only legislation generally governing copyright protection.

What Is Copyright?

A copyright is actually a collection of five exclusive, intangible rights:

1. The right to reproduce the work
2. The right to prepare derivative works
3. The right of distribution
4. The right to perform the work
5. The right to display the work

The first right allows the owner to reproduce the work by any means. The scope of this right can be hard to define, especially when it involves photocopying, microfiche, videotape, and the like. Under the Copyright Act of 1976, others may reproduce protected works only if such reproduction involves either a *fair use* or an *exempted use* as defined by the act, which will be discussed later in this chapter.

Second is the right to prepare derivative works based on the copyrighted work. A derivative work is one that transforms or adapts the subject matter of one or more preexisting works. Thus, derivative works of a photograph might include use in a composite and adaptations into another medium, such as television, film, or a painting.

Third is the right to distribute copies to the public for sale or lease. However, once a photographer sells an image or a print, the right to control its further distribution is usually ended. This rule, known as the *first sale doctrine*, does not apply if the work is merely in the possession of someone else temporarily, such as by bailment, rental, lease, or loan. *Bailment* is the legal term for temporary possession of someone else's property. That is, the *bailee*, or person holding the property, is deemed entitled to possess or hold that property, which actually belongs to someone else, known as the *bailor*. Leaving a camera with the repair shop establishes a bailment; so does leaving your photograph with a lab for purposes of it having it enlarged. In the latter instance, the copyright owner retains the right to control the further sale or other disposition of the photograph. If the copyright owner has a contract with the purchaser that restricts the purchaser's freedom to dispose of the work, and if the purchaser exceeds those restrictions, there may be liability. In this situation, the copyright owner's remedy will be governed by contract law rather than by copyright law.

You should distinguish between the sale of an image and the sale of the copyright in that print. If nothing is said about the copyright when the image is sold, you will retain the copyright. Since purchasers may not be aware of this, you may wish to call it to their attention either in the sales memorandum or on the back of the photograph.

Fourth is the right to perform the work publicly—for example, in the case of an audio/visual work, to broadcast a film on television, show it in a theater, or stream it on the Internet.

Fifth is the right to display the work publicly. Once the copyright owner has sold a copy of the photograph, however, the owner of the copy has the right to display that copy.

Who Owns the Copyright?

The general rule regarding ownership of copyright is that the creator of an image—the photographer—is the owner of the copyright in it. Before the Copyright Act of 1976, when a photograph was sold, ownership of a common law copyright was presumed to pass to the purchaser of that tangible photograph unless the photographer explicitly provided otherwise in a written agreement. In other words, there was a presumption in the law that a sale included not only the photograph itself, but all rights in that work. Under the old copyright law, the customer owned the negative, all prints, and all use rights in a photograph unless the parties contractually agreed otherwise, and the photographer was unable to print additional copies of a photograph, even if he or she retained possession of the negative. Thus, unless otherwise specified, the customer owned the negative, the right to sell or license the use of the negative, and the right to use the image commercially.

The Copyright Act of 1976 reverses the presumption that the sale of a photograph carries the copyright with it. Since January 1, 1978, unless there is a written agreement that transfers the copyright to the customer, the photographer retains the copyright, and the customer obtains only the tangible item and any rights expressly granted by the photographer. Notwithstanding this fact, the photographer may still not be able to reproduce the work for commercial purposes without the consent of the person photographed due to publicity or privacy laws (see chapter 3).

Joint Works

The creators of a joint work are coowners of the copyright in the work. A joint work is a work prepared by two or more people "with the intention that their contributions be merged into inseparable or interdependent parts of a unitary whole." Theatrical works, for example, are generally considered joint works under the act—coauthored by the script writer, composer, lyricist, set designer, choreographer, director, and others who contribute their talent to the final production. The owners of the copyrights in a theatrical work may vary according to the contracts between the producer and the individual authors who contribute to the work.

Whatever profit one creator makes from use of the work must be shared equally with the others unless they have a written agreement that states otherwise. If there is no intention to create a unitary, or indivisible, work, each creator may own the copyright to that creator's individual contribution. For

example, one creator may own the rights to written material and another the rights in the illustrative photographs.

Works Made for Hire

Works considered to be works made for hire are an important exception to the general rule that a photographer owns the copyright in an image he or she has created. If a photograph was taken by an employee in the scope of employment, the law considers the picture to be a work made for hire, and the employer will own the copyright. The parties involved may avoid application of this rule in some circumstances, however, if they draft their contract carefully. If the employment contract itself provides, for example, that creating the copyrightable material in question is not part of the "scope of employment," the employee will likely be considered the owner of the copyright, and the work-made-for-hire doctrine will not apply. Another method of achieving this same result is for the employee to have the copyright in the work expressly assigned back to him or her by the employer.

If the photographer is an independent contractor, the photographs will be considered works made for hire only if:

- The parties have signed a written agreement to that effect
- The work is specially ordered or commissioned as a contribution to a collective work, as part of a motion picture or other audiovisual work, as a supplementary work, as a compilation, as a translation, as an instructional text, as answer material for a test, or as an atlas

Thus, if there is no contractual agreement to the contrary, the photographer who is an independent contractor will own the copyright in these works.

The US Supreme Court in 1989, in *Community for Creative Non-violence v. Reid*, made it clear that a determination of the status of the person creating the work as either an employee or independent contractor must be made by considering the following factors:

- The hiring party's right to control the manner and means by which the product is accomplished
- The skill required
- The source of the instrumentalities and tools

- The location of the work
- The duration of the relationship between the parties
- Whether the hiring party has the right to assign additional projects to the hired party
- The extent of the hired party's discretion over when and how long to work
- The method of payment
- The hired party's role in hiring and paying assistants
- Whether the work is part of the regular business of the hiring party
- Whether the hiring party is in business
- The provision of employee benefits
- The tax treatment of the hired party

In 1992, in a case titled *Marco v. Accent Publishing Co.*, the US Court of Appeals for the Third Circuit held that a freelance photographer working for a client on a commission basis could not be considered the client's employee but, rather, was an independent contractor. As such, the photographer retained the copyright in his images. The court, in agreeing with the American Society of Media Photographers (ASMP), which had filed an amicus brief for the purpose of informing the court about its position, held that almost every aspect of the photographer's relationship with the client supported this conclusion. The photographer used his own equipment, worked at his own studio, paid his own overhead, kept his own hours, paid his own taxes, received no employee benefits, and was a skilled worker.

Transferring or Licensing the Copyright

A copyright owner may sell the entire copyright or any part of it. To accomplish this, there must be a written document, signed by the copyright owner or the owner's duly authorized agent, that describes the rights conveyed. Only a nonexclusive license authorizing a particular use of a work can be granted orally, but it will be revocable at the will of the copyright owner. All other licensing arrangements must be in writing. The scope of rights granted should be made clear. For instance, is the purchaser of a license permitted only a one-time use or multiple uses? Specifying the exact uses conveyed can often avoid a battle over rights. (For a discussion on licensing photographs, see chapter 12.)

It is not uncommon for a photographer to become the assignee or licensee of another person's copyright. This could happen, say, when a photographer wishes to incorporate another person's illustrations, photographs, recordings, writings, or other work into the photographer's work. In this case, the photographer will often enter into a licensing agreement or assignment of ownership with the other person.

Both an assignment of ownership and a licensing agreement can, and should, be recorded with the Copyright Office. The rights of the assignee or licensee are protected by recording an assignment in much the same way as the rights of an owner of real estate are protected by recording a real property deed with the county clerk's office. In a case of conflicting transfers of rights, if two or more transactions are recorded within one month of the execution, the person whose transaction was signed first will prevail. If the transactions are not recorded within one month, the one who records first will prevail. In some circumstances, a nonexclusive license will prevail over any unrecorded transfer of ownership. The cost to record a transfer is only $105 for the first title, plus $35 for each group of ten titles or fewer.

One section of the 1976 Copyright Act pertains to the involuntary transfer of a copyright. This section, which states that such a transfer will be held invalid, was included primarily because of problems arising from US recognition of foreign copyrights. This section of the act does not apply to a transfer by the courts in a bankruptcy proceeding or a foreclosure of a mortgage secured by a copyright.

Termination of Copyright Transfers and Licenses

It is not unusual for a photographer confronted with an unequal bargaining position vis-à-vis an advertising agency to transfer all rights in the copyright to the agency for a pittance, only to see the work become valuable at a later date. The 1976 Copyright Act, in response to this kind of apparent injustice, provides that after a certain period has lapsed, the photographer or certain other parties identified in the law may terminate the transfer of the copyright and reclaim the rights. Thus, the photographer is granted a second chance to exploit a work after the original transfer of copyright. This right to terminate a transfer is called a *termination interest*.

In most cases, the termination interest will belong to the photographer, but if the photographer is no longer alive and is survived by a spouse but no children or grandchildren, the surviving spouse owns the termination

interest. If the deceased photographer is not survived by a spouse, ownership of the interest belongs to any surviving children and the surviving children of any dead children. If the decedent is survived by both spouse and children, the interest is divided so that the spouse receives 50 percent and the children receive the remaining 50 percent.

Where the termination interest is owned by more than one party, be they other photographers or a photographer's survivors, a majority of the owners must agree to terminate the transfer.

Under the current law, the general rule is that termination may be effected at any time within a five-year period beginning at the end of the thirty-fifth year from the date on which the rights were transferred. If, however, the transfer included the right of publication, termination may go into effect at the end of thirty-five years from the date of publication or forty years from the date of transfer, whichever is shorter.

The party wishing to terminate the transferred interest must first serve written notice on the transferee, stating the intended termination date. This notice must be served not less than two and no more than ten years prior to the stated termination date. Also, a copy of the notice must be recorded in the Copyright Office before the effective date of termination.

What Can Be Copyrighted?

The Constitution authorizes Congress to provide protection for a limited time to "authors" for their "writings." An *author*, from the point of view of copyright law, is either the creator—be it a photographer, sculptor, or writer—or the employer in a work-made-for-hire situation. There have been debates over what constitutes a *writing*, but it is now clear that this term includes photographic images. Congress avoided use of the word "writings" in describing the scope of copyright protection. Instead, it grants copyright protection to "original works of authorship fixed in any tangible medium of expression." Legislative comments on this section of the act suggest that Congress chose to use this wording rather than "writings" in order to have more leeway to legislate in the copyright field.

Within these broad limits, the medium in which a work is executed does not affect its copyrightability. Section 102 contains a list of copyrightable subject matter, which includes:

- Literary works
- Musical works, including any accompanying words

- Dramatic works, including any accompanying music
- Pantomimes and choreographic works
- Pictorial, graphic, and sculptural works
- Motion pictures and other audiovisual works
- Sound recordings
- Architectural works

This list is not intended to be exhaustive, and courts are free to recognize as protectable those types of works not expressly included in the list.

The 1976 act expressly exempts from copyright protection "any idea, procedure, process, system, method of operation, concept, principle, or discovery." In short, a copyright extends only to the expression of creations of the mind, not to the *ideas* themselves. Frequently, there is no clear line of division between an idea and its expression, a problem that will be considered in greater detail in the Copyright Infringement and Remedies section of this chapter. For now, it is sufficient to note that a pure idea, such as a plan to photograph something in a certain manner, cannot be copyrighted—no matter how original or creative it is.

The law and the courts generally avoid using copyright law to arbitrate the public's taste. Thus, a work is not denied a copyright even if it makes no pretense to aesthetic or academic merit. The only requirements are that a work be original and show some creativity. Originality—as distinguished from uniqueness—requires that a photograph be taken independently but does not require that it be the only one of its kind. In other words, a photograph of underwater algae in the Antarctic is copyrightable for its creative aspects; the unusual, hard-to-shoot subject matter is irrelevant.

Nonetheless, in 1998, in *Ets-Hokin v. Skyy Spirits*, the district court for the Northern District of California held that photographs of a vodka bottle were not entitled to copyright protection, since, said the court, the photograph was merely a derivative work of a vodka bottle, which did not display sufficient variation from the bottle itself to be copyrightable. On appeal, however, in 2000, the US Court of Appeals for the Ninth Circuit disagreed, pointing out that photography generally contains sufficient creative choices and originality so as to enjoy copyright protection. This is particularly true in the context of commercial photography, where lighting, angle, layout, and overall subject matter are evaluated and the photographer's artistic plan is implemented. The appellate court also held that the photographs were not derivative works

because the underlying work, the vodka bottle, was a "useful article" and thus not copyrightable.

Approximately a month after the Ninth Circuit decision was announced, the US District Court for the Southern District of New York was presented with a similar situation. In *SHL Imaging, Inc. v. Artisan House, Inc.*, the court was presented with a dispute involving photographer Stephen Lindner, who had been hired to photograph Artisan's mirrored picture frames. The photographer alleged that he retained all rights and had merely licensed Artisan the right to reproduce a limited number of photographs for use by salespersons, but Artisan had used the photographs in thousands of brochures, catalogs, and the like. Lindner filed a lawsuit for copyright infringement, and Artisan argued that the photographs were not entitled to copyright protection, since they were merely derivatives of the uncopyrightable frames.

The court disagreed, holding that the photographs were not *derivative works*, as that term is used in the statute. All photographs, said the court, merely depict their subject matter and do not "recast, transform, or adopt" preexisting works. It is clear, said the judge, that the authorship of a photographic work is entirely different and separate from the authorship of the underlying work. Thus, the New York court held that photographs, even of functional works, are entitled to copyright protection. The court described two situations in which a photograph could be a derivative work:

1. A cropped photograph of an earlier photograph
2. Reshooting an earlier photograph with some alteration of the expressive elements

Unfortunately, the introduction of new technologies can bring about complications. For example, a 2008 case, *Meshwerks, Inc. v. Toyota Motor Sales U.S.A., Inc.*, involved creation of digital 3D models of Toyota vehicles to be used on Toyota's website. Meshwerks created the computer-generated digital models in part using measurements from the vehicles. The court held that because Meshwerks did not make decisions regarding lighting, shading, background, etc., and because Meshwerks's purpose was to depict "the car as car," Meshwerks had no copyright in its models, as Meshwerks contributed no original expression.

Obscenity

In the past, the Copyright Office occasionally denied protection to works considered immoral or obscene, even though it had no express authority for doing so. Today, this practice has changed. The Copyright Office will not attempt to decide whether a work is obscene, and copyright registration will not be refused because of the questionable character of any work. (For a discussion on censorship and obscenity, see chapter 4.)

Titles

Photographers should be aware that not everything in a copyrighted work is protected. For example, the title of a photograph cannot be copyrighted. It is protectable, if at all, as a trademark.

Notice

Under the 1909 act, most photographs that qualified for copyright had to be published with the proper notice attached in order to get statutory protection. The 1976 act dramatically changed the law in this respect. A photographer's images are now automatically copyrighted once they are "fixed in a tangible medium of expression." The photographer's product is considered to have been "fixed in a tangible medium of expression" as soon as he or she clicks the shutter. The photograph need not be developed or printed to be protected. However, after the 1976 act and prior to the 1988 amendment (effective March 1, 1989), a copyright could be lost if a photograph were published without the proper notice and if corrective steps were not taken within a certain period of time.

Public Domain

Once the copyright on a work has expired, or been lost, the work enters the public domain, where it can be exploited by anyone in any manner. A photographer may, however, have a copyright on a work that is derived from a work in the public domain if a distinguishable variation is created. This means, for example, that Rembrandt's *Night Watch* cannot be copyrighted, but a photograph of it may so long as the photographer somehow transforms the work. As a result, no one would be able to reproduce the photograph, whereas anyone can copy Rembrandt's original. Other examples include collages, photographs of photographs, and film versions. If the copy was identical in all particulars so as to be indistinguishable from the

original and the copying involved no creativity or originality, it would not be copyrightable.

Compilations

"Compilation" is defined in the Copyright Act as:

> a work formed by the collection and assembling of preexisting materials or of data that are selected, coordinated, or arranged in such a way that the resulting work as a whole constitutes an original work of authorship. The term "compilation" includes collective works.

"Collective work" is defined as

> a work, such as a periodical issue, anthology, or encyclopedia, in which a number of contributions, constituting separate and independent works in themselves, are assembled into a collective whole.

Compilations are also copyrightable as a whole, whether or not individual contributions or photographs are individually copyrighted. The copyright in a compilation does not cover the underlying material but protects the author's rights in the selection, arrangement, and coordination of those materials.

Publication

In copyright law, the concept of *publication* is different from what a layperson might expect it to be. Publication is essentially dissemination to the public, but it is a technical term of art that is important in copyright law. Under the old law, there was a doctrine of limited publication, which meant that publication would not be deemed to have occurred when a photographer displayed a work only "to a definitely selected group and for a limited purpose, without the right of diffusion, reproduction, distribution, or sale." When a photographer showed copies of a picture to close friends or associates with the understanding that such copies would not be further reproduced and distributed, the photographer had not published the pictures. Nor did the distribution of pictures to agents or customers for purposes of review and criticism constitute a publication. Thus, according to the US Supreme Court in 1907 in *American Tobacco Co. v. Werckmeister,* even an exhibition in a gallery or museum did not constitute publication if copying or photographing the work was prohibited.

The Revised Act of 1976 makes no specific reference to this doctrine of limited publication. It is now defined in the Copyright Act as:

> the distribution of copies or phonorecords of a work to the public by sale or other transfer of ownership, or by rental, lease, or lending. The offering to distribute copies or phonorecords to a group of persons for purposes of further distribution, public performance, or public display, constitutes publication. A public performance or display of a work does not of itself constitute publication.

Moreover, a congressional report on the Revised Act states that "the public" in this context refers to people who are under no explicit or implicit restrictions with respect to disclosure of the work's contents. This appears to suggest a continuation of the 1909 doctrine of limited publication under the current act. As will be seen later, publication is important, since it identifies the point when proper use of the copyright notice, discussed later in this chapter, will defeat certain defenses that may be raised to excuse an unauthorized use of a copyrighted work.

It also determines copyright duration in some instances.

Duration of Copyright

The duration of copyright depends upon when and how the work was created. In general, if the author is an individual, works created on or after January 1, 1978, will have copyright protection from the instant of creation until seventy years after the author's death. The same term applies for works created before 1978 but not published or registered before then. For works created jointly, the period is measured by the life of the last surviving author plus seventy years. The copyright in works made for hire and for anonymous or pseudonymous works lasts ninety-five years from the year of first publication or 120 years from the year of the work's creation, whichever period expires first. Unlike the 1909 act, the 1976 act requires no renewal. Renewal of copyrights in works first published prior to January 1, 1978, however, was required in the twenty-eighth year after first publication until a law providing for the automatic renewal of such works was enacted in June 1992.

Copyright Notice

Works published under the 1909 act had to contain the proper notice in order to be copyrighted. With few exceptions, any omission, misplacement, or imperfection in the notice on any copy of a work distributed by authority of the copyright owner placed the work forever in the public domain. Thus, it was important for a copyright owner signing a contract to make sure that the grant of a license to publish be conditioned on the publisher's inclusion of the proper copyright notice. That way, if the publisher made a mistake in the notice, the publication might be deemed unauthorized, and the copyright would not be affected. In addition, the publisher could be liable to the copyright owner for the loss of copyright if it did occur.

Even though the 1976 act allowed the photographer to save the copyright on works published without notice and the 1989 revision does not require notice, someone who copies a work believing it in the public domain because there is no notice may be considered an *innocent infringer*. In this situation, the photographer whose work was copied may be unable to recover damages. In fact, with respect to statutory damages, while the minimum award is usually $750, the court may reduce the award to as low as $200 in a case of innocent infringement. The court might even allow the copier to continue using the work. The 1989 amendment provides that if the notice is used, then there is a presumption that an infringer cannot be innocent.

Location of Copyright Notice

The 1909 act contained complicated rules for the proper placement of the copyright notice within the work. Improper placement was one more error that was fatal to the copyright. Since March 1, 1989, a copyright notice is no longer required to be affixed to a work; nevertheless, it is a good idea to use the notice, since it will make others aware of your rights, and use of the notice will prevent anyone from claiming that copying the work was innocent. Although it is customary to place a notice at the bottom of a work, you may now place the notice anywhere, so long as it is on or immediately adjacent to your photograph.

Wording of a Copyright Notice

Even though it is no longer necessary to place a notice on your work, it still should be used whenever possible. A copyright notice has three elements:

- First, there must be the word "copyright," the abbreviation "copr.," the abbreviation "copyr.," or the letter "c" in a circle—©. No variations are permitted.
- Second is the year of first publication (or, in the case of unpublished works governed by the 1909 act, the year in which the copyright was registered). This date may be expressed in Arabic or Roman numerals or in words.
- The third necessary element is the name of the copyright owner. If there are several, one name is sufficient. Usually the author's full name is used, but if the author is well known by a last name, the last name can be used alone or with initials. The same is true if the author is known by initials alone. A business that owns a copyright may use its trade name if the name is legally recognized in its state.

The following is an example of a proper copyright notice:

© [year the work was first published] [copyright owner's name]

Errors in or Omission of a Copyright Notice

Failure to give copyright notice or publishing an erroneous notice had very serious consequences under the old law. Under the 1909 act, the copyright was lost if the wrong name appeared in the notice. If the creator sold the copyright and recorded the sale, either the creator's or the new owner's name could be used, but if the sale was not recorded with the Copyright Office, use of the subsequent owner's name in the notice destroyed the copyright.

Under current law, a mistake in the name appearing in the notice is not fatal to the copyright. However, an infringer who was honestly misled by the incorrect name could use this as a defense to a lawsuit for copyright infringement if the proper name was not on record with the Copyright Office. This is obviously another incentive for registering a sale or license of a copyright with the Copyright Office.

Under the 1909 act, a mistake in the year of the first publication could also have had serious consequences. If a date earlier than the actual date was used, the copyright term would be measured from that year, thereby decreasing the duration of protection. If a later date was used, the copyright was forfeited and the work entered the public domain, but because of

the harsh consequences of losing a copyright, a mistake of one year was not penalized.

Under the current law, using an earlier date will not be of any consequence when the duration of the copyright is determined by the author's life. When the duration of the copyright is determined by the date of first publication, as in the case of a composite work or work made for hire, the earlier date will be used to measure how long the copyright will last. If a later year is used, the work is considered to have been published without notice.

If a work was published between January 1, 1978, and March 1, 1989, without notice, the copyright owner was still protected for five years. If, during those five years, the owner registered the copyright with the Copyright Office and made a reasonable effort to place a notice on copies of the photograph that were initially published without notice and distributed within the United States, full copyright protection was granted for the appropriate duration of the published work.

A copyright owner is forgiven for omitting the notice if the omission was in violation of a licensing contract containing a provision that gave the licensee the right to publish the work but required the proper notice to be included as a condition of publication. In other words, the copyright holder fulfilled his or her responsibility for notice by requiring the licensee to publish it, and the copyright owner will not be held responsible for the licensee's mistake. Also, if the notice was removed or obliterated by an unauthorized person, this will have no effect on the validity of the copyright.

Since the purpose of the notice is to inform members of the public that the copyright owner possesses the exclusive rights granted by the statute, it is logical that someone who infringes these rights could be consider "innocent" if the error was made because of the absence of the notice. Providing notice, though no longer required, helps prevent claims of *innocent infringement*, and, in some cases, the innocent infringer may be compelled to give up any profits made from the infringement. On the other hand, if the innocent infringer has made a sizable investment for future production, the court may compel the copyright owner to grant a license to such an infringer.

Deposit and Registration

While a copyright notice on a photograph tells viewers who holds the copyright, it does not constitute official notice to the US government. Once a photograph has been published, you should deposit (that is, deliver) the work

and submit an application for copyright registration with the US Copyright Office.

Depositing a work and registering an application are two different acts. Neither is a prerequisite for creating a federal copyright. As a general rule, copyright protection is automatic when an original idea is "fixed in a tangible medium of expression." The obvious question, then, is why bother to deposit the work and file the application? As will be seen later, registration is required as a prerequisite to filing a lawsuit for a "US work" and is also necessary in order for you to obtain certain remedies for infringement. A "US work" is any work by a US author, any work first published in the United States, or any foreign work published in the United States on the same day it was published in a foreign country. If you do not register the copyright at the time you make the mandatory deposit, it will be necessary to deposit additional copies when you register the work.

Mandatory Deposit

Under the deposit provisions of the current law, the owner of the copyright or the owner of the exclusive right of publication must deposit with the Copyright Office for the use of the Library of Congress two copies of the "best edition" of the work within three months after the work has been published. Sometimes such copies must be sent electronically. In other cases, electronic submission is not required. For more information on deposits, visit www.copyright.gov/circs/circ07d.pdf.

If the two copies are not deposited within the requisite three-month period, the Register of Copyrights may demand them. The Register of Copyrights is not omniscient, but the Copyright Office may know that a particular photograph had been published because of other correspondence with a publisher. If you have published a photograph on your own and never corresponded with the Copyright Office, it is not likely that this demand will be made, and you will thus need to deposit the copies only in connection with an application for registration.

If the copies are not submitted within three months after demand, the person upon whom demand was made may be subject to a fine ranging from $250 to $2,500 (the latter for a copyright proprietor who willfully and repeatedly refuses to comply with a demand). In addition, such person may be required to pay the Library of Congress an amount equal to the retail cost of the work or, if no retail cost has been established, reasonable costs incurred by the Library in acquiring the work.

Depositing copies is no longer a condition of copyright protection, but in light of the penalty provisions, it would indeed be foolish not to comply if asked.

Registration

The registration provisions of the 1976 act require that the copyright proprietor complete an application form (available from the Library of Congress) and pay a registration fee. Filing may be required to be submitted electronically, or mailing a traditional paper form may be permissible. Forms are available online at the US Copyright website at www.copyright.gov/forms. The fee for filing of an electronic form is only $35; the filing fee for a paper form is $85.

If you need to file an expedited registration, as is often done before bringing a lawsuit when the work has not already been registered, the fee to expedite (which is in addition to the registration fee) is $800. Because the time for processing a traditional paper application with correspondence is now around sixteen months, and even an electronic application without correspondence is likely to take about seven months, expedited registrations are becoming more important.

The copyright application is brief, but it is helpful to have an attorney teach you how to properly complete it. In addition, as noted above, the proprietor must deposit two copies of the "best edition" of the work to be registered (one copy if the photograph is unpublished). The media that will be accepted for copies now include multiple electronic formats. Because the list of acceptable formats is likely to change regularly as technology evolves, if you plan to submit the copies of your work in an electronic format, you should check the Copyright Office's website when you are ready to register your copyright.

If you have many pictures to register, you can save time and money by registering and copyrighting them as a single group. The US Copyright office adopted a final rule, effective February 20, 2018, for registering groups of photographs under one application and one filing fee. Different applications and procedures apply depending on whether the photographs are published or unpublished. Applications for registration must generally be submitted electronically and must meet certain conditions. Up to 750 photographs may be included in each registration. Contributions must be submitted in a digital format and meet certain requirements. Each photograph in a group is registered as a single work.

These are the requirements for registration of unpublished photographs:

- all of the works must be photographs
- each must be unpublished
- there can be no more than 750 photographs in one group
- all photographs must be by the same "author" (this would include an employer or other person for whom a work is "made for hire")
- the copyright claimant for each photograph must be the same person or organization (for example, this can be the photographer or a person or organization that owns all of the exclusive rights to each photograph)
- the applicant must provide a title for the group
- the applicant must provide a sequentially numbered list including a title and file name for each photograph (a template is provided by the Copyright Office)

The requirements for registration of published photographs are similar:

- all of the works must be photographs
- all of them must have been published within the same calendar year
- there can be no more than 750 photographs in one group
- all photographs must be by the same "author" (this would include an employer or other person for whom a work is "made for hire")
- the copyright claimant for each photograph must be the same person or organization (for example, this can be the photographer or a person or organization that owns all of the exclusive rights to each photograph)
- the applicant must provide a title for the group
- the applicant must provide a sequentially numbered list including a title and file name for each photograph (a template is provided by the Copyright Office). You can find specific, detailed instructions for registration under these two groups of photographs on the US Copyright Office website.

After the effective date of this final rule, photographers will no longer be able to register under the "unpublished collection" option that was available previously, and the "pilot program" (which allowed an unlimited number of photographs to be registered with the application designed for one work) is eliminated. There remains, however, a "pilot program" for registering photographic databases, but the Copyright Office prefers registration under the two new group registration provisions.

Since under the new registration system each photograph in each group is registered as a separate work and is not considered a "compilation" or "collective work," some of the uncertainty that has persisted in the law may be eliminated with respect to new registrations. There is disagreement between the federal courts as to whether "compilation" registrations are sufficient to permit the copyright owner to sue for infringement of the compilation's individual components, if not separately registered, and distinctions have been drawn as to whether the copyright registrant for the "compilation" also owned the copyrights for the components.

In 2013, in *Metropolitan Regional Information Systems, Inc. v. American Home Realty Network, Inc.*, the Fourth Circuit confronted the question of whether registration of an automated database (a multiple listing service) permitted an action for infringement on the components (photographs) by a real estate referral website. When the multiple listing service received pictures of property from real estate agents, it required them to assign the rights to the images to it and registered its automated database with the Copyright Office, updating it regularly. The real estate referral website took images from the multiple listing service website and included them on its own site. The Maryland district court had entered a preliminary injunction prohibiting the referral website from using the multiple listing service's photographs. The Fourth Circuit upheld the injunction, noting that the multiple listing service's registration, in the form submitted, was sufficient to give the individual photographs copyright protection, since it owned the rights to each picture, even though the pictures were not separately registered.

The Ninth Circuit, in 2014, ruled similarly in *Alaska Stock, LLC v. Houghton Mifflin Harcourt Publishing Co.*, holding that if photographers assigned their copyrights in individual pictures to a stock agency that then registered the collection, both the collection and the individual images were registered.

On the other hand, in the Southern District of New York in 2010, in *Muench Photography, Inc. v. Houghton Mifflin Harcourt Publishing Co.*, the court

reached the opposite conclusion, finding that the registration of a database compilation gave copyright protection only to the database as a whole and not to the individual pictures in it, even though the party registering the database had been assigned limited rights to the individual pictures for the purpose of registration, as the stock agency did not "author" each individual picture, and each individual photographer was not named in the registration .

The lesson to be learned from this is the choices made in registering a copyright in groups of pictures are important and can affect both protection of the parts and further what damages may be available in an infringement action.

To complicate matters even further, there is also disagreement between the federal courts of appeals as to what constitutes a "compilation" or "one work" for the purposes of statutory damages. Several circuits allow only one statutory damage award per compilation, while others employ a "separate economic value test" that, if met, could allow multiple statutory damage awards. Care must be taken at the registration stage so as to avail a photographer of all the best protections that can be obtained under copyright law.

There is also a new rule, effective July 31, 2017, for group registration for contributions to periodicals. It allows only electronic applications and sets up a system for digital deposits. A "contribution to a periodical" is a separate and independent work first published in a periodical. This could be a photograph published in a magazine or newspaper, or even an electronically printed publication if it meets the definition of a "periodical." A "periodical" is defined as "a collective work that is issued or intended to be issued on an established schedule in successive issues that are intended to be continued indefinitely. In most cases, each issue will bear the same title, as well as numerical or chronological designations."

These are the requirements for registration in this category:

- All contributions must be created by the same author and must not be works made for hire.
- The copyright claimant for all of the contributions must be the same person or organization.
- Each work must be first published as a "contribution to a periodical," and all contributions must have been published within a twelve-month period.

- The application must identify each contribution, with the date of its first publication and the periodical in which it was first published.
- The application must identify each contribution separately, along with identification of the periodical and the date it was first published.
- If the contributions were first published before March 1, 1989, certain notice requirements apply.
- Acceptable copies for deposit are required.

Detailed instructions for this type of registration are contained on the US Copyright Office website. A contribution to a periodical must be registered in a timely manner (within three months after publication for the earliest contribution in the group) in order to allow a claimant to collect statutory damages and attorney fees in an infringement action. Because internal rules of the Copyright Office are subject to change, a photographer should check with the Copyright Office regarding current registration requirements. Once a work has been registered as unpublished, it does not need to be registered again when published.

Copyright Office regulations require registration in the name of the copyright claimant on the date the application is submitted, and the claimant is defined as the author of the work or someone who has obtained all of the rights from the author. It is good practice for a photographer to take the responsibility for registering copyrights for his or her work instead of relying upon a publisher such as a magazine or newspaper to register a copyright. As earlier discussed, registration of a collection including a photographer's pictures may not include rights for the photograph individually or for the photographer. Moreover, if the photographer grants a copyright to a publisher or other party to use a photograph in a collective work of some kind, it is a good idea, if it can be negotiated, to make the right subject to a contractual obligation to assign the copyright back to the photographer.

When your claim to copyright has been accepted by the Copyright Office, you will receive a certificate of registration, which will include the registration number as well as the effective date of the registration. The effective date of registration is when the form, fee, and deposit are received together at the Copyright Office.

It can take quite a while for you to receive the certificate, so you should consider sending the application either electronically or by certified mail/

return receipt requested so you will be sure your application reached the Copyright Office. There will probably be no accompanying information with the certificate. The certificate is an official document that should be stored in a safe place.

Again, although registration is not a condition to copyright protection, the 1976 act specifies that the copyright owner cannot bring a lawsuit to enforce his or her copyright in a "US work" until the copyright has been registered.

There was disagreement in the federal appellate courts as to what had to be accomplished before a lawsuit could be filed. The Tenth and Eleventh Circuits believed that "registration" was not made until the Copyright Office acted on an application, and the Fifth and Ninth Circuits believed that a completed and submitted application was sufficient for "registration." The U.S. Supreme Court resolved this dispute on March 4, 2019, in *Fourth Estate Public Benefit Corporation v. Wall-Street.com, LLC*, when it ruled that registration of a copyright occurs when the Copyright Office registers the copyright, not when the application is submitted, and that is when an infringement suit may be commenced. Since it generally takes quite some time for the Copyright Office to act on an application, this is an additional reason to submit your application for copyright as soon as possible.

Additionally, if the copyright is registered after an infringement occurs, the owner's legal remedies will be limited. If the copyright was registered prior to the infringement, the owner may be entitled to more complete remedies, including attorneys' fees and statutory damages. No remedies will be lost if registration is made within three months of publication. Thus, the owner of a copyright has a strong incentive to register the copyright at the earliest possible time and certainly within the three-month grace period.

Another reason to register a copyright promptly is that if registration is made within five years of publication or if the registration is of an unpublished work, the facts contained in the registration are presumed to be true. That means if the alleged infringer is unable to present evidence that those facts are untrue, you will not have to present evidence of their accuracy.

Copyright Infringement and Remedies

A copyright infringement occurs any time an unauthorized person exercises any of the exclusive rights reserved to the copyright holder—for example, if an advertiser takes one or your photographs without your permission and uses it to sell a product. The fact that the infringing party did not intend to infringe is

relevant only with respect to the penalty. All actions for infringement of copyright must be brought in a federal court. The period within which suit must be brought is stated as follows in the Copyright Act: "No civil action shall be maintained under the [act] unless it is commenced within three years after the claim accrued" (17 U.S.C. §507(b)). Different courts interpret this language in different ways. A minority of courts start the three years running from the date of the infringement. This is known as the *injury rule*. A majority of courts start the period running from the time the copyright owner learns of the infringement, or should have learned of the infringement, whichever is sooner. This is known as the *discovery rule*. Since different jurisdictions calculate the time for this statute of limitations in different ways, you should promptly contact a copyright lawyer when you believe your work has been infringed.

In order to establish that there has been an infringement, the copyright owner will need to prove that the work is copyrighted and registered, that the infringer had access to the copyrighted work, and that the infringer copied a "substantial and material" portion of the copyrighted work. In order to demonstrate the extent of the damage caused by the infringement, the copyright owner must also provide evidence that shows how widely the infringing copies were distributed.

The copyright owner must prove that the infringer had access to the protected work, because an independent creation of an identical work is not an infringement. However, infringement can occur even if a work has not been copied in its entirety because any unauthorized copying of a substantial portion of a work constitutes an infringement.

Obviously, direct reproduction of a photograph without the copyright holder's permission constitutes infringement. In a 1994 Eighth Circuit Court of Appeals case, *Olan Mills, Inc. v. Linn Photo Co.*, Linn Photo was held to have infringed Olan Mills's photographs when it made reproductions of portraits taken by Olan Mills without Olan Mills's consent. Less obviously, a drawing or painting based entirely on a copyrighted photograph can constitute an infringement if it is substantially similar. A photographer who copies a copyrighted photograph of another by shooting a substantially similar photograph may be guilty of infringing the copyright. Note that while the copyright statute prohibits others from making a substantial copy of a protected work, it does not define *substantial copy*.

In 2000, in *Leigh v. Warner Bros., Inc.*, the United States Court of Appeals for the Eleventh Circuit was presented with a case involving Jack Leigh's

shooting of a photograph of the Bird Girl sculpture that was used as the cover of the novel *Midnight in the Garden of Good and Evil*. When Warner Brothers produced a movie based on the book, it used some of the same images of the sculpture both in the movie and in advertising for the movie. Warner Brothers shot its own images of the sculpture, and none of Leigh's images were actually used by the movie company.

The court pointed out that the photographer's copyright does not encompass the appearance of the sculpture itself. Nor did the photographer have any rights in the sculpture's setting. The court pointed out that Leigh's selection of lighting, shading, timing, angle, and film were protectable and should be considered, along with the overall combination of these elements and the mood they convey. The appellate court agreed with Warner Brothers that the images in the movie were not substantially similar to the photograph on the book cover, and thus no infringement occurred. When comparing the photographer's work to the motion picture company's still shots used in advertising materials, however, the court found that there were enough similarities between the protectable portions of the works that the question of copyright protection should be considered at trial.

Similarity of ideas alone will be insufficient to establish infringement. If the expression of ideas (rather than simply the ideas or subject matter) is found to be similar, the court must then decide whether the similarity is substantial. Different courts have established different tests and procedural rules for determining substantial similarity, but generally the court identifies which aspects of the work are unprotectable (general subject matter, etc.) and removes those items from consideration and examines the protectable areas, in a photograph—things like background, lighting, shading, and color—for similarities. Then a "subjective" judgment of the work's intrinsic similarity is made. In other words, would a lay observer, or sometimes a specialized observer, recognize that the defendant's work had been copied from the copyrighted work? Are they similar in concept and feel?

In *Kaplan v. Stock Market Photo Agency, Inc.*, a 2001 case in the Southern District of New York, the court held that the defendant's photograph of a businessman wearing wingtip shoes poised to jump from a tall building onto a car-lined street did not infringe the plaintiff's copyrighted photograph of the same scene because the similarities between the photographs involved elements not protected by copyright—like subject matter, as opposed to stylistic elements like background, lighting, shading, and color. Similarly, the

federal court for the Southern District of New York held, in 2005 in *Bill Diodato Photography, LLC v. Kate Spade, LLC*, that a photograph showing the calves and feet of a female model, as well as fashionable shoes and a handbag, under a closed toilet stall door did not infringe a photograph with the same subject matter, since copyright does not protect general ideas.

The Ninth Circuit Court of Appeals case in 2018, *Rentmeester v. Nike, Inc.*, involved a lawsuit brought by a photographer against Nike. He had staged and taken a photograph of Michael Jordan leaping toward a basketball hoop with a basketball raised above his head in his left hand—which the court described as a nonnatural position. The background of the photograph was a grassy knoll on the University of North Carolina campus in 1984. Nike obtained a license through him to use transparencies of the photo "for slide presentation only." Then Nike, beginning its partnership with Jordan by promoting Air Jordan athletic shoes, hired a photographer to take its own picture of Jordan. Although the court noted that the photo was "obviously inspired by Rentmeester's," it had the city of Chicago's skyline as a background, Jordan was wearing Chicago Bulls colors and was wearing Nike shoes, but Jordan was in a similar position. Thereafter, Nike created its iconic "jumpman" logo, a black silhouette of Jordan's figure as it appears in the Nike photo. Rentmeester sued Nike alleging that both the Nike photograph and the logo infringed his copyright.

The court determined that there was not substantial similarity between the two photographs and that the photographer was "entitled to protection only for the way the pose is expressed in his photograph, a product of not just the pose but also the camera angle, timing, and shutter speed Rentmeester chose. . . . What *is* protected by copyright is the photographer's selection and arrangement of the photo's otherwise unprotected elements. If sufficiently original, the combination of subject matter, pose, camera angle, etc. receives protection, not any of the individual elements standing alone." The court found that the two photos were different from each other in more than minor details and that Nike did not infringe the photographer's copyright.

A case in 1986 in the Second Circuit Court of Appeals, *Horgan v. Macmillan, Inc.*, held that the substantial-similarity test applies even when the allegedly infringing material is in a different medium. This case involved *The Nutcracker* ballet choreographed by George Balanchine, whose estate receives royalties every time the ballet is performed. Macmillan prepared a book of photographs that included sixty color pictures of scenes from a performance of *The Nutcracker*. In determining whether this constituted

infringement, the court of appeals noted that the correct test, as earlier artic- ulated by Judge Learned Hand, is whether "the ordinary observer, unless he set out to detect the disparities, would be disposed to overlook them, and regard their aesthetic appeal as the same." Furthermore, the court noted, "Even a small amount of the original, if it is qualitatively significant, may be sufficient to be an infringement, although the full original could not be recreated from the excerpt." The court did not decide whether infringement occurred; it sent the case back to the lower court to apply the correct test and continue with the case.

The First Circuit in 2002 addressed an interesting infringement matter in *Bruce v. Weekly World News*. The photographer had taken a photograph of Bill Clinton shaking hands with a Secret Service agent. The *Weekly World News* modified the photograph, without consent, to superimpose the Space Alien popularized by the *Weekly World News* onto the image of the Secret Service agent. Ultimately, Bruce was paid for the use, but the *Weekly World News* then used the same image on T-shirts and in other issues of the tabloid without consent. Bruce sought $359,000 but was awarded just over $25,000 for the infringing use due to insufficient damages proof.

Injunctive Relief

Even before trial, a copyright owner may be able to obtain a preliminary court order against an infringer. The copyright owner can petition the court to seize all copies of the alleged infringing work and the negatives that produced them. To do this, the copyright owner must file a sworn statement that the work is an infringement and provide a substantial bond, approved by the court. To succeed, the US Supreme Court ruled, in 2006, in a patent case, *eBay Inc. v. MercExchange, LLC*, that the party seeking injunctive relief must show:

- that he or she has suffered an irreparable injury
- that remedies such as monetary damages will not compen- sate adequately
- that after weighing the balance of hardships to be suffered by the parties, such a remedy is warranted
- and that the public interest would not be disserved if an injunction were granted. If an injunction is granted, after the seizure, the alleged infringer has a chance to object to the amount or form of the bond. After the trial, if the

work is held to be an infringement, the court can order the destruction of all copies and negatives and prohibit future infringement. If the work is held not to be an infringement, the alleged infringer may be able to recover its damages out of the bond.

Actual Damages

The copyright owner, assuming a successful registration, may request that the court award actual damages or, if registered prior to the infringement, statutory damages—a choice that can be made any time before the final judgment is rendered.

Actual damages are the actual damages suffered by the copyright owner as a result of the infringement and any profits of the infringer that are attributable to the infringement and not taken into account in determining actual damages. In proving the infringer's profits, the copyright owner need only establish the gross revenues received for the illegal exploitation of the work. The infringer then must prove any deductible expenses.

Statutory Damages

The amount of statutory damages is decided by the court, within specified limits: no less than $750 and no more than $30,000 per work infringed. The maximum possible recovery is increased to $150,000 if the copyright owner proves that the infringement was committed willfully. The minimum possible recovery is reduced to $200 if the infringer proves ignorance of the fact that the work was copyrighted. The court has the option to award the prevailing party its costs and attorneys' fees if the copyright was registered prior to the infringement. As noted above, registration within three months of publication is treated as having occurred on the date of publication.

Criminal Enforcement

The US Justice Department can prosecute a copyright infringer. If the prosecutor proves beyond a reasonable doubt that the infringement was committed willfully and for commercial gain, the infringer can be fined substantial sums and imprisoned for escalating terms depending on whether there were repeated offenses.

Fair Use

Not every copying of a protected work will constitute an infringement. There are two basic types of noninfringing use: fair use and exempted use. The Copyright Act of 1976 recognizes that copies of a protected work "for purposes such as criticism, comment, news reporting, teaching (including multiple copies for classroom use), scholarship or research" can be considered fair use and, therefore, not an infringement. However, this list is not intended to be complete, nor is it intended as a definition of fair use. *Fair use*, in fact, is not defined by the act.

Instead, the act cites four factors to be considered in determining whether a particular use is or is not fair:

1. The purpose and character of the use, including whether it is for commercial use or for nonprofit educational purposes
2. The nature of the copyrighted work
3. The amount and substantiality of the portion used in relation to the copyrighted work as a whole
4. The effect of the use upon the potential market for, or value of, the copyrighted work

The act does not rank these four factors, nor does it exclude other factors in determining the question of fair use. In effect, the act leaves the doctrine of fair use to be developed by the courts.

A classic example of fair use would be the reproduction of one photograph from a photography book in a newspaper or magazine review of that book. Another would be the photographing of a copyrighted photograph as background. Because of the fact that fair use is determined on a case-by-case basis, it is a good idea to be familiar with the facts and results of some of those cases.

In *Peterman v. Republican National Committee*, decided in March 2018 in the federal district court for Montana, the court confronted the question of whether the defendant, the Republican National Committee, could successfully use the defense of "fair use" to terminate a photographer's copyright infringement case against it early in the judicial process, dismissing the case and eliminating the photographer's right to a trial. The photographer contracted with the Montana Democratic Party to take photographs of a democratic candidate and gave the Democratic Party a limited license to use her photograph and registered it with the US Copyright office. The

photograph showed the candidate, from behind, wearing a cattleman's hat with three bright lights in the distance. The Republican National Committee, without the photographer's permission, sent out a mass mailing using her picture to negatively depict the candidate, with the only difference being a treble clef and text over the bottom left of the image. The court determined that the committee's case "fair use" defense was not so good as to deny the photographer a trial. Most of the factors the court considered supported the photographer's case as opposed to the committee's. Among other things, the court found the photograph to be more like an artistic portrait than an informational or functional work, explained that there was basic copying of the whole photograph and very little transformation of it, and ruled that the case could proceed to trial.

In 2018, in *Philpot v. LM Communications II of South Carolina, Inc.*, the federal district court for the Eastern District of Kentucky ruled in favor of the plaintiff photographer on his copyright infringement claim without making him go to trial on the issue. The photographer, a professional concert photographer, took a photo of Willie Nelson during a Farm Aid concert in St. Louis, Missouri. He published it on Wikipedia and offered to allow others to use it if they complied with the terms of a Creative Commons license that would permit use of the photograph as long as the proper attribution was given to the photographer. The photographer then registered the copyright with the US Copyright office. The defendant, without the photographer's permission and without providing a proper attribution, posted a copy of the photograph on its website as part of a promotion for an upcoming concert by Willie Nelson and another performer. The court found that there had been infringement as a matter of law, deciding the issue in advance of a trial and obviating the need for a trial, as the defendant could not demonstrate "fair use," since the use of the photograph was not for "criticism, comment, news reporting, teaching . . . scholarship or research." Moreover, nothing had been done to transform the photograph, as it had simply repackaged or published the original.

In *Rogers v. Koons*, in 1992, the Court of Appeals for the Second Circuit rejected a sculptor's argument that his use of a photograph as a model to make a sculpture was fair use. Before sending the photograph to a workshop for the purpose of having a maquette created, the sculptor removed the plaintiff's copyright notice. The sculptor subsequently sold three wooden copies of the maquette for a total of $367,000. The court held that the use was commercial and to make a profit, the original was a work of art, Koons copied the essence

of the photograph, and the sculpture could impact the market for the original photograph.

Jeff Koons was, however, successful in defending a later lawsuit in 2006, in the Second Circuit Court of Appeals, *Blanch v. Koons*, brought by a fashion photographer. Koons had adapted a photograph of a model's lower legs and feet resting on a man's lap in an airplane, using only the legs and feet in a collage painting, along with three other pairs of legs. The court felt this use was transformative and a comment on its social meaning.

The 1968 case in the Southern District of New York of *Time, Inc. v. Bernard Geis Associates* involved Abraham Zapruder of Dallas, Texas, who took home movies of President Kennedy's arrival in Dallas. Zapruder started the film as the motorcade approached. When the assassination occurred, he caught it all. Zapruder had three copies made of this film. Two he gave to the Secret Service solely for government use, and the other he sold to *Life* magazine. *Life* registered the copyright to the films and refused to allow publisher Bernard Geis Associates the right to use pictures from the film in a book. When the publisher reproduced frames in the film by charcoal sketches, *Life* sued for copyright infringement. The court found, however, that the publisher's use of the pictures was a fair use and outside the limits of copyright protection, reasoning that the public had an interest in having the fullest possible information available on the murder of President Kennedy. The court also noted that the book would have had intrinsic merit and salability without the pictures and that the publisher had offered to pay *Life* for its permission to use the pictures. The court also noted that *Life* sustained no injury, because the publisher was not in competition with it.

When, however, a Boston CBS affiliate station reused a photograph of mobster Stephen Flemmi without permission in connection with a news story about a different mobster, the federal district court in Massachusetts in 2007, in *Fitzgerald v. CBS Broadcasting, Inc.*, rejected the fair use defense, finding that in both instances, the photograph was used for the same purpose (news reporting) and, thus, the reuse affected the potential market for the photograph.

A use of a copyrighted work in the background is discussed in Second Circuit Court of Appeals case in 1998, in *Sandoval v. New Line Cinema Corp.*, which involved inclusion of a photographer's images in the motion picture *Seven*. The photographic transparencies were visible only for about thirty-five seconds and then shown only from a distance with some blurring. The

court held that the use of the photographs was *de minimus* and thus not an infringement.

Playboy was able to successfully argue that its reproduction of a Playmate's high school photograph on her Playmate bio page in the magazine was fair use. The federal court in the Eastern District of California in 2008, in *Calkins v. Playboy Enterprises International*, found the use was incidental, as well as *transformative* (used in a new way), since *Playboy* used the photograph to inform and entertain its readers, whereas copies of the original photograph were used as gifts for family and friends. Further, the *Playboy* publication did not injure the market for the plaintiff's work.

In *Bill Graham Archives v. Dorling Kindersley, Ltd.*, the Second Circuit, in 2006, held that reproductions of Grateful Dead posters in a 480-page book about the Grateful Dead were fair use, since they were used as "historical artifacts" and were dramatically reduced in size and combined with textual material.

As is apparent from this brief discussion, fair use is a complex subject, and if you plan to rely on this defense, it would be a good idea to check with a copyright lawyer first.

Parody

Another area in which the fair use defense has been used successfully is in cases involving parody. The courts have generally been sympathetic to the parodying of copyrighted works, often permitting incorporation of a substantial portion of a protected work. The test has traditionally been whether the amount copied exceeded that which was necessary to recall or "conjure up" in the mind of the viewers the work being parodied. In these cases, the substantiality of the copy, and particularly the "conjuring up" test, may be more important than the factor of economic harm to the copyright proprietor.

Walt Disney Productions v. Air Pirates, decided by the Ninth Circuit in 1978, involved publication of two magazines of cartoons titled *Air Pirates Funnies* in which characters resembling Mickey and Minnie Mouse, Donald Duck, the Big Bad Wolf, and the Three Little Pigs were depicted as active members of a free-thinking, promiscuous, drug-ingesting counterculture. The court held that a parodist's First Amendment rights and desire to make the best parody must be balanced against the rights of the copyright owner and the protection of the owner's original expression. The

court explained that the balance is struck by giving the parodist the right to make a copy that is just accurate enough to conjure up the original. Since the Disney cartoon characters had widespread public recognition, a fairly inexact copy would have been sufficient to call them to mind to members of the viewing public. The court held that by copying the cartoon characters in their entirety, the defendants took more than what was necessary to place firmly in the reader's mind the parodied work and those specific attributes that were to be satirized. Thus, the Air Pirates cartoons were deemed an infringement.

In the *Campbell v. Acuff-Rose Music* case, however, the United States Supreme Court, in 1994, found that it was possible that the musical group 2 Live Crew's conversion of the popular song "Pretty Woman" into one that was overtly sexual was fair use despite the commercial nature of the parody and its copying of the "heart" of the original work. The court found error in that the lower court had applied a presumption that the commercial nature of the use made it unfair. The case was returned to the lower courts to resolve the issue without application of a presumption of unfairness and explained that all of the elements of the fair use inquiry should have been considered.

The Second Circuit, in 1997, *Leibovitz v. Paramount Pictures, Inc.*, found a photograph that incorporated a substantial portion of the original to be a parody. A photograph promoting the movie *Naked Gun 33 1/3: The Final Insult* spoofed the *Vanity Fair* nude photograph shot by Annie Leibovitz of Demi Moore at eight months pregnant. The promotional shot superimposed the smirking face of the movie's star, Leslie Nielsen, over the face of a pregnant woman in the same pose used in the Demi Moore photograph. The court held that while the photograph was commercial, it was a parody and transformative in character and, therefore, a fair use.

In another case, Mattel sued photographer Thomas Forsythe for his series of photographs in which he depicted Barbie in various positions, often nude with kitchen appliances. For instance, *Barbie Enchiladas* depicts Barbie dolls wrapped in tortillas and covered with salsa. *Fondue a las Barbie* shows Barbie heads in a fondue pot. In 2003, in *Mattel, Inc. v. Walking Mountain Productions*, the Ninth Circuit explained that parody is a socially significant form of social and literary criticism and held that Forsythe's work was fair use as a parody, commenting on the harm Forsythe perceived in Barbie's influence on gender roles and the position of women in society.

Photocopying

One area in which the limits of fair use are hotly debated is the area of photocopying. The Copyright Act provides that "reproduction in copies . . . for purposes such as criticism, comment, news reporting, teaching (including multiple copies for classroom use), scholarship, or research" can be fair use, which leaves many questions. Reproduction of what? A piece of an image? Over half an image? An image no longer generally available? How many copies? To help answer these questions, several interested organizations drafted a set of guidelines for classroom copying in nonprofit educational institutions. These guidelines are not a part of the Copyright Act but are printed in the act's legislative history. Even though the writers of the guidelines defined the guide as "minimum standards of educational fair use," major educational groups have publicly expressed the fear that publishers would attempt to establish the guidelines as maximum standards beyond which there could be no fair use.

Online education has become quite popular, and online educators realized that much of what takes place in the classroom might be unlawful if presented online. It was for this reason that the Technology, Education and Copyright Harmonization Act of 2002 (TEACH Act) was enacted by Congress. Many hoped that this law would "level the playing field" between online educators and those who teach in a traditional classroom. While the law does provide some protection for online educators, it is by no means the "safe harbor" for which educators had hoped. In fact, the TEACH Act makes it clear that if the educator is uncertain about whether an online use is permitted, then the educator should rely on the fair use doctrine if possible.

Obtain Counsel

As all this demonstrates, it is not easy to define what sorts of uses are fair uses. Questions continue to be resolved on a case-by-case basis. Thus, you should consult an experienced copyright lawyer if it appears that one of your works has been infringed or if you intend to use someone else's copyrighted work. The lawyer can research what the courts have held in cases with similar facts.

Exempted Uses

In many instances, the ambiguities of the fair use doctrine have been resolved by statutory exemptions. *Exempted uses* are those specifically permitted by statute in situations where the public interest in making a copy outweighs any harm to the copyright holder.

The Copyright Act contains a number of provisions limiting the rights of a copyright owner. Sections of the act discuss and detail a number of limitations with significant specificity. Some most relevant to photographers are:

- Fair use (discussed previously)
- Reproduction by libraries and archives
- The first sale doctrine (mentioned earlier)
- Exemption of certain performances and displays
- Sovereign immunity

Reproduction by Libraries and Archives

Perhaps the most significant of these exemptions is the library-and-archives exemption, which basically provides that libraries and archives may reproduce and distribute a single copy of a work provided that:

- Such reproduction and distribution is not for the purpose of direct or indirect commercial gain
- The collections of the library or archives are available to the public or available to researchers affiliated with the library or archives, as well as to others doing research in a specialized field
- The reproduction includes a copyright notice

Small numbers of copies can also be made for certain library collection purposes.

According to the legislative history of the Copyright Act, Congress particularly encourages copying of films made before 1942, because these films are printed on film stock with a nitrate base that will decompose in time. Thus, so long as an organization is attempting to preserve our cultural heritage, copying of old films is allowed and encouraged under the fair use doctrine.

The exemption for libraries and archives is intended to cover only a few copies of a work. It generally does not cover multiple reproductions of the same material, whether made on one occasion or over a period of time, and whether intended for use by one person or for separate use by the individual members of a group. Under interlibrary arrangements, various libraries may provide one another with works missing from their respective collections, unless these distribution arrangements substitute for a subscription or purchase of a given work.

This exemption in no way affects the applicability of fair use, nor does it apply where such copying is prohibited in contractual arrangements agreed to by the library or archives when it obtained the work.

The First Sale Doctrine

As mentioned before, the first sale doctrine allows the legitimate purchaser of a physical copy of a work to sell, display, give away, or otherwise dispose of that copy. This exemption, however, does not permit unauthorized reproduction of the copy. Moreover, the owner of a lawful copy of a work may, without the copyright owner's permission, display the copy to viewers present at the place where the copy is located. Photographers should be aware that there is significant confusion and differences of opinion in the case law with respect to application of this section of the copyright law to digital copies and ebooks. The law is evolving in these areas.

Exemption of Certain Performances and Displays

This limitation provides, among other things, that it is not an infringement to perform or display a work by instructors or pupils in the course of a face-to-face teaching activity in a nonprofit educational institution. There is significantly more detail in the Copyright Act on the subject, and if this exemption becomes an issue, the law should be reviewed in its entirety.

Be aware—limitations and exemptions in copyright law are complex, and the guidance of a good intellectual property lawyer is recommended.

Sovereign Immunity

A number of comparatively recent cases have involved the question of whether or not the federal government or any state can be liable for copyright infringement. Thus far, because of the doctrine of sovereign immunity, federal and state governments have been found to be protected against liability for infringement when using copyrighted works. Since the US government or a state government can only be sued when it consents to be sued, the plaintiff must establish that the government authorized or consented to the infringement and that the government agreed to be sued for it.

Although the Copyright Amendment of 1990 provides that states can be held liable for copyright infringement, many cases have held that this amendment is prohibited by the Eleventh Amendment to the US Constitution. Thus,

a photographer may have work infringed by the state or federal government and have no redress.

The Computer Age and Copyright

With the advent of the Internet, many of the legal issues presented throughout this text are being reexamined. The rights of copyright, publicity, libel, privacy, and trademark are among the most prominent.

A major concern for the photography profession is computer-enhanced imagery. Digital technology enables a computer to produce vivid images that can be manipulated and distorted to varying degrees. As a result, many opportunities and risks are surfacing that have not yet been clearly delineated.

In *Mendler v. Winterland Production, Ltd.*, in 2000, the Ninth Circuit was presented with the question of whether a modified photograph used without the photographer's permission was a copyright infringement. The photographer granted a clothing company a license to use his yacht race photographs as "guides, models, and examples, for illustrations to be used on screen-printed T-shirts or other sportswear." The clothing company scanned one of the photographs and then digitally modified it, flipping the image and changing the colors, among other things. The photographer sued for copyright infringement, arguing that this use of his photograph was not authorized by the license agreement, because the T-shirts bore an altered photograph, not an illustration. The clothing company argued that the alteration transformed the image from a photograph to an illustration based on a photograph. The court held that the image retained its photographic characteristics, so that the use of the photograph constituted copyright infringement.

While it does not involve photography, the Supreme Court case of *New York Times Co., Inc. v. Tasini* in 2001 is nonetheless an important case for photographers. Freelance authors of articles that appeared in the *New York Times* and other publications sued due to the publishers' reproduction of those articles in electronic databases without permission. The publishers claimed that the use of the articles in such databases constituted a revision of the editions of the publications in which the articles originally appeared. The Supreme Court disagreed, basing its opinion on a number of factors with respect to the storage and retrieval systems of the databases, and ruled that republishing the freelance contributions in the databases without the express consent of the writers was an infringement of the writers' copyrights.

Similar cases have involved photographers. In *Greenberg v. National Geographic Society*, the Eleventh Circuit in 2001 originally found that *National Geographic* violated the law when it reproduced a photographer's work in a set of CD-ROM magazines containing 108 years of the *National Geographic* magazine. Despite the magazine's argument that the CD-ROMs were similar to copies on microfilm, the court held that the work was not a revision of the prior work but constituted a new collective work. On rehearing in 2008, however, the court agreed with *National Geographic* that the CD-ROMs were, in fact, similar to microfilm, because the electronic version presented scans of pages exactly as they appeared in print, even though the electronic version included a search engine. A Second Circuit case in 2005, *Faulkner v. National Geographic Enterprises*, reached the same conclusion.

According to *Bridgeman Art Library, Ltd. v. Corel Corp.*, no one who merely scans a photograph obtains any additional rights in the digital form of the copyright. In this case in the Southern District of New York in 1998 and after rehearing in 1999, the question arose as to whether photographs of approximately seven hundred paintings by European masters (which paintings are in the public domain) would enjoy copyright protection. The court felt that the photographs were not entitled to copyright protection and, since the intention of the photographer was to actually depict the two-dimensional painting, there was no creativity or originality in taking the photographs. Indeed, said the court, in this case, there was nothing more than "slavish copying," and thus the skilled and artistic input necessary to support a copyright was not present.

The law is evolving in this area as recognized by the court in *Goldman v. Breitbart News Network, LLC*, in the Southern District of New York in 2018. It stated:

> When the Copyright Act was amended in 1976, the words "tweet," "viral," and "embed" invoked thoughts of a bird, a disease, and a reporter. Decades later, these same terms have taken on new meanings as the centerpieces of an interconnected world wide web in which images are shared with dizzying speed over the course of any given news day. That technology and terminology change means that, from time to time, questions of copyright law will not be altogether clear. In answering questions with previously uncontemplated technologies, however, the Court must not be distracted by new terms or

new forms of content, but turn instead to familiar guiding principles of copyright.

The court in that case determined that the defendants, online news outlets and blogs, infringed Justin Goldman's copyright in his picture of Tom Brady by embedding a Tweet including the photograph into articles on their websites.

Digital Millennium Copyright Act

The Digital Millennium Copyright Act (DMCA), enacted originally in late 1998, was intended in part to implement treaties signed at the World Intellectual Property Organization (WIPO) Geneva Conference in 1996. It is a complex and controversial act. It tries to balance the interest of copyright holders and Internet service providers when infringement occurs in the digital world. The act contains many provisions, some of which:

- Prohibit the unauthorized removal or alteration of "copyright management information" (CMI), which includes identifying information about the work, the author, the copyright owner, and the terms and conditions for use of the work
- Prohibit use of false CMI
- Generally limit the copyright infringement liability of Internet service providers (ISPs) for simply transmitting users' information over the Internet if certain conditions are met

As noted previously, the act is detailed and complex and is a subject that would require multiple books to explain. Its coverage includes matters such as circumvention of antipiracy measures built into software, code-cracking software to illegally copy software, and requirements that webmasters pay license fees to record companies, among others. The coverage here is necessarily limited. Photographers should be aware of the act and discuss DMCA issues with their intellectual property lawyers if they arise.

Some case law under the act has involved photographs. *Kelly v. Arriba Soft Corp.*, decided by the Ninth Circuit in 2003, involved the application of this law to a photographer. The plaintiff, Leslie Kelly, was a photographer who maintained two websites containing some of his photographs. The defendant operated a visual search engine, which returned the results as thumbnail

images. The user of the search engine could see the full-size version of the image, along with an address for the originating website, by clicking on the thumbnail image. No copyright notice was shown, however. The plaintiff sued for copyright infringement and violation of the anticircumvention provisions of the DMCA. The court held that the defendant's use of the images was fair use, that the defendant had not removed any CMI in violation of the law since the court found this to apply to removal from the original work, not from a reproduction, that users of the defendant's search engine were no more likely to infringe than users of the plaintiff's website, and that the defendant had no reasonable basis to believe that the users of its search engine would infringe the photographer's copyright.

On appeal, the appellate court upheld the ruling that the thumbnail images were not infringing but sent the question about the full-size images back to the lower court for rehearing. Use of thumbnail images was also addressed by the Ninth Circuit, in 2007, in *Perfect 10, Inc. v. Amazon, Inc.*, which upheld the *Kelly* ruling that thumbnail images are fair use.

In another DMCA case, photographer Lloyd Shugart sued the shoe company Propet USA over use of his images outside the scope of the usage agreement, failure to return his images, as well as removal of CMI. The jury awarded Shugart $12,800 for damages arising from the infringement and also awarded $500,000 for Propet's removal of CMI and $303,000 for failure to return images.

TRADEMARK LAW

As a photographer, you are probably aware that trademark issues may arise in several ways: over the names of your photographs, the name of your business, or, perhaps, your domain name. What you may not be aware of is that your photographs themselves may infringe the trademark rights of others.

The Rock and Roll Hall of Fame Foundation registered the design of its museum as a service mark, and when a professional photographer began to sell a poster featuring a photograph of the museum, the foundation brought suit for trademark infringement. In *Rock and Roll Hall of Fame and Museum, Inc. v. Gentile Productions*, the Sixth Circuit in 1998 held that the plaintiff had not shown that the museum building was used as a trademark. The court did not, however, hold that such a scenario could never be deemed trademark

infringement, so you should contact an attorney if you are planning to distribute any photographs containing trademarks.

Photographers have attempted to protect their styles using the trademark and trade dress laws, but this attempt has been rejected by the courts. A photograph can, of course, be used as a trademark or service mark for products and services.

MORAL RIGHTS

As an art, photography is a form of property requiring unique consideration, and as a photographer, you have an interest in deciding whether to disclose your work, seeing that your work retains the form you gave it, and ensuring that you are properly credited. While these rights indirectly affect the photographer's economic interests, they more basically affect the photographer's reputation and, therefore, generally are referred to as *moral rights* or *droit moral*.

The artist's moral rights are recognized in some form in most countries, including the United States, and have been included in the Berne Convention, which covers international copyright protection in addition to many elements of the droit moral. All signatories to the Berne Convention are obligated to adhere to its moral rights provisions. While moral rights principles are often considered antagonistic to the property rights of owners in the United States, protection of certain minimal moral rights became mandatory when the United States became a signatory to the convention in 1988.

In 1990, Congress passed the Visual Artists Rights Act (VARA), which amends the Copyright Act by providing to authors or artists of certain works the rights of attribution and integrity. The act expressly includes photographs produced for exhibition purposes only, in a signed, numbered edition of two hundred or fewer. These rights may be enforced by any applicable remedy, other than criminal penalties, otherwise available for infringement under the Copyright Act. Visual Artists Rights belong solely to the photographer and are not transferable. The moral rights granted by VARA may be waived by the artist, but only in writing, and may not be transferred. The moral rights granted by VARA only affect works by living artists and, for works created on or after the effective date of the 1990 act, last for the life of the artist. Under this statute, the "author of a work of visual art" has the right to:

- Claim authorship of the work;
- Prevent the use of his or her name as the author of any work of visual art he or she did not create;
- Prevent the use of his or her name as the author of the work if it has been distorted, mutilated, or otherwise modified in a way that would be prejudicial to his or her honor or reputation;
- Prevent the prejudicial intentional distortion, mutilation, or modification of the work;
- Prevent the destruction of a work of "recognized stature" and any intentional or grossly negligent destruction of the work.

TRADE SECRET LAW

Another form of protection, known as the *trade secret law*, can afford protection to innovations not covered by copyright or trademark laws. All that is necessary for something to be protectable as a trade secret is that:

- It gives the possessor a competitive advantage
- It will, in fact, be treated as a secret by you
- It is not generally known in your industry

The fundamental question of trade secret law is "What is protectable?" The way you use knowledge and information, the specific portions of information you have grouped together, even the mere assembly of information itself may be a trade secret, even if everything you consider important for your secret is publicly available information. For example, if there are numerous methods for producing a particular photographic effect and you have selected one of them, the mere fact that you have selected this particular method may itself be a trade secret. The identity of your suppliers may be a trade secret, even if they are all listed in the yellow pages. The fact that you have done business with these people and found them to be reputable and responsive to you may make the list of their names a trade secret.

Many trade secrets will be embodied in some form of document. One of the first things you should do is to mark any paper, photograph, or the like that you desire to protect as a trade secret, identifying it as confidential. You

should also take steps to prevent demonstrations of your trade secret. Taking these steps will not create trade secret protection, but the fact that an effort has been made to identify the materials and methods you consider secret will aid you in establishing that you treated them as a trade secrets should litigation ever occur. In this area, a little thought and cleverness will go a long way toward giving you the protection of the trade secret laws.

You should have some degree of physical security. It has been said that physical security is 90 percent common sense and 10 percent true protection. You should restrict access to the area in which the trade secret is used. Some precaution should be taken to prevent visitors from peering into the area where the secret process, formula, or technique is employed. Employee access to trade secret information should be on a "need-to-know" basis; a procedure should be established for controlled employee access to the documents. It is also a good idea to have employees sign confidentiality and nondisclosure agreements when hired. You should have outsiders sign a similar agreement before you reveal anything to them about the subject of your trade secret. An attorney who deals with intellectual property can prepare form agreements for use within your business.

Trade secret laws may be the only protection available for your business secrets. Care should, therefore, be taken to restrict access to the information and to treat the information as truly secret.

Defamation and Libel

In the year 399 BCE, the Greek philosopher Socrates was tried for, and convicted of, teaching atheism to the children of Athens. In his defense, Socrates claimed that most of the charges were based on lies and that his reputation had been unjustly attacked for years. For example, he argued that in *The Clouds*, a play by Aristophanes that was performed before the entire population of Athens, the bumbling teacher of philosophy was named Socrates. In Athens, at the time, free speech, other than heresy—voicing an opinion contrary to accepted religious doctrine—was an absolute right. Having been convicted of the thing prohibited, and there being no protection from defamatory statements since such speech was a right, Socrates was sentenced to death.

Despite the First Amendment guarantee that freedom of speech will not be abridged, in contemporary America that freedom has limits. Defamatory material, including photographs, is prohibited by law in all fifty states. A statement will generally be considered defamatory if it falsely tends to subject a person to hatred, contempt, or ridicule or if it results in injury to that person's reputation while in office, in business, or at work.

The American Law Institute, whose publications are influential to courts, defines libel as publication of defamatory matter "by written or printed words, by its embodiment in physical form, or by any other form of communication which has the potentially harmful qualities characteristic of written or printed words." Things that have been found to be defamatory include falsely calling someone a liar, a cheat, or a thief.

Photographs can be defamatory. Generally, a picture by itself cannot be the basis for liability, because truth is a defense to libel and the camera merely records what is there, though it can become defamatory if edited with photo-editing software or is otherwise altered in a way that exposes the subject to ridicule or contempt.

For instance, figure skater Nancy Kerrigan brought a defamation suit after she discovered computer-generated pornographic photographs of herself on a website. The case was settled for an undisclosed sum, and the defendant agreed not to publish any more images of Kerrigan.

Usually, liability for defamation arises due to the accompanying text or captions. Online the defamation could occur due to a link from or to the site containing the photograph at issue. In determining whether or not a photograph is defamatory, the court will consider a publication in its entirety. So, to protect against liability for defamation, a photographer should caption photographs accurately before selling them. Also, the photographer should be careful not to participate in or explicitly approve of false or injurious text accompanying the photographs.

In *Cantrell v. Forest City Publishing Co.*, a reporter wrote a story that to some extent inaccurately portrayed the circumstances and abject poverty of a family whose father had been killed in a flood. A photographer for the newspaper, traveling with the reporter, took fifty pictures of the family's home, some of which were published with the story. The story contained a number of errors, and the family sued the newspaper, the reporter, and the photographer. At trial, the jury found all three were liable. On appeal in the Sixth Circuit federal court of appeals, none were found liable. The US Supreme Court, in 1974, describing the case as one based on a "false light" theory of invasion of privacy, reinstated the liability finding for the reporter and newspaper, but not for the photographer.

If defamation is written or otherwise tangible, it is *libel*; if it is oral, it is *slander*. For the most part, the same laws and principles govern all defamatory statements, but since a photographer's liability involves images that appear on transparency, on paper, and in digital form, we will focus here on libel. As a photographer, you must be cautious about any photographs or captions that might be considered defamatory. If the work is published—and, as you will see, "published" has a very broad meaning in the context of libel—you, as the photographer, could be sued for libel along with the publisher.

Note that due to Section 230 of the Telecommunications Act of 1996, Internet service providers (ISPs), unlike traditional publishers, have immunity for defamation claims in some circumstances, such as when the ISP merely provides access to content provided by other parties and had nothing to do with developing or encouraging the defamatory content. This would provide no protection to a photographer, however, who provided defamatory material to the ISP.

It is not always easy to determine whether a photograph is defamatory. In order to give you some idea of the scope of libel, let us take a closer look at what kinds of photographs the courts have found to be libelous. Then, we will look at who can sue a photographer for libel and various defenses a photographer can use against different types of plaintiffs.

ACTIONABLE LIBEL

Actionable libel is libel that would furnish legal grounds for a lawsuit. In order for a photograph to be libelous, it must, in legal terminology, "convey a defamatory meaning" about an identifiable person or persons and must have been published. Thus, a photograph of, for example, a Jewish leader on which a Nazi armband has been airbrushed would be libelous.

Courts have traditionally put libel into two categories: *libel per se* and *libel per quod*. In libel per se, the defamatory meaning is apparent from the statement or thing itself. In libel per quod, the defamatory meaning is conveyed only in conjunction with other explanation or material. The category into which a libel falls determines the kind of pleading and proof of damages that a plaintiff must make.

In many jurisdictions, if libel is per se, damage to reputation is presumed and need not be proven. If libel is per quod, there is no presumption of damage to reputation, and a plaintiff must plead and prove *special damages,* that is, damages of a nature that are not the necessary consequences of the injury about which complaint is made. In other words, things like bills, loss of income, and other things measured in money. These are different from general damages, which might not be measured by a specific dollar figure. In most jurisdictions, in a per quod case, there must be proof of special damages, but at least one jurisdiction permits a per quod action without proof of special damages if the publisher knew or should have known of the outside facts that were necessary to make the publication defamatory.

Libel Per Se

One example of libel per se is a false accusation of criminal or morally reprehensible acts. An accusation of criminal conduct is libelous per se, even though it is not explicitly stated. If the photographer has published a photograph and caption that describe a crime or has cast suspicion by innuendo,

that is sufficient for libel per se. In *Time, Inc. v. Ragano*, the court found potential defamation liability based on publication of a photograph of seven men seated at a restaurant table accompanied by an article that referred to the men, two of whom were attorneys, as Cosa Nostra hoodlums. Similarly, in *Hagler v. Democrat News, Inc.*, a newspaper ran a photograph of a sign identifying a couple's cabin to illustrate an article on a drug raid. The owners of the cabin sued for defamation and invasion of privacy. As the pictured cabin was in no way implicated in the drug raid, the photograph would indeed have been defamatory had the text of the article not made it clear that the drug raid had occurred in another cabin.

On the other hand, it is never libel per se to say that someone is exercising a legal right, even though the person may not want the fact known. Although these statements may cast suspicion, they cannot be libelous per se because they merely report the exercise of a legal right.

To falsely state that someone has a loathsome or contagious disease, such as syphilis, is libelous per se. An untrue statement that describes deviant sexual conduct or unchastity, particularly by a woman, is libelous per se. However, changing societal norms result in modifications of what is considered libelous per se. In 2009, a federal court judge in New York ruled in *Stern v. Cosby* that, due to changes in attitude about homosexuality, calling someone (in this case, Howard K. Stern, Anna Nicole Smith's lawyer) a "homosexual" was no longer defamation per se, although the plaintiff was permitted to attempt to prove that it was defamatory in context.

Similarly, in *Amrak Productions v. Morton*, in 2005, the Fifth Circuit Court of Appeals held that a photograph of a gay man mistakenly captioned as portraying another man was not defamation, since the caption identified the man as "Madonna's secret lover," and nothing in the gay man's appearance gave any indication of homosexuality.

The suggestion of unwed pregnancy also undermines a woman's reputation for chastity and can be the basis for defamation action. In *Triangle Publications, Inc. v. Chumley*, the Georgia Supreme Court, in 1984, confronted a case in which a newspaper published a photograph of a teenage girl embracing a young man and a photograph of her alleged diary with an entry stating she was pregnant for an advertisement for a television show on teen pregnancy. The girl claimed that she was not pregnant and had never had sex with anyone. The court held that a jury could find that the photographs were defamatory and refused to dismiss the case.

Actress Florence Henderson, who starred as the mom on *The Brady Bunch*, brought suit against Serial Killer, a company selling T-shirts displaying her picture with the words "Porn Queen" underneath. The company immediately removed the offending merchandise from its website.

When the statement involves politics, the determination of libel per se is more difficult. Today, courts generally agree that a statement that a person belongs to a particular political group will be libel per se only if that group advocates the use of violence as a means of achieving political ends. In *Elhanafi v. Fox Television Stas., Inc.*, a New York case in 2012, the court described a libelous per se statement as one that imputes fraud, dishonesty, misconduct, or unfitness in conducting one's profession. It decided that a television sequence of cuts in a news story could implant in the minds of average viewers that three brothers were engaged in terrorist activities, making the question of libel one for a jury, and refused to dismiss a case for libel.

While one of the brothers had been indicted for traveling to Yemen to meet with members of Al Qaeda, the two other brothers, who sued as a result of the newscast that included wrongfully obtained copies of their driver's licenses and other photo identification, worked for the US Department of Veterans Affairs and for the City University of New York. The court refused to grant Fox's motion asking that the case be dismissed.

It also is usually deemed libel per se to falsely impute to a professional person a breach of professional ethics, general unfitness, or inefficiency. For example, it may be libel per se to indicate that a person's business is bankrupt, because the statement implies a general unfitness to do business. However, to indicate that the business person did not pay a certain debt may not be not libel per se, because everyone has a legal right to contest a debt.

There is a gray area concerning statements or pictures about certain business practices that may not be illegal but that, nonetheless, could give a business bad publicity. To indicate someone is cutting prices would likely not be libel per se, but to indicate someone is cutting prices to drive a competitor out of business most likely would be.

In the 2013 case of *Leser v. Penido*, in New York, the court determined that a business competitor was liable for libel per se when he published photographs and the home address of a luxury purse vendor on pornographic websites, surrounded by sexually explicit pictures, falsely implying that she was sexually lustful and promiscuous.

It is impossible to describe every situation that could constitute libel per se, since any situation can be libel per se if it is likely to produce a reprehensible opinion of someone in the minds of a large number of reasonable people. Remember, the rule of thumb is that a photograph or statement is libelous per se when the defamatory meaning is clear from hearing or seeing it by itself without the need for other explanation.

Libel Per Quod

In libel per quod, since the defamatory meaning is conveyed only in conjunction with explanation or if additional knowledge is required, the plaintiff who sues for libel must introduce the context of the situation and demonstrate to the court how the picture and caption, text, or other pictures—as a whole—produce a defamatory inference or innuendo. For example, the 1982 California case of *Gomes v. Fried* involved a photograph that showed an officer sitting in his police car with his head tilted to one side, and it was accompanied by a caption reading: "Officer Gomes car shown in the center of the lightly traveled Bristol Avenue (Sunday afternoon) prowling for traffic violations. His head tilted may suggest something." While the officer admitted that the photograph was accurate, the court observed that the photo with the caption was potentially defamatory, suggesting to ordinary readers that the officer was sleeping on duty. Since the newspaper people knew that the officer was not sleeping but was writing a traffic citation at the time the photograph was taken, the court held that the photograph could provide a legitimate basis for a lawsuit.

Another example of a case involving libel per quod was characterized as "libel by thank you." In April 1993, a Los Angeles federal judge dismissed an unusual libel suit brought by a Beverly Hills entertainment lawyer, Milton Rudin, against celebrity author Kitty Kelley. Rudin charged Kelley with defaming him in her 1991 unauthorized biography of Nancy Reagan when she listed him, along with 610 other people, as a source for the book. Rudin claimed that she destroyed his law practice, because, although he had refused to give her any information, she had maliciously listed him to create the false impression that he revealed confidential details to her about a relationship between Nancy Reagan and Frank Sinatra, who was a former client of Rudin.

The judge dismissed Rudin's case, and the decision was affirmed on appeal in the Ninth Circuit Court of Appeals, who noted that Rudin had failed to

prove that his practice was damaged by the reference that was neither clearly defamatory nor even particularly noticeable.

In *Bartholomew v. YouTube, LLC.*, a 2017 California case, the court held that removal of a video from a website, along with a statement that the video violated the website's terms of service, linking to a page setting out those terms, did not support a claim of libel per quod.

Defamatory Advertising and Trade Libel

Photographers should be aware that they are potentially liable for a type of defamation known as *trade libel* if they help to create advertisements that impugn the quality of commercial merchandise or products. If an advertisement falsely reflects adversely on a competitor's character, it can constitute *defamation per se*. If the advertisement implies that a competitor is fraudulent or dishonest, and if the competitor can prove financial loss, he or she may have an action for *defamation per quod*.

PUBLICATION

As mentioned earlier, a photograph must be published in order to constitute actionable libel. The legal meaning of *publication* in the libel context is very broad. Once a photograph is communicated to a third person who sees and understands it, the photograph, in the eyes of the law, has been published. Thus, if you show a photograph to someone other than the subject of it, you have published the photograph.

Generally, the person who is defamed can bring a separate lawsuit for each repetition of the defamatory photograph. However, when the photograph is contained in a book, magazine, or newspaper, a majority of courts have adopted what is known as the *single-publication rule*. Under this rule, a person cannot make each copy of the book grounds for a separate suit; rather, the number of copies is taken into account only for purposes of determining the extent of damages. The same rule applies online—and republication will be deemed to occur only if there is substantial modification to the defamatory content.

WHO CAN SUE FOR LIBEL?

In order to support a suit for libel, the photograph at issue must clearly depict or identify the plaintiff, the party bringing the suit. This is easy to prove,

of course, when the plaintiff is identified by name in the text or caption or where the plaintiff is clearly visible and identifiable in the photograph, but if a plaintiff is not identified by name, the plaintiff can prove that he or she was nonetheless "identified" by showing that a third party would reasonably believe that the photograph was of the plaintiff. For example, if the plaintiff had a unique and distinctive tattoo and it was visible in the photograph, even though the plaintiff's face was not, then the plaintiff would likely be able to establish that he or she was depicted in it.

The courts have uniformly held that groups, corporations, and partnerships can sue for libel, just as an individual can. Although there has been disagreement among the states as to whether nonprofit corporations should be protected, the trend seems to be to allow nonprofit corporations to sue when they are injured in their ability to collect or distribute funds.

If a defamatory picture is published depicting an identified group of people, the possibility of each member of that group having a good cause of action will depend on the size of the group and whether the photograph defames all or only a part of the group.

The individual members of a group might not prevail if the allegedly defamatory statement referred to only a portion of the group. If, for example, someone states that "some members" of a particular trade group shown in a photograph "are communists," the individual members probably cannot prevail in a defamation suit, since the statement is not all inclusive and since those included are not named. Again, the size of the group could affect the court's ruling.

If the partially defamed group is small and the people are recognizable, it would be more likely that the reputation of each member had been damaged, even though the statement was not all-inclusive.

Where the group is composed of more than one hundred members, the individuals generally do not have a good cause of action. If, for example, someone published a photograph of thousands of people in a ballpark audience and added a caption indicating that all depicted were thieves, it is unlikely that one person's reputation could be damaged as a result of the photograph. On the other hand, if that same caption described a small group of individuals in the photograph, those individuals could probably win a defamation suit, since they would be more likely to be subject to contempt, hatred, or ridicule as a result of the defamatory picture.

A photographer confronted with the question of whether or not to publish a work that identifies a person, group, or entity should make a two-step

analysis. First, does the picture — along with any caption or related material—defame anyone? If the answer is no, then it may be safely published (assuming no other wrongful act, such as copyright infringement or invasion of privacy, is involved). If the answer is yes, the second step is to determine whether there is a valid defense.

DEFENSES TO LIBEL

Since photographers often write captions or descriptions to accompany their photographs, you as a photographer need to know the situations in which you can defend your rights to publish. Even if a plaintiff proves defamation, publication, and damages (where damages must be proved), the photographer may, nevertheless, prevail in a lawsuit if he or she is able to establish a valid defense.

Disclaimers

In the past, parties sued for defamation have relied on use of an appropriately worded disclaimer to prevent potential defamation problems. A 2006 case in the First Circuit Court of Appeals, however, made reliance on a disclaimer a risky proposition. In *Stanton v. Metro Corporation*, the court found a disclaimer insufficient. The plaintiff was one of five young people pictured in a photograph that was juxtaposed with an article on teen promiscuity. Underneath the text in the main article, in very small font, were the words: "The photos on these pages are from an award-winning five-year project on teen sexuality. . . . The individuals pictured are unrelated to the people or events described in this story." Finding the disclaimer easy to overlook, the court held that the article was reasonably susceptible to a defamatory meaning.

Truth

Truth is an absolute defense to a charge of defamation, although it may not protect against other charges, such as invasion of privacy. It is not necessary for a potentially defamatory statement to be correct in every respect in order to be considered true. As long as the statement is true in all essential particulars, the defense will be acceptable. For example, if the caption "X robbed Bank A" appeared under a photograph of a bank robbery, it might not be considered actionable even if the photograph was, in fact, depicting a robbery of Bank B.

Opinion

Another possible defense is that the supposedly defamatory material was one of *opinion* rather than fact. The rationale for this defense is that one's opinion can never be false and, therefore, cannot be defamatory. Of course, the line between a statement of fact and an opinion is often hard to draw, particularly in the area of literary or artistic criticism.

Not surprisingly, art, literary, and drama critics have frequently been accused of libel after they have published particularly scathing reviews. When criticizing the work of artists, the critic is free to use rhetorical hyperbole as long as the statements do not reflect on the character of the artist. For example, in the early 1970s, Gore Vidal sued William F. Buckley Jr. for calling Vidal's book *Myra Breckenridge* pornography. The court found the claim not actionable, as Buckley had not attacked Vidal's character personally.

An example of criticism that did assail character is a famous case from the 1890s in which the American artist James Whistler won a defamation suit against John Ruskin, the English art critic. In his assessment of Whistler's painting *Nocturne in Brown and Gold*, Ruskin wrote: "I have seen, and heard, much of Cockney impudence before now, but never expected to hear a coxcomb ask 200 guineas for flinging a pot of paint in the public's face." On the surface, this statement was an expression of opinion of the painting's worth. At the same time, it implied facts about Whistler's motives, suggesting that he was defrauding the public by charging money for something that was not even art. The court found these implied facts to be defamatory, since they described Whistler as professionally unfit.

If an opinion assailing character concerns a topic of public interest, it might be allowed, since such opinions do have some, if limited, privilege. Such a situation arose in the Third Circuit case, in 1985, of *Lavin v. New York News, Inc.*, when a court declined to find that a photograph of two policemen captioned "Best Cops Money Can Buy" constituted defamation. The court held that the photograph and the accompanying article on organized crime came within the privilege concerning opinions on subjects of public interest.

Note that it is often required that, in order to take advantage of the opinion defense, the basis for the opinion be given, so that the persons to whom the defamatory content is published can determine how reliable the opinion is. In such a situation, the defense is available only if the stated facts are complete and accurate.

Consent

Someone accused of defamation may also raise the defense of *consent*. It is not libelous to publish a photograph of a person who has consented to its publication. In this situation, the extent of the material that may be legally published is governed by the terms and context of the consent.

An interesting 1958 case involving consent concerned a student humor magazine that had run a piece for Mother's Day consisting of four pictures. One picture was totally black. Under it was the caption "Father Loves Mother." Another picture showed a little girl with the caption "Daughter Loves Mother (And wants to be one too!)." A third picture showed a boy whose arm was tattooed with a heart enclosing the word *Mother* captioned "Sailor Boy Loves Mother," and the final picture showed a face partly covered by a hood labeled "Midwife Loves Mother." The picture of the little girl happened to be a photograph of the daughter of a local Methodist minister, Mr. Langford, and it was rumored that he was about to sue the school newspaper for libel. Langford maintained that the pictures and captions made innuendos about the unchastity of his daughter, his wife, and himself. Another student newspaper sent two reporters to interview the minister, and he gladly consented to the interview. When the minister filed suit, the newspaper that had conducted the interview published an article that truthfully set out the facts of the suit and contained material from the interview. It also republished the allegedly libelous material. The minister then sued the second paper, but he lost because the court found that he had consented to republication of the material.

In 1991, in *Miller v. American Sports Co., Inc.*, the Supreme Court of Nebraska found that a model's consent to use her picture in connection with the sale of products shown on a brochure was a defense to her invasion of privacy and her libel claim against the issuer of the brochure. The court found that the brochure, used for selling bathtubs and refrigerators, did not libel the model who was shown on the cover wearing only a bathing towel, even though the cover also displayed the word "sex." When the brochure was fully opened, the letters forming the word became part of the phrase "See us next time you build or buy." The remainder of the brochure did not suggest that the model was promoting or selling herself for another's sexual gratification—she was not identified, and the brochure did not disclose how she might be contacted.

Further, the court held that even if the brochure were libelous, the model's consent to her photograph being used in the brochure was an absolute

defense. Although the model did not know exactly which uses might be made of her picture, she admitted that she could have restricted its use but did not.

Reports of Official Proceedings

Another defense to what would otherwise be considered defamation is that the statement or picture was part of a report of *official proceedings* or a *public meeting*. As long as the context is a "fair and accurate" account of those proceedings, there can be no liability, even if the picture in question is both defamatory and false. The requirement that the publication be fair and accurate means that whatever was published must be a fair and balanced rendition. For example, a writer may not quote only one side of an argument made in court if there was also a rebuttal to that argument. The account need not be an exact quote, and it is permissible to include some background material to put an accompanying photograph into proper perspective. However, a photographer or caption writer must be careful not to include extraneous information, because this will not be protected by the report-of-official-proceedings defense.

Photographers and lawyers learned long ago that it is not always clear what constitutes an official proceeding or public meeting. Court proceedings from arrest to conviction are definitely official proceedings. On the other hand, photographs taken outside of court are not. A newsletter sent by a legislator to constituents does not generally constitute an official proceeding, whereas a political convention probably does.

Reply

Another defense to an accusation of libel is that of *reply*. If someone is defamed, that person is privileged to reply, even if the person accused of committing libel is defamed in the process. This privilege is limited to the extent that the reply may not exceed the provocation. For example, if A publishes a photograph of B and indicates that B is a communist, B has a right to reply that A is a liar or that A is a right-wing extremist, because both of these comments bear some relation to the original defamation. If, later on, A sues B for libel because of the statement about A being a right-wing extremist, B can simply show that the statement was in response to the material published by A (the reply defense), but if B made the mistake of responding to A by calling A a thief—a statement that bears no relation to A's accusation—B cannot have recourse to the reply defense.

Statute of Limitations

Another possible defense is the *statute of limitations*. Basically, statutes of limitations limit the time period within which an injured party can sue. The reason for these time limits is the difficulty of resolving old claims once the evidence becomes stale and the witnesses forget or disappear.

In the case of libel, the injured party must generally sue within one or two years from the date of first publication, although in some states the period is longer. If suit is brought after this time has elapsed, the statute of limitations will be available as a defense to bar the suit.

The period of time allowed by statutes of limitations for libel begins when a photograph is first published. Since publication means the act of communicating the matter at issue to one or more persons, the first publication of a book, magazine, or newspaper containing the photograph is deemed to occur when the publisher releases the finished product for sale. A second edition is generally not considered a separate publication for calculating time elapsed under the statute of limitations, at least where the single-publication rule is followed.

Sometimes, in some jurisdictions, in cases involving publications of a confidential nature, courts will apply a discovery rule—starting the statute of limitations clock from the date a plaintiff discovers that defamation occurred.

Additionally, in some jurisdictions, a demand for retraction may be required to be made. For instance, in Oregon, a plaintiff is not entitled to recover "general damages" (those not measurable by proof of a specific monetary loss) for a defamatory statement published in a newspaper, magazine, other printed periodical, or broadcast by radio, television, or motion pictures, unless a retraction has been demanded but not published.

Absence of Actual Malice

The defense most frequently used now in libel suits was created by the US Supreme Court in 1964 in *New York Times Co. v. Sullivan*. The case against the *Times* concerned a publication that contained some inaccuracies that allegedly defamed Sullivan, the police chief of Montgomery, Alabama. The Supreme Court held that the *New York Times* was not guilty of libel, emphasizing the existence of a profound national commitment to the principle that debate on public issues should be uninhibited, robust, and wide open, and explaining that such debate may well include vehement, caustic, and sometimes unpleasantly sharp attacks on government and public officials.

Public Officials

Because of this protection, when a public official sues for defamation, the official must prove with "convincing clarity" that the defendant published the statement with "actual malice." *Actual malice* is defined as knowledge of the falsity of, or a reckless disregard for the truth or falsity of, the statements published. *Reckless disregard* is further defined as serious doubts about the truth of the statement. The Sullivan case heightened the burden of proof for public officials bringing defamation cases. Prior to *Sullivan*, a public-official plaintiff only had to prove defamation by a "preponderance" of the evidence—now the courts require "convincing clarity," which is somewhere between the "preponderance of the evidence" required in most civil suits and the "proof beyond a reasonable doubt" required in criminal cases.

The standards introduced in *Sullivan* were applied in 1984 in the highly publicized case *Sharon v. Time Inc.*, which arose after the massacre of Palestinian refugees by Lebanese Phalangists in retaliation for the assassination of Lebanon's President Gemayel. At the time, Lebanon was occupied by Israeli forces and Ariel Sharon was Israel's defense minister. *Time* magazine published a story alleging that Sharon had secretly discussed the possibility of such a retaliatory attack with Gemayel's family, who remained politically powerful. Sharon sued *Time*, which steadfastly refused to retract the allegations.

The jury held that *Time*'s article was false and that Sharon was defamed by it, but the jury also found that *Time* did not possess actual malice. As a result, the magazine did not have to pay. Both sides claimed victory. Sharon declared himself vindicated of the allegations, while *Time* pointed to the fact that it did not have to pay damages to Sharon. Most commentators, however, did agree that *Time* suffered great damage to its journalistic reputation because of the case.

Ariel Sharon went on to file a second lawsuit for libel against *Time* in Israel. According to a legal treaty between the United States and Israel, judgments of Israeli courts were recognized in America and vice versa. The Tel Aviv district court judge ruled that he would accept the American jury's ruling that *Time* had defamed Sharon and had printed false material about him. It was not then necessary for Sharon to prove malice in a libel suit under Israeli law; it was necessary only to show that a story was false and defamatory. Consequently, *Time*'s Israeli lawyer was reported as stating that the magazine had little chance of winning in the Israeli court.

In January 1986, while the Tel Aviv judge was in the process of decid-ing the case, the parties announced an out-of-court settlement. In return for Sharon's dropping his libel action, *Time* stated to the Tel Aviv court that the reference to Sharon's supposed conversation in Beirut was "erroneous." In addition, *Time* agreed to pay part of the Israeli minister's legal fees. The *Time* statement appeared to acknowledge more culpability than had previously been admitted.

The difference in the outcomes in the two cases illustrates the importance of requiring a plaintiff to prove actual malice in a libel suit. To some extent, this requirement in American law results in broader protection for the press than exists in other countries.

The American jury's verdict in *Sharon* may have spurred a settlement in another much-publicized case being tried at the same time, *Westmoreland v. CBS*. In *Westmoreland*, the former commander of American troops in Vietnam challenged allegations of wrongdoing on his part made by CBS in a documentary about the war. It has been speculated that the parties in *Westmoreland* realized that a verdict similar to that in *Sharon* would be dam-aging to both of them. Settlement of the case allowed both sides to claim victory without the necessity of submitting the issues to a jury.

The depth of criticism required for a finding of libel under the public-official privilege created in *Sullivan* varies from case to case. While the most intimate aspects of private life are fair game when one is discussing an elected official's or a candidate's qualifications for political office, when discussing civil servants, such as police and firefighters, only comments directly related to their function as civil servants are privileged.

The Supreme Court has defined public officials as those "who have, or appear to the public to have, substantial responsibility for or control over the conduct of governmental affairs." This category has been held to include many civil servants. Recently, the courts have begun applying the public-of-ficial exception to public figures as well, but it has experienced a good deal of difficulty in determining who should be considered a public figure.

Public Figures

As the US Supreme Court explained in 1974 in *Gertz v. Robert Welch, Inc.*, the public-figure designation "may rest on either of two alternative bases. In some instances an individual may achieve such pervasive fame or notoriety that he becomes a public figure for all purposes and in all contexts. More commonly,

an individual voluntarily injects himself or is drawn into a particular public controversy and thereby becomes a public figure for a limited range of issues. In either case such persons assume special prominence in the resolution of public questions." The first category includes those who are frequently in the news but are not public officials, such as Madonna and Brad Pitt. The fact that they are deemed public figures "for all purposes" means that the scope of privileged comment about them is virtually without limit. The second way of becoming a public figure is to thrust oneself into the middle of a particular public controversy in order to influence a resolution of the issues involved. There must be both a public controversy and a voluntary action by the person whose public figure status is at issue.

The Supreme Court in 1976 in *Time, Inc. v. Firestone* held that not every newsworthy event is a public controversy, nor is an event a public controversy merely because there may be different opinions about it. The *Firestone* case is a good example of how narrowly the court applies the term "public controversy." *Time* magazine erroneously published a story stating that Mr. Firestone was divorced from Mrs. Firestone because of her extreme cruelty and their adultery. In fact, the divorce was granted because the judge found that neither party to the divorce displayed "the least susceptibility to domestication," which was a novel ground for divorce under Florida law. *Time* went astray because the judge had once commented that there was enough testimony of extramarital adventures on both sides "to make Dr. Freud's hair curl," and *Time*, by mistake, gave infidelity as the reason the divorce was granted.

In its defense against Mrs. Firestone's suit for libel, *Time* insisted that Mrs. Firestone was a public figure. As evidence of this, it showed that the divorce had been covered in nearly every major newspaper and that Mrs. Firestone herself had held periodic press conferences during the trial. The court refused to equate a cause célèbre with a public controversy, however. As a result, Mrs. Firestone was required to prove only that *Time* had been negligent in its reading of the court's opinion and that there was actual injury. She did not have to prove actual malice.

The second type of public figure, the limited-purpose-public-figure category, is one in which the person has voluntarily thrust himself or herself into the controversy in order to influence a resolution of the issues. This requirement would be met if someone's actions were calculated to draw attention to himself or herself and to arouse public sentiment. For example, a student who makes a speech during a peace demonstration may be considered a public

figure, but only with respect to the subject of that demonstration. In matters that have nothing to do with that political controversy, the courts would probably regard the student as a private individual.

In *Lane v. Phares*, a 2018 Texas court of appeals case, the court found an operatic singer and voice professor was at least a limited-purpose public figure because she chose a career that regularly involved media attention and promoted her successes on websites, and because there was a public controversy about her teaching. Since she could not prove *actual malice* in her case, her case was dismissed.

In 2018, in *Turner v. Wells*, the Eleventh Circuit Court of Appeals found that an offensive line coach for the Miami Dolphins football team was a public figure but also found that text messages calling his behavior "inappropriate" and accusing him of "poor judgment" were statements of opinion and not actionable.

Proof in Cases of Public Concern

The Supreme Court, in 1986, increased the burden of proof for private plaintiffs suing newspapers or media defendants writing about matters of public concern in *Philadelphia Newspapers, Inc. v. Hepps*. A businessman operating a franchise in Philadelphia sued the *Philadelphia Inquirer* based on the publication of several articles asserting that he had links to organized crime and had used those links to influence local government.

The Supreme Court described the issues that confronted it and its resolution of them in that case as follows:

> This case requires us once more to "[struggle] . . . to define the proper accommodation between the law of defamation and the freedoms of speech and press protected by the First Amendment." *Gertz v. Robert Welch, Inc.*, 418 US 323, 325 (1974). In *Gertz*, the Court held that a private figure who brings a suit for defamation cannot recover without some showing that the media defendant was at fault in publishing the statements at issue. . . . Here, we hold that, at least where a newspaper publishes speech of public concern, a private-figure plaintiff cannot recover damages without also showing that the statements at issue are false.

As a result, the plaintiff was given the burden of proving that the statement was false, and it was not incumbent on the media defendant to prove that

the statements were true if the plaintiff could not do so. The court found that the Constitution required that result so that true speech on matters of public concern would not be stifled. It stated:

> When the speech is of public concern and the plaintiff is a public official or public figure, the Constitution clearly requires the plaintiff to surmount a much higher barrier before recovering damages from a media defendant than is raised by the common law.

How does one determine whether information is of public concern? The Supreme Court, in 1985, in *Dun & Bradstreet v. Greenmoss Builders,* dealt with a case involving a reporting service that published and circulated a grossly inaccurate credit report. The reporting service pleaded First Amendment protection, but the court, by a five-to-four vote, held that since the credit report was not a matter of public concern and because the reporting service was a private party, it was not entitled to First Amendment protection, so the plaintiff did not have to prove actual malice.

Unfortunately, there is no encompassing explanation of what kind of speech or what photograph raises public concerns. Lacking such a definition, photojournalists and other photographers need to be extremely careful about the subjects of their pictures and accompanying text.

Despite the tremendous burden of proof placed upon public officials and public figures, they are still able to win in many defamation suits. For example, Barry Goldwater was successful in his suit against Ralph Ginzburg, who had published an article stating that Goldwater was psychotic and, therefore, unfit to be president. Goldwater proved that material in the article was intentionally distorted. In a later case, actress Carol Burnett won a libel suit against the *National Enquirer.* The article said that Burnett had been drunk and boisterous in a Washington restaurant when, in fact, her behavior had been beyond reproach. Burnett was able to show that the article was published with reckless disregard for the truth or falsity of the facts and thus satisfied the malice requirement.

PROTECTION AGAINST DEFAMATION SUITS

Since the law on libel is complicated and subject to continual modification by the courts, any potentially libelous work should be submitted to a

lawyer for review before publication is considered. Remember, everyone directly involved in the publication of libelous material can be held liable. Photographers should be aware that publishers may attempt to protect themselves from defamation suits by including a clause in the photographer's contract stating that the photographer guarantees not to have libeled anyone and accepts responsibility for covering costs if the publisher is sued. The risks involved in agreeing to such a clause are obvious. It is also wise to obtain a signed privacy-and-property-release form from anyone whose name or work is being associated with yours.

The Rights of Privacy and Publicity

The right to be protected from a wrongful invasion of privacy, largely taken for granted today, is a relatively new legal concept. In fact, the right of privacy was not suggested as a legal principle until 1890, when arguments for developing the right appeared in a *Harvard Law Review* article written by the late justice Louis Brandeis and his law partner, Samuel Warren. This article, written largely because of excessive media attention given to the social affairs of Warren's wife, maintained that the media were persistently "overstepping in every direction the obvious bounds of propriety and of decency" in violation of the individual's right "to be let alone."

From this rather modest beginning, the concept of a right to privacy began to take hold. In many of the early privacy cases, the *Harvard Law Review* article was cited as justification for upholding privacy claims, although courts also found their own justifications. For example, in 1905, a Georgia court suggested that the right of privacy is rooted in natural law. In the words of the court: "The right of privacy has its foundations in the instincts of nature. It is recognized intuitively, consciousness being the witness that can be called to establish its existence." Other courts have upheld right-of-privacy laws on constitutional grounds, both state and federal, arguing that although there is no express recognition of a right to privacy in the US Constitution, it can, nevertheless, be inferred from the combined language of the First, Fourth, Fifth, Ninth, and Fourteenth Amendments.

Although the right of privacy is now generally recognized, the precise nature of the right varies from state to state. Ten states have explicit constitutional provisions relating to some sort of right of privacy. Some states have enacted right-of-privacy statutes. Some simply recognize the right as a matter

of common law. There is considerable variation from jurisdiction to jurisdiction as to which, if any, specific privacy rights are recognized and how the sources of those rights are characterized. You should, therefore, keep in mind that the situations discussed in this chapter might be handled differently in the state where you live or work. The cases here should not be relied upon to determine a photographer's rights and liabilities. They are included simply to illustrate some of the legal developments in the area of privacy rights so that you can avoid obvious traps and identify problems as they arise. If you have specific questions or problems relating to your work as a photographer, consult a lawyer. Since most photographers distribute their work throughout the country, it is prudent to comply with the most stringent state requirements.

Many cases have dealt with the issue of a right to privacy, and the balance required between it and the right to broadcast news and discuss concerns and issues publicly. There are defenses to right-of-privacy claims similar to those in defamation cases. For example, *Foster v. Svenson*, a 2015 New York case, involved a photograph of a plaintiff and the plaintiff's home and children taken by an acclaimed art photographer with a telephoto lens from the dark interior of an apartment across from the plaintiff's apartment. The pictures were then displayed at an art gallery, in a show, along with pictures of other inhabitants of the plaintiff's apartment building.

The case was brought under a New York civil rights privacy statute that prohibited the use of a person's "name, portrait or picture" for "advertising" or "trade" purposes. The court explained that there was an exception to application of the privacy statute for newsworthy events and matters of public concern. It stated:

> The newsworthy and public concern exemption's primary focus is to protect the press's dissemination of ideas that have informational value. However, the exemption has been applied to many other forms of First Amendment speech, protecting literary and artistic expression.

The court concluded that works of art were protected by the newsworthy and public concerns exemption from the privacy statute because the public had a strong interest in the "dissemination of images, aesthetic values and symbols contained in the form of art work." Since the court determined that the photographs were works of art, the plaintiffs lost the case. However, the

court did recognize that the facts of the case were troubling and suggested that the legislature make new laws "in these times of heightened threats to privacy posed by new and ever more invasive technologies."

In addition to claims brought for invasion of privacy under the provisions of federal and state constitutions and specific state statutes, different types of civil invasions of privacy have been recognized by various courts. They include:

- Intrusion upon another's seclusion
- Public disclosure of private facts
- Portrayal of another in a false light
- Commercial appropriation of another's name or likeness

INTRUSION UPON ANOTHER'S SECLUSION

Generally, an intrusion upon another's seclusion will be wrongful if: 1) there is an actual intrusion of some sort; 2) it is of the type that would be offensive to a reasonable person; and 3) the intrusion is into someone's private domain. For example, it is generally not unlawful to take pictures of a person in a public place or disclose facts the person has discussed publicly. It is likely, however, that an intrusion would be wrongful if someone goes on someone else's land without permission or opens someone else's private desk and reads materials found there. Publication is not a necessary element in a case for intrusion, since the intrusion itself is the invasion of privacy.

The nature of a wrongful intrusion upon another's seclusion is well illustrated by two cases: *Dietemann v. Time, Inc.*, decided in 1971 by the Ninth Circuit Court of Appeals; and *Galella v. Onassis*, a 1973 case in the Second Circuit. In *Dietemann*, the plaintiff claimed to be a healer. Investigators for *Life* magazine sought to prove that he was a charlatan. In the process of checking out his claim, reporters entered Dietemann's house under false pretenses, and, while in his house, they surreptitiously took pictures and recorded conversations. This information was then written up in an exposé appearing in *Life*. The court held that the healer's right of privacy had indeed been violated, since there was no question that his seclusion was invaded unreasonably.

An even more obvious intrusion is illustrated by *Galella v. Onassis*. Ronald Galella, known for his persistence and tenacity, is a freelance photographer specializing in photographs of celebrities. For a number of years,

Jacqueline Onassis, Caroline Kennedy, John Kennedy Jr., and other members of the Kennedy family were among his favorite subjects. Onassis and the others were constantly confronted by Galella, who used highly offensive chase scene techniques, in parks and churches, at funeral services, theaters, schools, and elsewhere. One of his practices was to shock or startle his subjects in order to photograph them in a state of surprise. While taking these photographs, he would sometimes utter offensive or snide comments. After hearing a wealth of evidence regarding this type of behavior, the court, in a scathing opinion, held that Galella had wrongfully intruded upon the seclusion of his subjects. Finding monetary damages to be an inadequate remedy, the court issued a permanent injunction that prohibited Galella from getting within a certain distance of Onassis and the others. A decade later, the court found that Galella had repeatedly violated this injunction and was thus guilty of civil contempt. In order to avoid a prison sentence of up to six years and a fine of up to $120,000, Galella promised the court he would never again photograph Onassis or her children.

In both *Dietemann* and *Galella*, the defendants maintained that any attempt to restrain their efforts to get information or photographs was constitutionally suspect, since it would infringe upon their First Amendment rights. These arguments were obviously not persuasive in these cases.

Courts have universally attempted to balance rights in intrusion cases. The right of the press to obtain information is balanced against the equal right of the individual to enjoy privacy and seclusion, and, for the most part, the courts have refused to construe the First Amendment as a license to steal, trespass, harass, or engage in any other conduct that would clearly be wrongful or offensive.

This balancing approach is apparent in *Galella*. The court found that the intrusions were so pervasive and offensive that it did not matter that many of the acts occurred while Onassis and her children were in public rather than private places. Their right to privacy had been significantly infringed. Furthermore, the products of Galella's efforts were trivial, being nothing more than fodder for gossip magazines. The harmful effect of suppressing Galella's First Amendment freedoms was found to be slight or nonexistent. Significantly, the court did not at first forbid further photographs but merely regulated the manner in which they could be taken.

For the dedicated photojournalist, the possibility of an intrusion suit should always be weighed against the natural tendency to aggressively pursue the facts.

Even photojournalists on important assignments have no right to harass, trespass, use electronic surveillance, or enter a private domain without permission.

Photographers should be aware that even a photograph taken in a public place can result in liability for wrongful intrusion. In *Daily Times Democrat v. Graham*, a 1964 Alabama case, the court found wrongful intrusion when a photographer, without consent, took the picture of a woman whose skirt was blown upward while she was standing in a fun house at a county fair.

Some states have statutes that make the use of hidden cameras a misdemeanor.

There are specific statutes regulating photography is some states. Oregon, for example, has a statute, ORS § 163.700, prohibiting the making of photographs or videos, without consent, of "nudity" or "intimate areas" (defined as: "nudity, or undergarments that are being worn by a person and are covered by clothing"), where the person has a reasonable expectation of privacy—such as when in restrooms, lockers rooms, and dressing rooms.

In general, however, most photographs shot in public places are not problematic. For instance, in the 2010 Third Circuit case of *Boring v. Google*, the court ruled that although Google's camera-car trespassed to take pictures, driving past a "private road" sign in the plaintiffs' driveway to photograph their house, there was no actionable invasion of privacy, under Pennsylvania law, as no reasonable person could have been "shamed, humiliated or have suffered mentally."

But be aware of the law applicable to you. Various states have unique privacy-protecting statutes. California has a law, Cal. Civ. Code § 1708.8, which among other things prohibits trespassing with the intent to capture any type of visual image, sound recording, or other physical impression of another engaging in "private, personal or familial activity" where the physical invasion occurs in a manner "offensive to a reasonable person." It also prohibits the attempt to capture such an image, through the use of any device, if the image could not have otherwise been obtained without a trespass.

A person who violates this law is liable for up to three times the amount of actual damages, and possibly for punitive damages. If the invasion of privacy was committed for a commercial purpose, a liable defendant may have to pay the proceeds he or she received to the plaintiff. The court can also grant a restraining order.

Additionally, under California's vehicle code, Cal. Ven. Code § 40008, a person is prohibited from, and subject to criminal penalties for, violating

certain traffic offenses with the intent to capture an image or other physical impression of another person for a commercial purpose.

Remember, be careful of how, where, and of whom you take photographs and, if possible, obtain the consent of the person photographed. Find a good lawyer and familiarize yourself with any state legislation that may be applicable to your situation.

PUBLIC DISCLOSURE OF PRIVATE FACTS

The public disclosure of private facts was the aspect of the right of privacy that first prompted Warren and Brandeis to publish their article in the *Harvard Law Review*. Plaintiffs are less likely to win in this category of invasion of privacy, because the First Amendment weighs heavily in favor of protecting the dissemination of "newsworthy information." Where the information disclosed is true, the First Amendment freedoms afforded to the press often outweigh an individual's right of privacy.

In order to bring a case for this kind of invasion of privacy, the plaintiff must prove that private facts, facts about which he or she had a reasonable expectation of privacy, were publicly disclosed and that such a disclosure would be objectionable to a person of ordinary sensibilities. Where the facts disclosed are newsworthy, the disclosure must be outrageous if the plaintiff is to succeed.

The first question, then, is whether a photograph involves private facts. This is basically a matter of common sense. Anything that one keeps to oneself and would obviously not wish to be made public is probably a private fact. Thus, debts, certain diseases, psychological problems, and the like are generally considered private facts. However, the person seeking to protect private information must reasonably expect that the information would remain private.

For example, in *Nucci v. Target, Corp.*, a 2015 decision by the Florida Court of Appeals, the plaintiff in a slip-and-fall personal injury case tried to keep the attorney from Target, who represented the store in which she fell, from gaining access to her Facebook photos and account to use against her in the lawsuit. She argued that when she set up her Facebook account, she had selected the privacy setting that prevented the general public from gaining access to her account and therefore she should have a right of privacy protected by the Florida State Constitution. Though the court explained that

the Florida Constitution contained a broader right of privacy than that provided by the US Constitution, her argument failed, because she did not have "a legitimate expectation of privacy." It stated: "We agree with those cases concluding that generally the photographs posted on a social networking site are neither privileged nor protected by any right of privacy, regardless of any privacy settings that the user may have established." Since information on Facebook may be copied and disseminated to others, the court reasoned, any expectation of privacy was not reasonable. The court found the evidentiary relevance of the Facebook information outweighed any right of privacy. The defense attorneys in the plaintiff's personal injury case were allowed to get her Facebook information.

There is some seemingly personal information that courts will treat as public. "Official public records" are not considered private, and their disclosure is not an invasion of privacy. They include legislative, judicial, and executive records and records of documents affecting title to property, such as deeds and vehicle title transfers. This principle was firmly established by the Supreme Court in the mid-1970s in *Cox Broadcasting Corp. v. Cohn*. At issue was the constitutionality of a Georgia statute that made it a misdemeanor to publicly disclose the identity of a rape victim. In violation of this statute, someone at the broadcasting company reported the name of a rape victim that was included in a court indictment. The plaintiff, the father of the deceased victim, sued the broadcaster for publicly disclosing private facts. The highest Georgia court ruled in favor of the father, but when the case reached the Supreme Court, the decision was reversed. In a sweeping opinion, the court declared that the state could not legislate liability for truthfully disclosing information contained in an official court record subject to public inspection. Such disclosures enjoy an "absolute privilege" and are treated as public facts, regardless of how personal the information may be. A privilege also exists for public disclosure of private facts made in the context of legislative or executive proceedings.

The second thing a plaintiff must prove in a case involving a claim for public disclosure of private facts is that disclosure would be offensive to a reasonable person of ordinary sensibilities. Although a recluse may place a very high premium on absolute privacy, the law does not provide such special rights. If a disclosure is minimal and, therefore, would not be offensive to a reasonable person, the recluse will have no cause of action, even though to him the disclosure may seem egregious.

Truthful newsworthy information is generally protected by the First Amendment, and an individual's right to privacy will outweigh this right of free speech and expression only when the disclosure is outrageous. Even information falling short of the category of newsworthiness may be protected. For example, in 1986, in *Anderson v. Fisher Broadcasting Companies, Inc.*, the Oregon Supreme Court refused to recognize an accident victim's claim that his privacy was invaded when a tape of his accident and injury was shown in an advertisement for a news feature on emergency medical care. The court stated that the "claim based solely on publicizing private facts that are true but not newsworthy has met critical response." It concluded:

> in Oregon the truthful presentation of facts concerning a person, even facts that a reasonable person would wish to keep private and that are not "newsworthy," does not give rise to common-law tort liability for damages for mental or emotional distress, unless the manner or purpose of defendant's conduct is wrongful in some respect apart from causing the plaintiff's hurt feelings.

Generally, truthful disclosures pertaining to public figures or public officials are considered newsworthy, at least to the extent that the disclosure bears some reasonable relationship to the public role. If, however, the disclosure is unrelated and is highly personal, the disclosure may not be privileged and may be actionable. This is particularly true where the individual is not particularly famous or notorious. A presidential candidate or a mass murderer, for example, should expect considerably greater intrusions into, and disclosure of, his or her private affairs than a minor public official or a traffic offender should. Similarly, private individuals who are involuntarily thrust into the public light will receive more protection than those seeking fame and notoriety.

A person no longer in the public eye may or may not be considered newsworthy. Some people, of course, remain newsworthy even though they have long since left the public eye, but generally, the newsworthiness of people who once were public officials or public figures tends to decrease with the passage of time. To the extent that these people become less newsworthy, their right to privacy becomes stronger.

Melvin v. Reid, decided in 1931 in California, illustrates the point. The plaintiff was a former prostitute who had been charged with murder but was

acquitted after a rather sensational trial. Thereafter, she led a conventional life, married, and made new friends. Some years after the trial, a movie of the woman's early life was made, in which she was identified. She sued, alleging public disclosure of private facts, and the court ruled in her favor. The court conceded that the events that initially brought the woman into the public eye such as matters brought out at her public trial remained newsworthy, but that her identification and disclosure after she had reformed of other details constituted a "willful and wanton disregard of the charity which should actuate us in our social intercourse." But note that times and attitudes change. This case might have concluded differently at another time and place.

Another subject of litigation in this area has been whether an excerpt taken from a publication and used in an advertisement is privileged to the same extent as it was in the original publication. Although the answer is not always clear, one factor to consider and that might make a difference is whether the advertisement was used to promote the earlier work or has some other purpose.

Betty Friedan, the noted feminist, wrote and published an account of her early domestic life. In it, she included several photographs of those early years, one of which was a family portrait of her, her former husband, and their child. This picture was selected for use in a television commercial promoting the publication. Carl Friedan, the defendant's former husband, sued her, in *Friedan v. Friedan* in 1976, under the New York Civil Rights Act, alleging that the original publication, as well as the advertisements, constituted an invasion of his privacy under the public-disclosure-of-private-facts category of claim. The court easily disposed of the claim, reasoning that since Betty Friedan was a noted feminist, her life was a matter of public interest. Because he was her former spouse, Carl Friedan also became newsworthy, despite the fact that he had persistently sought to avoid publicity. Because the publication was deemed newsworthy, the disclosure was permissible. As to the commercial, the court stated that where an advertisement is used to promote the publication from which the excerpt was taken, the advertisement will enjoy the same protection as the original publication. Mr. Friedan failed to succeed on either complaint.

The 1975 New York case of *Rinaldi v. Village Voice, Inc.* involved a slightly different situation. The plaintiff was a prominent judge. The *Village Voice* published an article critical of his performance on the bench. At issue was the question of whether the *Village Voice* could incorporate excerpts from that

article into an advertisement for itself. The court held that the advertisement was designed to sell a product and was not entitled to the same protection that a news article would be.

Where excerpts or photographs are used for purposes other than advertising, such as the circulation of galley proofs of forthcoming books to newspapers and magazines for review, the excerpts or photographs are more likely to enjoy the same privilege as the original information. In the 1968 New York case of *Estate of Hemingway v. Random House, Inc.*, Ernest Hemingway's widow brought an action against the writer and publisher of the book *Papa Hemingway*. The book's author had drawn largely on his own recollections of conversations with Ernest Hemingway and included two chapters on the famous novelist's illness and death. The court found that Hemingway was clearly a public figure and rejected the widow's argument that the description of her feelings and conduct during the time of her husband's mental illness was so intimate and unwarranted as to constitute an outrageous disclosure. Additionally, the court rejected her claim that circulation of galley proofs to book reviewers of sixteen journals and newspapers amounted to unlawful use of private facts for advertising purposes. In holding that circulation of proofs to reviewers is not generally advertisement, the court stated:

A publisher, in circulating a book for review, risks unfavorable comment as well as praise; he places the work in the arena of debate. The same reasons which support the author's freedom to write and publish books require a similar freedom for their circulation, before publication, for comment by reviewers.

In summary generally, a public disclosure of private facts will support a lawsuit if the effect of the disclosure would be objectionable to persons of ordinary sensibilities, unless the disclosure is newsworthy. Whether a disclosure is or is not newsworthy will depend upon the social value of the facts disclosed, the extent to which the plaintiff voluntarily assumed public fame or notoriety, and the extent to which the disclosure related to the plaintiff's public role. Finally, even a disclosure relating to newsworthy persons may be actionable if it would outrage reasonable persons.

The 2017 California case of *Jackson v. Mayweather* involved a well-known professional male boxer and his relationship with an aspiring female model. She sued him for, among other things, publicly disclosing private facts about

her on social media—specifically, their relationship, her pregnancy, its ter-
mination, and her cosmetic surgery. The court found that the postings were
newsworthy "celebrity gossip" and not actionable. The court explained that
newsworthiness was not limited to "news" in the narrow sense but also applied
to "the use of names, likenesses or facts in giving information to the public for
purposes of education, amusement or enlightenment, when the public may
reasonably be expected to have a legitimate interest in what is published."
However, the court would not dismiss the model's claim for damages based
on his posting of a copy of her sonogram and medical reports.

PORTRAYAL OF ANOTHER IN A FALSE LIGHT

To portray another in a false light has been actionable as an invasion of pri-
vacy for some time in a variety of courts and in a variety of situations. It is
not actionable in all jurisdictions. The law is evolving in this area. In 1816,
in what was probably the first case to address the issue, the poet Lord Byron
successfully fought the publication under his name of a rather bad poem that
he did not in fact write. Byron was extremely protective of his reputation and
apparently felt that the inferior piece would harm his image as an artist.

To bring a suit under a false-light theory, a plaintiff must prove that the
defendant publicly portrayed the plaintiff in a false light and that the por-
trayal would be offensive to reasonable people had it been of them. In cases
involving the media, the plaintiff must also prove that the portrayal was done
with malice.

False-light cases often involve works that erroneously ascribe conduct or
action to the plaintiff. Usually, photographs do not portray their subjects in
a false light, but the accompanying caption or story may, or the type of pub-
lication in which it appears might create a false impression. For instance, in
Douglass v. Hustler Magazine, Inc., a Seventh Circuit case in 1985, a model
was found to have presented facts supporting a case for false-light invasion of
privacy where she was pictured nude, without her consent, in *Hustler* mag-
azine, and there was an insinuation that she was a lesbian and the type of
person who would pose nude for *Hustler*.

Leverton v. Curtis Publishing Co., a 1951 Third Circuit case, is another
example. A young girl who had been struck by an automobile was photo-
graphed while a bystander lifted her to her feet, and that photograph appeared
in a local newspaper the following day. Nearly two years later, the *Saturday*

Evening Post published an article titled "They Ask to Be Killed," the gist of which was that most pedestrian injuries are the result of carelessness on the part of the pedestrian. The photograph of the girl was used to illustrate the story. The girl sued the *Post* for invasion of privacy, alleging, among other things, that the *Post* had portrayed her in a false light. The court ruled in her favor, because the rational inference from the use of the photograph in the article was that the plaintiff had been injured because of her carelessness, when in fact she had been completely without fault.

Another frequent cause of false-light cases involves publications that attribute to someone views or opinions that the person does not actually hold or statements that the person did not make. Minor distortions or inaccuracies involving insignificant events, places, and dates might be overlooked, provided the errors are not pervasive. However, false statements pertaining to significant aspects of someone's life are more likely to result in liability, particularly if they involve highly personal and sensitive matters. The crucial question is whether the false portrayal would be offensive to a reasonable person if he or she were the person portrayed. Would the person likely be humiliated, embarrassed, or estranged from friends or family because of the publication?

In addition to proving an objectionable portrayal in a false-light case, depending on the case, the plaintiff might also have to prove malice, as is necessary in some defamation cases after *New York Times v. Sullivan* (discussed earlier). In 1967, in *Time, Inc. v. Hill,* the Supreme Court took the opportunity to extend the rationale of *Sullivan* to false-light cases of invasion of privacy, holding that newsworthy plaintiffs suing media defendants for either defamation or for a false-light invasion of privacy must prove that the defendant published with actual malice.

Although defamation and false-light cases are substantially similar, they do differ in some respects. The Colorado Supreme Court, in *Denver Publishing Co. v. Bueno,* in 2002, did an exhaustive discussion of the similarities and differences between them and, after doing so, decided not to permit a case for a false-light-invasion-of-privacy in Colorado as was the rule in Texas, as it inflicted an "unacceptable chill" on the media. Claims for false-light-invasion-of-privacy are not accepted in all jurisdictions, but the law in this area is rapidly evolving. In 2007, in *Welling v. Weinfeld,* the Supreme Court of Ohio recognized claims for false-light-invasion-of-privacy, stating that "the viability of a false-light claim maintains the integrity of the right to

privacy, complementing the other right-to-privacy torts." In 2017, the Nevada Supreme Court, in *Franchise Tax Bd. v. Hyatt*, also recognized the legitimacy of false-light-invasion-of-privacy claims.

COMMERCIAL APPROPRIATION OF ANOTHER'S NAME OR LIKENESS

Commercial appropriation of someone's name or likeness as an invasion of privacy is different from cases based upon wrongful intrusion, public disclosure of private facts, or portrayal in a false light. In the latter situations, the plaintiff must prove that the defendant's actions, words, or pictures caused the plaintiff to suffer harassment, humiliation, embarrassment, or loss of self-esteem, focusing on the injury to the plaintiff's sensibilities. In contrast, the law against appropriation is designed to protect someone's commercial interest in one's own name or likeness and the money it can make. Athletes, movie stars, authors, and other celebrities obviously receive a considerable amount of their income from the controlled exploitation of their names and likenesses. Courts have ruled that it is a right entitled to protection in a court of law.

In suing for unauthorized commercial appropriation, a person is exercising the *right of publicity*, which is defined as a person's right to exploit his or her own name, likeness, or reputation. Many states have some form of protection for the right of publicity through statutes or as a result of the common law.

The gravamen for such a claim is that the defendant wrongfully appropriated the plaintiff's name or likeness for commercial purposes. *Appropriation* in this sense means use. The fact of appropriation is rarely at issue in these cases, since the use is obvious. However, the purpose of the use must be commercial, or expected to bring profits, either directly or indirectly. A purely private use will not result in liability for wrongful appropriation.

As with the other kinds of invasion of privacy, any use that is considered newsworthy or informative will not be actionable as a commercial appropriation, even though some commercial gain might result from the use. As you might suspect, it is often difficult to know where to draw the line between what is "newsworthy" and what is not. Each case is looked at in light of its own facts, and there are often gray areas.

In *Finger v. Omni Publications Intern., Ltd.*, a 1990 New York case, a family sued when the picture of their unidentified, large, naturally conceived

family was published without their permission in a magazine article about in vitro fertilization. The court found that, since there was a "real relationship" between the article and the photograph of the large family, the photograph was newsworthy. The court stated that questions of newsworthiness "are better left to reasonable editorial judgment and discretion." Only where there is not any real relationship between a photograph and an article, or where the article is an "advertisement in disguise," should the judiciary intervene. The plaintiffs' complaint was dismissed.

The California Supreme Court, in 2001, ruled in *Comedy III Productions, Inc. v. Gary Saderup, Inc.* that California's statutory right of publicity bars commercial exploitation of celebrity images where significant creative elements have not been added. An artist made charcoal drawings of the Three Stooges, which he reproduced on T-shirts and as lithographic prints without the consent of the owner of the rights in the Three Stooges. The court recognized the tension between the First Amendment and the right of publicity, stating:

> The tension between the right of publicity and the First Amendment is highlighted by recalling the two distinct, commonly acknowledged purposes of the latter. First, "to preserve an uninhibited marketplace of ideas and to repel efforts to limit the 'uninhibited, robust and wide-open' debate on public issues." . . . Second, to foster a "fundamental respect for individual development and self-realization. The right to self-expression is inherent in any political system which respects individual dignity. Each speaker must be free of government restraint regardless of the nature or manner of the views expressed unless there is a compelling reason to the contrary."

After balancing the two interests, the court found that the value of the artist's work derived primarily from the fame of the Three Stooges rather than from creative elements provided by him. The artist was not entitled to freely use the images to make money for himself.

In *Downing v. Abercrombie & Fitch*, a 2001 Ninth Circuit case, a group of surfers sued a company for publishing a picture of them and naming them in a catalogue without their consent. The court concluded that the use of the surfers' photograph did not contribute significantly to a matter of the public interest and that the company could not use the First Amendment defense to

the surfers' claim of commercial misappropriation under California law. The use made of the photograph, the court determined, was "essentially as window-dressing to advance the company's catalog's surf-theme."

In *Hilton v. Hallmark Cards*, a 2010 Ninth Circuit case, the court held that Paris Hilton could pursue a right of publicity claim for Hallmark's use of her image and catch phrase ("that's hot") from her television show in one of its greeting cards.

On the other hand, in *Sarver v. Chartier*, the Ninth Circuit, in 2015, was called upon to consider whether the movie *The Hurt Locker* was an actionable commercial misappropriation. The plaintiff led an ordnance company in Iraq and contended that the movie's main character was based on his life and experiences. The court determined that the movie was not "commercial speech" and that the plaintiff had not invested time or money to "build up economic value in a marketable performance or identity." It found the movie entitled to First Amendment free-speech protection and that the plaintiff could not pursue his case under a commercial misappropriation theory under California law.

In one case, the right of publicity was held to be limited by certain aspects of the federal copyright law. In *Baltimore Orioles v. Major League Baseball Players*, a 1986 Seventh Circuit case, baseball players sued club owners, asserting that their performances during ball games were being telecast without the players' consent and that, under state law, the telecasting constituted a misappropriation of the players' property right of publicity in their performances. The court found that the players' performances were within the scope of their employment, and thus the club owners owned the copyright. When state and federal law conflict, the federal law takes precedence. The players' rights of publicity in the game-time performances, as granted by state law, was found to be preempted by federal copyright law.

On the other hand, in 2005, in *Toney v. L'Oréal USA, Inc.*, the Seventh Circuit found that because a model's identity was not and could not be fixed in a tangible medium of expression and therefore was not copyrightable, the rights protected by the Illinois Right of Publicity Act (which grants an individual the right to control and to choose whether and how to use an individual's identity for commercial purposes) did not conflict with the copyright laws. The model could pursue her right of publicity claim, as it was not preempted by copyright law.

Appropriation after a Celebrity's Death

Another question is whether a lawsuit based upon commercial appropriation can be brought after the death of the person whose name or likeness was used. There is considerable controversy over this issue.

In some states, an entertainer's right of publicity ends when that person dies. Thus, the estates of the deceased stars would have no recourse in many jurisdictions. But the law is evolving in this area. For example, in *Memphis Development Foundation v. Factors, Etc., Inc.*, the Sixth Circuit, in 1980, ruled that, as it read Tennessee law, there is no descendible right of publicity in Tennessee. Thereafter, the court of appeals in Tennessee, in 1987, in *State ex rel. Elvis Presley Int'l Memorial Found. v. Crowell*, declared that a celebrity's right to publicity descended to his or estate on his or her death and that the estate then had the right to control commercial exploitation of the celebrity's name and image.

Since then, the Tennessee legislature passed a statute that explicitly states that "every individual has a property right in the use of that person's name, photograph, or likeness in any medium in any manner" and that the right is assignable and licensable and does not expire on death but passes to the executors, assigns, heirs, or devisees of the individual for a period of ten years after the person's death or a shorter period if there is nonuse for a two-year period.

Several other states have passed similar laws. As of the writing of this book, more than thirty-five states had some sort of common law precedent, and more than twenty had some type of statute protecting the right of publicity. Some of these statutes guarantee the survival of such a right regardless of whether the person's name was commercially exploited during life. However, others, while recognizing that the right to publicity can survive death, maintain that it will do so only if it was commercially exploited during life and give no rights to the heirs of those famous individuals who chose not to exploit their names and faces while alive.

The Washington statute differentiates the right of "individuals" and those of "personalities." The former have a right that lasts for ten years past death. For personalities, the right lasts seventy-five years after death. "Individual" is defined as "a natural person, living or dead." A "personality" is defined as "any individual whose name, voice, signature, photograph, or likeness has commercial value, whether or not that individual uses his or her name, voice, signature, photograph, or likeness on or in products, merchandise, or goods,

or for purposes of advertising or selling, or solicitation of purchase of, products, merchandise, goods, or services."

The law in different states is conflicting or unsettled on whether the right to sue for commercial appropriation survives death and, if it does, for what length of time it survives. But be aware that more courts and legislatures are recognizing that death should not automatically extinguish a right as meaningful and valuable as the right to control the use of a person's name or likeness. Prudent photographers should attempt to comply with the strictest state laws, since their work is likely to be distributed throughout the country.

RELEASES

Use of a photograph without written consent always raises the possibility of a lawsuit based on violation of some theory of the right-to-privacy. The surest and simplest way to avoid right-to-privacy suits is to obtain a release from the subject of the picture or a release from the owner of any property photographed.

In some states, such as New York, a photographer must obtain written consent for the use of a person's photograph in advertising or promotion. Although an oral release may be legally valid in other circumstances or locales, it may be hard to prove that you received an oral release and difficult to enforce one, so it is prudent to obtain a written release.

Generally, contracts require consideration—something that indicates compensation for a service rendered. As a release might be considered a contract, it is probably wise to pay the subject at least a small amount to get one. However, at least one authority has stated that photographic releases are valid even when the photographer pays the subject nothing in modeling fees or use rights.

Most releases to protect photographers are designed to be signed by a model or subject, but if a model has hired an agency, the release should also cover the agency. A release should be drafted to include permission for the photographer to take the picture, as well as permission for the photographer to make a certain use, or an unlimited use, of the picture. The fewer limitations on use or alteration, the better for the photographer.

Sometimes litigation is threatened or instituted even when a release exists, as was the case with Vanessa Williams. In 1986, the former Miss America dropped a $400 million lawsuit against *Penthouse* magazine and two

photographers after concluding that she had signed a model release for the nude pictures that resulted in her relinquishing her crown under pressure.

It is common for a photographer to use a standard release form, but the form should be used intelligently and modified as needed. Each release should specifically, if briefly, describe the subject matter and note the use the photographer plans to make of the picture or that the use is unlimited, and set out the duration of the release. A photographer would also be wise to stamp the photograph with the same date as the date on the release form; this prevents any confusion or ambiguity as to what is covered when the photograph is released.

A well-drafted model release provides protection for the photographer. In *Myskina v. Conde Nast Publ'ns, Inc.*, a 2005 New York district court case, the court found for defendants in a case brought by tennis player Anastasia Myskina, who had posed nude as Lady Godiva for *GQ*'s October 2002 sports issue after signing a standard model release authorizing use of the photographs. After the shoot, Myskina posed topless for additional photographs, she said, after the photographer orally agreed not to publish them. Both the Lady Godiva and topless photographs were published in the Russian magazine *Medved*. Myskina argued, among other things, that the release was not binding because she was not fluent in English and that she would not have signed it if she knew the photographs could be used for anything other than the *GQ* cover. The court found that, absent fraud or duress, the release was binding, since Myskina signed it, and that evidence of the photographer's oral agreement could not be considered because it contradicted the clear terms of the written release.

In *Russell v. Marboro Books*, a 1959 New York case, a fashion model posed reading in bed, fully clothed, for an advertisement to promote a book club. The model signed a broadly worded waiver that allowed the book club to make unrestricted use of the photograph, although it did not permit the photograph to be altered. After the book company sold the photograph to a bedsheet manufacturer, who retouched the photograph, adding the title of a well-known pornographic book to the book the model held in the picture, and ran the photograph with sexually suggestive copy, the model sued. She alleged that her personal and professional standings were damaged by the bedsheet advertisement. The court upheld her claim for invasion of privacy and libel, reasoning that the release was ineffective because the photograph was altered so as to make it substantially unlike the original.

On the other hand, the opposite result was reached in *Krupnik v. NBC Universal, Inc.*, a 2010 New York case, where the court dismissed a model's claims under New York law. The model objected to the inclusion of a photograph of herself in a brochure used during a scene in *Couples Retreat*, a PG-13 rated movie released by defendants. The photograph depicted her in a bikini and was originally created on a photo shoot for inclusion on the website Bikini.com. The plaintiff was paid in connection with the photograph and executed a release that permitted the use of her image for any and all purposes, including commercial uses, and expressly waived any claims for misappropriation of the right of privacy or publicity, or for defamation.

In a 2018 New York federal district court case, *Passelaigue v. Getty Images (US), Inc.*, a professional, internationally known model sued for, among other things, a violation of the New York Civil Rights law prohibiting the use of her name and picture for the purpose of "advertising or trade," without her consent. She learned that pictures that had been taken during a 2004 Clinique photo shoot and a 2009 Spiegel photo shoot were being used, without her consent, for an advertising campaign for Botox and on a webpage for synthetic beauty products. The court refused to dismiss her complaint for right-of-publicity claims based on the use of the 2009 photographs, as it found they were entirely commercial in nature and not art, which is protected by the newsworthy exception, but did dismiss her claims for use of the 2004 photographs, as she had signed a model release permitting the use of these photos.

The lesson to be learned from these cases is that to fully protect a photographer, and permit him or her full use of the photograph in the future, a release should include a clause permitting use of the photograph for any purpose and allowing alteration of the photograph and granting the right to add any type of copy or caption.

In the event a photographer has not obtained a release for a particular photograph, and even if he or she has, it may be possible to achieve limited protection against a third party's unauthorized use of the photograph by stating on the back of the picture: "This photograph cannot be altered for commercial or advertising use; nor can it be copied, televised, or reproduced in any form without the photographer's permission."

Photographers should be aware that a release signed by the parent of a child subject may not be valid in all instances. Some court decisions uphold the validity of releases signed by parents. However, language in these cases

indicates that courts would refuse to find the releases binding under certain circumstances.

In 1985, in *Faloona v. Hustler Magazine, Inc.*, a federal district court case in Texas, the mother of two minor children executed a full release to a photographer taking nude pictures of her children for an educational text on human sexuality. The children and their mother sued the photographer when the children's picture, which the court specifically stated was not pornographic, appeared in *Hustler* magazine. While not objecting to the photographs per se, the plaintiffs believed that publication in *Hustler* constituted false-light invasion of privacy, public disclosure of private facts, and commercial misappropriation. The court applied Texas law, which provides that a parent has the authority to consent to matters of substantial legal significance concerning a child, and dismissed the case.

Other states have similar laws. Note, however, that in *Faloona*, *Hustler* showed the children's photograph to illustrate a review of a sex education book in which the photograph originally appeared. Had *Hustler* used the photograph in a salacious manner, the court most likely would have invalidated the consent.

In *Shields v. Gross*, a 1983 New York case, the court held that when the parent or guardian of a minor gives unrestricted consent to a photographer to make a commercial use of the minor's photograph, the minor may not later make use of the common-law right to vitiate a contract entered into while she was a minor. However, photographers should be aware that this case contains a strong dissent, and the holding was influenced by the fact that Ms. Shields was a professional actress, although a child. The holding has evoked critical commentary, as many believe that a minor's right to privacy should supersede the business community's interest in binding minors to contractual terms, and later cases have limited the reach of the decision. In *Hantash v. V Model Mgmt. N.Y., Inc.*, a 2007 federal case in New York, the court stated, referring to the ruling in *Shields*, "In no way can this limited holding be read to stand for the broad proposition that defendants are espousing here: that an infant cannot disaffirm a general modeling contract when the contract is executed by that infant's parent."

The law is also developing in this area, and some states, including California, have legislation, known as Jackie Coogan–type legislation, requiring photographers and others to follow strict requirements when using minors as models or actors. It is, therefore, advisable to check with an attorney before

you use a child model to get good, concrete advice on what you should and should not do under the circumstances.

With respect to children, be aware that images of child pornography are not protected by the First Amendment and any such images are illegal contraband. Possession or distribution of them is a crime. Federal law defines child pornography as any visual depiction of sexually explicit conduct involving a minor (someone under eighteen years of age). The age of eighteen applies regardless of any state determination of minority.

Since the legal concepts discussed in this chapter are still evolving, and because their treatment varies from state to state, you as a photographer would be well advised to work closely with a lawyer when a question arises regarding invasion of a right to privacy.

Censorship and Obscenity

The First Amendment of the United States Constitution states in part, "Congress shall make no law . . . abridging the freedom of speech, or of the press." First Amendment absolutists insist that the words are all encompassing and that no law should ever be enacted that places any restriction whatsoever on the free exercise of speech or press. Although a strict reading of the Constitution may support this opinion, the judiciary has never fully upheld it and has ruled that certain types of speech are not protected by the First Amendment.

One theory that has been used to justify exceptions to First Amendment protection is that although "speech" normally deserves First Amendment protection, such protection will not be forthcoming if the right of another outweighs it. Examples of "speech" (including expressions of ideas in whatever manner, including photos) that may not be protected include speech that is defamatory, that advocates unlawful conduct, or that invades someone's privacy.

Another theory suggests that certain expressions do not constitute "speech" for purposes of First Amendment analysis because they are without serious social value. Under this theory, courts often maintain that obscene works are not protected.

PRIOR RESTRAINT

When the First Amendment was written, the memory of the English licensing system, under which nothing could be published without prior approval, was still vivid in the minds of its writers. Some historians suggest that the First Amendment was written specifically to prevent such prior restraints. Today, the First Amendment means more than freedom from prepublication

censorship, but because of its potential for abuse, censorship before publication is still considered more serious than restrictions imposed after publication. The US Supreme Court, in 1931, in *Near v. Minnesota,* recognized that "liberty of the press . . . has meant, principally although not exclusively, immunity from previous restraints and censorship."

Prior restraints impose an extreme burden upon the exercise of free speech, since they limit open debate and the unfettered dissemination of knowledge. It is not surprising that the Supreme Court has almost always found that it is unconstitutional to restrain speech prior to a determination of whether the speech is entitled to First Amendment protection.

Prohibition of False Statements

In 2012, in *United States v. Alverez,* the Supreme Court affirmed the judgment of the Ninth Circuit Court of Appeals that the Stolen Valor Act was unconstitutional. The issue came to the court after a board member, during a public meeting of a water board, told people that he had been awarded the Congressional Medal of Honor when he had not. Although he pled guilty to violating the act, which prohibited false claims of the receipt of any "decoration or medal authorized by Congress for the Armed Forces," he preserved his right to challenge the constitutionality of the act. The opinion, written by Justice Kennedy, confronted the question of whether the government could restrain speech merely because it was false and determined that it could not. The court recognized that restrictions on the content of speech had been upheld by the judiciary only in certain circumstances that the court named, along with references to their earlier opinions on the subjects:

Among these categories are advocacy intended, and likely, to incite imminent lawless action, see *Brandenburg v. Ohio,* 395 US 444, 89 S. Ct. 1827, 23 L. Ed. 2d 430 (1969) (per curiam); obscenity, see, e.g., *Miller v. California,* 413 US 15, 93 S. Ct. 2607, 37 L. Ed. 2d 419 (1973); defamation, see, e.g., *New York Times Co. v. Sullivan,* 376 US 254, 84 S. Ct. 710, 11 L. Ed. 2d 686 (1964) (providing substantial protection for speech about public figures); *Gertz v. Robert Welch, Inc.,* 418 US 323, 94 S. Ct. 2997, 41 L. Ed. 2d 789 (1974) (imposing some limits on liability for defaming a private figure); speech integral to criminal conduct, see, e.g., *Giboney v. Empire Storage & Ice Co.,* 336 US 490, 69 S. Ct. 684, 93 L. Ed. 834 (1949); so-called "fighting words," see

Chaplinsky v. New Hampshire, 315 US 568, 62 S. Ct. 766, 86 L. Ed. 1031 (1942); child pornography, see *New York v. Ferber*, 458 US 747, 102 S. Ct. 3348, 73 L. Ed. 2d 1113 (1982); fraud, see *Virginia Bd. of Pharmacy v. Virginia Citizens Consumer Council, Inc.*, 425 US 748, 771, 96 S. Ct. 1817, 48 L. Ed. 2d 346 (1976); true threats, see *Watts v. United States*, 394 US 705, 89 S. Ct. 1399, 22 L. Ed. 2d 664 (1969) (per curiam); and speech presenting some grave and imminent threat the government has the power to prevent, see *Near v. Minnesota ex rel. Olson*, 283 US 697, 716, 51 S. Ct. 625, 75 L. Ed. 1357 (1931), although a restriction under the last category is most difficult to sustain, see *New York Times Co. v. United States*, 403 US 713, 91 S. Ct. 2140, 29 L. Ed. 2d 822 (1971) (per curiam). These categories have a historical foundation in the Court's free speech tradition. The vast realm of free speech and thought always protected in our tradition can still thrive, and even be furthered, by adherence to those categories and rules.

But as to whether speech should be restrained just because it was false, the court drew a line. It ruled that false statements alone were protected by the First Amendment, as there would inevitably be false statements in "open and vigorous expression of views in public and private conversation." The court distinguished the earlier-mentioned categories of acceptable prohibitions against speech as involving situations resulting in "legally cognizable harm associated with a false statement." Rather than restraining speech that was simply false, the court recognized that there was a better solution: "The remedy for speech that is false is speech that is true. This is the ordinary course in a free society."

Prohibition of Political Speech

A prior-restraint lawsuit generally begins with a request, often by the government, for a court order prohibiting publication of information already in the media's possession. Where controversial political speech is involved, the government may argue that publication will cause substantial and irreparable harm to the United States—that it will damage the national security. In *New York Times Co. v. United States*, a 1971 US Supreme Court case, for example, the government tried to stop the publication of the Pentagon Papers, which detailed US involvement in Vietnam prior to 1968. The government claimed

that publication would prolong the war and embarrass the United States in the conduct of its diplomacy.

The Supreme Court found that the government's claim of potential injury to the United States was insufficient to support a prior restraint. The justices, although believing that publication would probably be harmful, were not persuaded that there was enough of a justification to prohibit it—that there was not a dangerous likelihood of grave or irreparable injury to the national interest.

Prohibition of Pretrial Publicity

Another time the government may wish to suppress the free flow of information is when it is publicity preceding the trial of a case. Here the conflict is between the individual's right to a fair trial and the right of the press to its First Amendment guarantee of free speech. This conflict was addressed in the 1976 US Supreme Court case of *Nebraska Press Association v. Stuart,* where the Nebraska Press Association appealed a court order prohibiting the press from reporting on confessions and other information, much of which was in the public domain, implicating a defendant accused of murdering six family members. The trial judge originally issued the order prohibiting the reports, because he felt that pretrial publicity would make it difficult to select a jury that had not been exposed to prejudicial press coverage. The Supreme Court struck down the trial judge's order, finding that the impact of publicity on jurors was "speculative." The justices went on to suggest alternatives to restraining all publication, including changing the location of the trial, postponing the trial, asking in-depth questions of prospective jury members during the selection process to determine bias, explicitly instructing the jury to consider only evidence presented at trial, and isolating the jury. The complete restraint of reports went too far and was unconstitutional.

Prohibition of Commercial Speech

In other areas, however, the court has been more tolerant of prior restraints. For example, the US Supreme Court, in 1976, in *Virginia State Board of Pharmacy v. Virginia Consumer Council, Inc.,* held that prior restraints are sometimes permissible when purely commercial speech, such as advertisements or other promotional material, is involved. But in the case before it, the court found that a Virginia statute that prohibited pharmacists from advertising prices of prescription drugs was unconstitutional. Even though the

case involved commercial speech, the court found that it was entitled to First Amendment protection, since the free flow of commercial information was indispensable to well-informed private economic decisions.

Prohibition of Obscene Speech

Prior restraints have also been permitted where the material to be suppressed was obscene, a topic that will be covered shortly in more detail. Prior restraints on commercial or obscene speech are less often condemned by the courts because the topics have not been considered important to public interest or debate, but the Supreme Court, in 1964, in *A Quantity of Copies of Books v. Kansas*, ruled that a state statute with respect to the seizure of allegedly obscene books was constitutionally deficient where the owner of the books was not afforded a hearing on the obscenity of the books first. This and other Supreme Court cases have imposed procedural safeguards for these types of case.

The Scope of Permissible Prior Restraint

As was explained in by the Supreme Court in 1931 in *Near v. Minnesota*, the chief purpose of the First Amendment's freedom-of-the-press provision was to prevent prior restraints on publication. Some permissible areas for restraints were described in 2012, in *United States v. Alvarez*, which was discussed earlier. But of course there are others. Sometimes something less will justify a restraint. In 2013, a federal district court in California, in *Anthony v. Oliva*, rejected a claim for First Amendment protection where a man's cell phone was confiscated when he recorded the actions of three sheriff's deputies interacting with a third party. Stating that it made a difference that the recording occurred in the courthouse, that there was a court rule prohibiting recording without a court order, and that the restriction was not based on the content of the recording but on the place it was made, the court declined to find that the First Amendment was violated. On the other hand, in *Fields v. City of Philadelphia*, the Third Circuit, in 2017, held that private individuals have a First Amendment right to observe and record police activity in public.

The scope of permissible restraint is often litigated, and a host of cases describe and discuss it in a variety of factual situations and circumstances. A lot depends on where and how filming or photography is conducted.

OBSCENITY

Obscenity is perhaps the area where most of the censorship in this country has occurred. A variety of laws have been passed to regulate allegedly obscene materials. Some state laws prohibit the publication, distribution, public display, or sales to minors of obscene material. Some ordinances prohibit any commercial dealings in pornography. Transporting obscene material across a state line or national border is forbidden by federal law, and it is a crime to send obscene materials through the US mail. Many statutes have been challenged, and the Supreme Court has issued many opinions dealing with obscenity, how to define it, and how to constitutionally apply restrictions on it.

In *Stanley v. Georgia*, in 1969, the court ruled that a state cannot prohibit people from possessing obscene material for their own use, stating that "the mere private possession of obscene matter cannot constitutionally be made a crime," and found a Georgia statute prohibiting it unconstitutional.

The same rule does not apply to child pornography, however. A series of US Supreme court cases have made that clear. In *Ginsberg v. State of New York*, in 1968, the court ruled that it was permissible for the state of New York to criminalize the sale of material "harmful to minors", even though the material might not be obscene for adults. In *New York v. Ferber*, in 1982, the court upheld a New York law prohibiting the visual depiction of children under the age of sixteen engaging in sexual acts, whether or not obscene. In 1990, in *Osborne v. Ohio*, the court upheld a statute making even the private possession of child pornography illegal. The court felt that child pornography was entitled to minimal protection and that the states' interest in destroying the market for child pornography was sufficient to allow Ohio to proscribe the possession and viewing of it.

There have been a multitude of cases dealing with obscenity and the rights of states to attempt to regulate it. The Supreme Court for decades struggled with a way to define it, and the current definition is not easy to fully understand or apply. The law is somewhat of a morass in this area. A prudent photographer is well advised to avoid problems of this type. Not only is there potential criminal liability if your work is declared obscene, but you may face a lawsuit from your publisher, since many photographer-publisher contracts contain a warranty or indemnity clause in which the photographer warrants that nothing in the work is obscene and promises to resolve any problems that arise from its use. If a publisher uses the photograph and suffers damage

as a result, it may sue for breach of warranty or bill the photographer for any losses the publisher incurred.

Defining Obscenity

It is the task of the Supreme Court, as the ultimate interpreter of the Constitution, to devise a definition of obscenity that is specific and, at the same time, flexible. Specificity is necessary if it is to provide useful guidance, and flexibility is required to accommodate changes in social mores and ethics. As the court has attempted, over decades, to formulate such a definition, the law of obscenity has undergone rapid changes.

The Roth Definition

In 1959, in *Roth v. United States*, the Supreme Court formulated an early test to help define obscenity. A New York publisher and distributor was convicted for violating federal and California obscenity statutes after he mailed allegedly obscene circulars and advertising, and an allegedly obscene book. He appealed to the US Supreme Court, claiming that his conduct was protected by the First Amendment and that his convictions were unconstitutional. The court rejected his argument and affirmed the conviction, finding that the lower court had properly found the materials obscene. In the course of its opinion, it did away with the test that had been applied to obscenity cases since 1868, a test devised by a British court in *Regina v. Hicklin*.

The new test to be applied, it announced, was "whether to the average person, applying contemporary community standards, the dominant theme of the material taken as a whole appeals to prurient interest," and it jettisoned the former test that asked "whether the tendency of the matter charged as obscenity is to deprave and corrupt those whose minds are open to such immoral influences and into whose hands a publication of this sort may fall."

Because the old test required that material be judged "merely by the effect of an isolated excerpt upon particularly susceptible persons," it was discarded as a threat to any adult treatment of sex, among other things, and endangered the right to publish and distribute many highly acclaimed literary works.

It was hoped that *Roth* would clarify the law of obscenity, but confusion remained. In *Jacobellis v. Ohio*, the Supreme Court, in 1964, reversed Jacobellis's conviction for violation of an Ohio statute for showing a French film with a three-minute sex scene in it in a movie theater. The Supreme Court held that the lower court had erroneously construed the phrase

"contemporary community standards" to mean local rather than national standards. The court feared that such a construction would have the effect of denying some areas of the country access to materials that were acceptable there, because publishers and distributors would be reluctant to risk prosecution under the laws of more conservative states. Because the film received positive critical acclaim, although not universally, and was described as one of the best films of the year, the court believed that if it applied a national standard, the film could not be considered obscene. It was in *Jacobellis* that Justice Stewart made his famous statement:

> [C]riminal laws in this area are constitutionally limited to hard-core pornography. I shall not attempt further to define the kinds of material. . . . But I know it when I see it, and the motion picture involved in this case is not that.

The Memoirs Definition

When the attorney general of Massachusetts requested a court order declaring the erotic book *Fanny Hill* obscene, the Massachusetts courts ruled in his favor. On appeal, in *A Book Named "John Cleland's Memoirs of a Woman of Pleasure" v. Attorney General of Massachusetts*, the Supreme Court reversed the Massachusetts courts, stating that a work could not be obscene unless it was "utterly without redeeming social value." It established a three-part test including the no-social-value component that had to be met:

> (a) the dominant theme of the material taken as a whole appeals to a prurient interest in sex; (b) the material is patently offensive because it affronts contemporary community standards relating to the description or representation of sexual matters; and (c) the material is utterly without redeeming social value.

Unfortunately, even this test did not bring clarity to the law of obscenity.

In 1972, six years after the *Memoirs* decision, the Supreme Court was again confronted with a state court's overly broad definition of obscenity in a case involving publication of a photograph. In *Kois v. Wisconsin*, an underground newspaper publisher appealed his conviction on two counts of violating a state obscenity statute that prohibited the dissemination of "lewd, obscene, or indecent written matter, pictures, sound recording, or

film." The first count was for publication of an article that reported the arrest of one of the newspaper's photographers on a charge of possession of obscene material. Two relatively small pictures, showing a nude couple embracing in a sitting position, accompanied the article. The second count was for distributing a newspaper with a poem recounting the author's recollection of sexual intercourse. The Supreme Court reversed the obscenity convictions, finding that for the first count, the pictures were rationally related to an article that was clearly entitled to First Amendment protection; and as to the second, that the poem had "some of the earmarks of an attempt at serious art."

Various attempts thereafter to apply what was then known as the Roth-Memoirs test did not eliminate confusion, which continued both in the US Supreme Court and in the state courts.

The Miller Definition

The US Supreme Court tried again to provide a workable definition of obscenity in *Miller v. California,* a 1973 decision. The court again jettisoned an old test and adopted a new one. It applies today.

In reviewing *Roth* and *Memoirs,* the court concluded that one thing had been categorically settled: "Obscene material is unprotected by the First Amendment," but because any limitation on an absolute freedom of expression could lead to undesirable and dangerous censorship, it was deemed essential that state obscenity laws be limited in scope and properly applied. These concerns are manifest in the *Miller* obscenity test, which substantially modified the *Roth-Memoirs* test. The *Miller* test was articulated as follows:

> The basic guidelines for the trier of fact must be: (a) whether "the average person, applying contemporary community standards" would find that the work, taken as a whole, appeals to the prurient interest, *Kois v. Wisconsin, supra,* at 230, quoting *Roth v. United States, supra,* at 489; (b) whether the work depicts or describes, in a patently offensive way, sexual conduct specifically defined by the applicable state law; and (c) whether the work, taken as a whole, lacks serious literary, artistic, political, or scientific value.

The court discarded the "utterly without redeeming social value" test of *Memoirs,* replacing it with a "serious . . . value" language, and upheld the right

of a state to apply community rather than a national standard in enforcing its obscenity laws.

The *Miller* test is still law, but courts do not entirely agree on what it means in specific situations and how it should be applied. Inconsistencies in case results and in prevailing statutes and ordinances require the photographer to be aware of the law in each area where distribution of a given photograph is planned.

Some of the difficulties in attempts to apply the *Miller* test to particular cases are apparent from the cases that followed *Miller*.

Defining "Community Standards"

One problem in applying the *Miller* test has been in defining "community" for the purposes of ascertaining moral standards. The Supreme Court in 1974, in *Hamling v. United States*, said that the effect of *Miller* was "to permit a juror sitting in obscenity cases to draw on knowledge of the community or vicinage from which he comes in deciding what conclusion 'the average person, applying contemporary community standards' would reach in a given case." The court, however, did not provide specific guidelines on how to identify a community but stated only that since the case was tried in the southern district of California, "presumably" it would be that community, but "this is not to say that a district court would not be at liberty to admit evidence of standards existing in some place outside of this particular district, if it felt such evidence would assist the jurors in the resolution of the issues which they were to decide."

Defining "Patently Offensive"

The Supreme Court in *Miller* provided some guidance as to the meaning of "patently offensive," indicating that the phrase refers to "hard-core" materials, which, among other things, include "patently offensive representations or descriptions of ultimate sexual acts, normal or perverted, actual or simulated" and "patently offensive representations or descriptions of masturbation, excretory functions, and lewd exhibitions of the genitals." These examples indicate that materials less than "patently offensive" may well be entitled to First Amendment protection and thus serve as a limitation on the states' powers to arbitrarily define obscenity as something lesser.

In 1974, in *Jenkins v. Georgia*, the Supreme Court compared the explanation of patently offensive from *Miller* to the scenes contained in the Academy

Award–winning film *Carnal Knowledge* and determined that the movie was not obscene. It stated:

> Nothing in the movie falls within either of the two examples given in Miller of material which may constitutionally be found to meet the "patently offensive" element of those standards, nor is there anything sufficiently similar to such material to justify similar treatment. While the subject matter of the picture is, in a broader sense, sex, and there are scenes in which sexual conduct including "ultimate sexual acts" is to be understood to be taking place, the camera does not focus on the bodies of the actors at such times. There is no exhibition whatever of the actors' genitals, lewd or otherwise, during these scenes. There are occasional scenes of nudity, but nudity alone is not enough to make material legally obscene under the Miller standards.

In *State v. Padilla*, a 2018 decision by the Supreme Court of Washington, the court relied upon *Jenkins v. Georgia* in finding that a definition of "pornographic materials" as "images of sexual intercourse, simulated or real, masturbation, or the display of intimate body parts" was overly broad and unconstitutional, since "[t]he prohibition against viewing depictions of intimate body parts impermissibly extends to a variety of works of art, books, advertisements, movies, and television shows."

Defining the "Prurient Interest" of the "Average Person"

According to the ruling in *Miller*, to be judged obscene, a work must appeal to the "prurient interest" of the "average person." "Prurient interest" is an elusive concept, but that did not stop the Supreme Court from attempting to define it in *Roth* as that which "beckons to a shameful, morbid, degrading, unhealthy, or unwholesome interest in sex." Some states have attempted to write their own definition of "prurient interest" into their obscenity statutes. One such attempt that was challenged as overly broad led to yet another Supreme Court decision on obscenity in *Brockett v. Spokane Arcades, Inc.*, in 1985.

The statute challenged in *Brockett* defined obscene matter as that appealing to the "prurient interest," which was further defined as "that which incites lasciviousness or lust." The Supreme Court held that, by including "lust" in the definition, the statute extended to material that merely stimulated normal sexual responses and found it overly broad and unconstitutional.

In a 2017 Nevada Supreme Court case, *Shue v. State*, the court examined Nevada criminal statutes regulating the "sexual portrayal" of minors that defined it as "the depiction of a person in a manner which appeals to the prurient interest in sex and which does not have serious literary, artistic, political or scientific value." The court determined that the definition was not overbroad and unconstitutional. The court stated that the phrase "which does not have serious literary, artistic, political or scientific value" sufficiently narrowed the conduct prohibited under the statute so that it did not violate the First Amendment.

The issue of whether material appeals primarily to the prurient interest may be influenced by the manner in which it is advertised. Evidence of an advertising practice known legally as *pandering* may contribute to the likelihood that a work will be declared obscene. Pandering occurs when materials are marketed by emphasizing their sexually provocative nature.

The relevance of pandering was first determined by the Supreme Court in 1966, in *Ginzburg v. United States.* In *Ginzburg*, the Supreme Court reviewed a conviction under a federal obscenity statute for distribution of several publications containing erotic materials that, because they were of some value to psychiatrists and other professionals, were not in and of themselves obscene. Since the defendants had portrayed the materials as salacious and lewd in their marketing and had indiscriminately distributed those works to the general public, however, the trial court had found the materials to be obscene. The Supreme Court affirmed, stating that evidence of pandering is relevant to the question of obscenity. It again noted the relevance of pandering in *Hamling v. United States*, where the court explained that when the obscenity question is a close one, evidence of pandering may be considered.

OBSCENITY AND PRIVACY IN THE INTERNET AGE

The widespread use of the Internet and state and federal attempts to regulate it have resulted in an explosion of recent federal and state cases. In the first case to address the regulation of sexually explicit content on the Internet, the US Supreme Court, in 1997, in *Reno v. American Civil Liberties Union*, ruled that portions of the 1996 Communications Decency Act were unconstitutional by prohibiting the right to free speech under the First Amendment. The intent of the provisions of the act that were challenged was to protect minors from offensive and indecent content on the Internet, but the court believed that the

language adopted in the statute was too broad and, because important terms were undefined, that the law could impermissibly prohibit nonpornographic material that could have educational or other value. Thereafter, Congress passed other versions of the law leading to further appeals.

In *Packingham v. North Carolina*, the US Supreme Court, in 2017, found that a North Carolina statute, which made it a felony for anyone on the state's registry of sex offenders to access various websites, including Facebook, if the sites were known to permit access to minors, impermissibly restricted lawful speech in violation of the Constitution's First Amendment. It emphasized the importance of cyberspace and social media as a place to exchange views, where people can "speak and listen, and then, after reflection, speak and listen once more."

In an August 31, 2018, decision, *State v. Vanburen,* the highest court in Vermont ruled that a Vermont statute prohibiting "revenge porn" or "nonconsensual pornography" (distributing sexually graphic images of individuals without their consent) was constitutional and did not threaten freedom of speech on matters of public concern. After finding the problem of "revenge porn" was widespread, that forty states had enacted legislation to address it, and that federal legislation had also been proposed, it examined Vermont's statute. The law provided that it was a crime to "knowingly disclose a visual image of an identifiable person who is nude or who is engaged in sexual conduct, without his or her consent, with the intent to harm, harass, intimidate, threaten, or coerce the person depicted, and the disclosure would cause a reasonable person to suffer harm." It defined "nude" and "sexual conduct," and a provision set out some circumstances under which the statute did not apply, such as when there was no expectation of privacy. The law also provided that a person damaged by a violation of the law could bring a civil action against the offender and permitted restraining orders and injunctions.

The case arose because a woman took naked pictures of herself and sent them to someone, privately, on Facebook Messenger, but someone else (describing herself as the recipient's girlfriend) found them and posted them online, tagging the sender. The lower court found the statute unconstitutional, stating that it imposed a content-based restriction on protected speech, and, as a result, the state had to show that the law was "narrowly tailored" to address a "compelling state interest" and that there was no "less restrictive alternative." The trial court did not believe that the state had proved its case.

The Vermont Supreme Court disagreed. It started its analysis by considering whether "revenge porn" fell within an "established categorical exception to full *First Amendment* protection," found that it did not, and declined to predict that the US Supreme Court would recognize a new exception. After announcing the *Miller* test, the court could not find that "revenge porn" should be placed in the obscenity category, since the purposes of the obscenity exception and the Vermont statute were so different. The obscenity exception was meant to protect people exposed to offending images, but the Vermont statute was meant to protect "revenge porn" victims. Since the statute did not fit into an exception to First Amendment protection, the court continued with the analysis of whether Vermont could legislate in this area and whether the law was narrowly tailored enough to pass scrutiny and whether there was a less restrictive alternative.

It discussed invasion of privacy law, referred to the 1890 *Harvard Law Review* article by Samuel Warren and Louis Brandeis, summarized the rulings in a number of US Supreme Court cases, and stated:

> The Supreme Court has never struck down a restriction of speech on purely private matters that protected an individual who is not a public figure from an invasion of privacy or similar harms; to the contrary, the Court has repeatedly reconciled the tension between the right to privacy and freedom of expression with an analysis of the specific privacy claims and the public interest in the communications at issue, rather than a broad ruling prioritizing one of these values over another.

Thus, finding implicit permission for a state to regulate invasion of privacy with respect to private persons, and determining that the images were "private" and that there were no "matters of public concern" involved, it considered whether the state had done so in the proper manner and for a good reason. It ruled that it had. One justice filed a dissenting opinion commenting that "I cannot agree that, in this day and age of the Internet, the state can reasonably assume a role in protecting people from their own folly and trump First Amendment protections for speech."

An appellate court in Texas, in 2018, in *Ex Parte Jones*, reached a different opinion, finding a Texas law prohibiting "revenge porn" unconstitutional as a content based prohibition on expression.

Additionally, there have been flurries of cases on the right of states and schools to regulate sexting, Twitter, Instagram, and other forms of Internet communication and social media. This is a rapidly developing area of law.

Federal Statutes

Although obscenity laws are often state and local, in some situations the federal government has passed legislation dealing with specific issues:

- 18 U.S.C. § 1460 covers the possession with intent to sell, and sale, of obscene matter on federal property
- 18 U.S.C. § 1461 deals with the mailing of obscene or crime-inciting matter
- 18 U.S.C. § 1462 involves the importation or transportation of obscene matters
- 18 U.S.C. § 1463 covers the mailing of indecent matter on wrappers or envelopes
- 18 U.S.C. § 1464 has to do with the broadcasting of obscene language
- 18 U.S.C. § 1465 deals with the transportation of obscene matters for sale or distribution
- 18 U.S.C. § 1466 involves engagement in the business of selling or transferring obscene matter
- 18 U.S.C. § 1466A regulates obscene visual representations of the sexual abuse of children
- 18 U.S.C. § 1467 provides for criminal forfeiture resulting from violations
- 18 U.S.C. § 1468 deals with the distribution of obscene material by cable or subscription television
- 18 U.S.C. § 1470 covers the transfer of obscene material to minors
- 18 U.S.C. § 2251 deals with the production of child pornography
- 18 U.S.C. § 2252 and 2252A involve the possession, distribution, and receipt of child pornography
- 39 U.S.C § 3010 deals with the mailing of sexually oriented advertising.
- 39 U.S.C § 3008 contains rules about "pandering advertisements."

This list does not pretend to be complete. A photographer concerned about liability for potentially obscene images is well advised to seek the guidance of a good lawyer.

Forfeiture or Closure Legislation

Photographers should be aware that some states and federal statutes allow the authorities to close businesses or even permit the forfeiture of premises from which the obscene materials were disseminated. Some statutes have been upheld, and others have been found to be unconstitutional depending on their language and their reach. Photographers should be aware of this potential very serious consequence of the violation of obscenity laws in addition to other financial and criminal penalties.

INFORMAL CENSORSHIP

Formal censorship occurs when a law actually prohibits certain activities. Informal censorship, which may occur indirectly through government action or through the actions of private parties, can be just as damaging to freedom of speech.

Government Funding

There is the possibility that government funding could be distributed in such a way as to constitute informal censorship. In *National Endowment for the Arts v. Finley*, the US Supreme Court, in 1998, held that the government had the right to withhold funding of certain allegedly obscene art and that a statute that permitted the National Endowment for the Arts (NEA) to take "decency and respect" into account when making awards was not violative of the First Amendment. Controversy has surrounded funding by the NEA over the years, both as to what has been funded by the government and as to what has not been funded.

The Supreme Court, in 2003, in *United States v. American Library Ass'n.*, also upheld provisions of the Children's Internet Protection Act (CIPA) requiring libraries to use filtering software in order to be eligible for federal assistance for Internet access, finding no violation of the First Amendment. Without question, government funding may encourage or discourage forms of expression. The ultimate question is whether the funding conditions or requirements prohibit protected speech.

PREDICTING LIABILITY

As we have indicated here, whether or not a photograph is likely to be deemed obscene under the *Miller* test is extremely difficult to predict. Courts have experienced numerous problems in applying the test, and there is no indication that these problems are likely to be resolved in the near future.

Perhaps the most significant barrier to predictability in obscenity cases is that obscenity is a factual question to be determined by a jury. Presumably, juries are composed of reasonable persons, but it has long been recognized that reasonable persons may disagree. Consequently, it is not particularly surprising that different juries have come up with different results in obscenity cases involving essentially the same facts and issues.

How, then, is the photographer to predict whether a particular jury might reasonably find a photograph to be obscene? You probably cannot make this prediction, at least not without the assistance of a lawyer familiar with the relevant decisions. By analyzing the various obscenity cases in which the defendant was convicted and contrasting them with those in which the defendant was acquitted and by staying on top of any new obscenity laws that may be enacted in the future, an attorney should be able to provide a fairly accurate prediction as to whether the work in question will or will not be considered obscene. Unfortunately, graphic materials, such as photographs and films, are much more often found to be obscene than written material.

OTHER CENSORSHIP PROBLEMS

Censorship of obscene material is only one limitation the government places on photographers' rights. For instance, the government forbids the photographing of money or postage stamps unless certain requirements are met. These and other such restrictions are discussed in more detail later.

Governmental Licenses and Restrictions on Photographing Public Places and Private Property

LICENSING

The purpose of state and local licensing statutes is threefold: (1) to generate revenue; (2) to regulate entry into certain trades and professions; and (3) to regulate the standards to which those in a particular trade or profession are held. Cities and states generally have the power to pass law regulating professions that could present a threat to the general public, such as healthcare professionals and building contractors. Whether or not it is appropriate for a state to require a photographer to be licensed has been the subject of a number of cases. Generally, such licensing statutes have been held unconstitutional, as they interfere with an individual's constitutional rights, such as the right under the Fourteenth Amendment to engage in a lawful occupation or business. As photography poses no threat to the general public, it has been concluded that a state does not have the authority to regulate the profession.

The licensing of photographers was held to be constitutional by the North Carolina Supreme Court in 1938 in *State v. Lawrence*, but the same court, in 1949, in *State v. Ballance,* changed its mind and struck down the licensing scheme. Subsequently, there have been a number of other state supreme courts who have similarly ruled licensing requirements for photographers as unconstitutional.

In 1964, the Colorado Supreme Court, in *Abdoo v. Denver*, held that a portrait photographer was entitled to a reversal of his conviction for operating without a license, as the Denver Municipal Code requiring licensure had no reasonable relation to those areas in which a city can legitimately exercise police powers, such as public health, morals, safety, or general welfare. The court stated that the business of photography was a lawful activity that was "harmless in itself" and "useful to the community."

In 1970, the South Dakota Supreme Court, in *Watertown v. Hagy*, held unconstitutional a city ordinance requiring all itinerant or transient photographers to be licensed and bonded. The court concluded that it was invalid, because there was no similarly imposed requirement for local photographers, so the ordinance violated the Commerce Clause of the Constitution.

RESTRICTIONS ON PHOTOGRAPHERS

Local, state, and national laws regulate aspects of, and rules with respect to, photography. They vary greatly from place to place and change over time. The following discussion is limited to some, but by no means all, general categories of legislative restrictions.

Restrictions on Photographing Governmental Items, Certain Installations, and Personnel

It is not permissible to photograph certain governmental items. The US presidential seal, for example, may not be reproduced in any form without the proper authorization. US currency and stamps may be reproduced, but, to prevent counterfeiting and forgery, there are rules about whether the reproductions must be black and white or whether they may be in color and with respect to permissible sizes of the reproductions.

Photography is prohibited, under 18 U.S.C. § 795, at certain US military and naval installations and of certain military and naval equipment. Other government locations also restrict photography without permission. The Department of Homeland Security has a list on its website of items of intellectual property that should not be used without prior authorization from the agency. The list includes agency-related trademarks. See www.dhs.gov /department-homeland-security-intellectual-property-policy.

Regulations also prohibit the use in promotional or advertising materials of identifiable personnel employed by federal entities so as not to imply

affiliation with or the approval of the government. It is also criminal to use, without authorization, official seals, insignias, or emblems along with other identifying symbols used by federal entities. It is not permissible to use authentic uniforms, markings, or other designations used by the Department of Defense. There are various rules and regulations about photography in other federal buildings and government properties.

It is a federal offense to "knowingly and for profit" manufacture, reproduce, or use the character "Smokey Bear" (18 U.S.C. § 711) or "Woodsy Owl" (18 U.S.C. § 711a) without permission. These characters were created by the US Forest Service, a division of the Department of Agriculture.

In 1993, however, a federal district court in Washington State, in *Lighthawk, The Environmental Air Force v. F. Dale Robertson*, held that the US Forest Service was not justified in relying on this statute to prevent the use of a chain-saw-wielding Smokey Bear by an environmental organization in a political advertisement. The court stated that this depiction of Smokey Bear was purely expressive, noncommercial speech protected under the First Amendment and that such a use was unlikely to cause confusion or to dilute the value of Smokey Bear to help prevent forest fires.

These are only a few of the restrictions on photography under federal law. There are others, and there are many more under state law and in foreign countries. A good lawyer can be helpful in identifying those restrictions that may be applicable to you in your photographic ventures.

Restrictions on Photography in Public Places

Newsworthy events often occur in public places such as streets, sidewalks, or parks. These places are public forums, because they are open to the public and few restrictions are placed on the activities that may take place in them. Reporters can be barred from covering activities in public forums only if newsgathering restrictions are reasonable.

Photographs of so-called "perp walks" (alleged perpetrators being purposely walked through a public area by police to allow the media access) have generated some controversy. In *Brown v. Pepe*, a federal district court in Massachusetts, in 2014, found that a perp walk occurring at the main entrance to a county jail was not a violation of the arrestee's constitutional rights. The case, described by the court as one of first impression in the circuit, involved a prisoner who escaped from jail in Massachusetts and was arrested in Georgia. The court rejected claims that the perp walk and resulting photographs

violated his rights under the Fourth, Eighth, and Fourteenth Amendments to the Constitution. Although the media's recording of the event intruded on the prisoner's privacy, that interest was outweighed by the government interest of showing that he had been captured and was being extradited.

A different result was reached in the Second Circuit case, in 2000, of *Lauro v. Charles*. An arrestee in *Lauro* was photographed in a reenactment of his arrest, staged to allow the media to record it. The court explained that the incident did violate the arrestee's Fourth Amendment right to be free of unreasonable searches and seizures, since, although the press and the public had in interest in viewing his perp walk, this recording was not of his actual arrest, but a staged recreation and that the public interest was not well served by an "inherently fictional dramatization of an event that transpired hours earlier."

Perp-walk cases have been analyzed under various Constitutional provisions. In *United States v. Corbin*, a 2009 federal district court case in New York, the court determined, under the specific facts of that case, that publication of a perp-walk, showing a legislator in handcuffs, did not violate his right to a fair trial under the Sixth Amendment.

As a general rule, photographers are allowed to shoot photographs in national parks, just as are tourists. However, permits may be required, as may insurance, when the photography is "commercial" or involves advertisement of products or services or the use of models, sets, and props, or when such photography could result in damage to the resources or significant disruption of normal visitor uses. Permits are also required for photographers to shoot in areas normally closed to the visiting public, though oral approval may suffice for a photographer engaged in bona fide newsgathering activities.

In some cities, there are municipal code provisions that require permits in order to take motion pictures, to telecast, or to photograph in public places. Some regulations prohibit the use of certain equipment, such as tripods, in certain public areas. This may be based on whether your photography will disrupt the flow of traffic, interfere with government activities, or create a dangerous situation.

Photojournalists have First Amendment legal protection of their right to report on, or photograph, newsworthy subjects, but the right is not absolute. The media has no constitutional right of access to the scenes of crime or disaster or other locations where the general public is excluded. In 1978, in *Houchins v. KQED, Inc.*, the US Supreme Court held that the guarantee to

the press of the right to publish did not include a special right of access and allow the media to enter a prison with camera equipment and take pictures of inmates for publication purposes.

The Fifth Circuit Court of Appeals, in 2017, in *Turner v. Driver*, confronted the question of whether there is a right to record police activity in a case that arose from the handcuffing and placement of the plaintiff into a squad car after he recorded a police station from a public sidewalk across the street. The court stated:

> We agree with every circuit that has ruled on this question: Each has concluded that the First Amendment protects the right to record the police. As the First Circuit explained, "[t]he filming of government officials engaged in their duties in a public place, including police officers performing their responsibilities, fits comfortably within [basic First Amendment] principles." This right, however, "is not without limitations." Like all speech, filming the police "may be subject to reasonable time, place, and manner restrictions" [footnotes omitted].

Recognizing that the First Amendment provides protection to the "right to photograph and record matters of public interest," the Ninth Circuit, in 2018, in *Askins v. United States Dep't of Homeland Security*, faced the question of regulation of photography in public parts of US ports of entry on the United States/Mexico border. Recognizing greater rights to photograph in public places, the court outlined a test established to determine whether locations were public. It stated:

> determining whether a location is properly categorized as a public forum involves largely factual questions. We have adopted "a fact-intensive, three-factor test to determine whether a location is a public forum in the first instance." We consider "1) the actual use and purposes of the property, particularly [its] status as a public thoroughfare and availability of free public access to the area; 2) the area's physical characteristics, including its location and the existence of clear boundaries delimiting the area; and 3) traditional or historic use of both the property in question and other similar properties." [citations and footnotes omitted].

Based on the record before it, the court did not decide whether the allegedly public areas the plaintiff wished to photograph were in fact public. The court sent the case back to the lower court to more fully develop the factual details.

COURTROOM PROCEEDINGS

Rule 53 of the Federal Rules of Criminal Procedure provides:

> Except as otherwise provided by a statute or these rules, the court must not permit the taking of photographs in the courtroom during judicial proceedings or the broadcasting of judicial proceedings from the courtroom.

The US Courts' webpage on the history of cameras in courts at the time of the writing of this book (www.uscourts.gov/about-federal-courts/cameras -courts/history-cameras-courts) listed the following as the present policy on cameras in courtrooms:

> A judge may authorize broadcasting, televising, recording, or taking photographs in the courtroom and in adjacent areas during investi- tive, naturalization, or other ceremonial proceedings. A judge may authorize such activities in the courtroom or adjacent areas during other proceedings, or recesses between such other proceedings, only:
> 1. for the presentation of evidence;
> 2. for the perpetuation of the record of the proceedings;
> 3. for security purposes;
> 4. for other purposes of judicial administration;
> 5. for the photographing, recording, or broadcasting of appellate arguments; or
> 6. in accordance with pilot programs approved by the Judicial Conference.
> When broadcasting, televising, recording, or photographing in the courtroom or adjacent areas is permitted, a judge should ensure that it is done in a manner that will:
> 1. be consistent with the rights of the parties,
> 2. not unduly distract participants in the proceeding, and
> 3. not otherwise interfere with the administration of justice.

Generally speaking, the propriety of granting or denying permission to the media to broadcast, record, or photograph court proceedings involves weighing the constitutional guarantees of freedom of the press and the right to a public trial on the one hand and, on the other hand, the due process and fair trial rights of the defendant. Another consideration is the power of the courts to control their proceedings in order to permit the fair and impartial administration of justice.

The US Supreme Court, in 1980, in *Richmond Newspapers v. Virginia*, ruled that an order closing a murder trial to the public and the press was improper. Although the members of the court could not agree on an opinion, there was agreement that the closure violated the right of access of the public and the press to criminal trials granted by the First and Fourteenth Amendments in light of the fact that the trial judge did not articulate an overriding contrary interest.

According to *Waller v. Georgia*, a 1984 Supreme Court case, closing a courtroom is permissible only if: (1) there is "an overriding interest that is likely to be prejudiced"; (2) the closure is "no broader than necessary to protect that interest"; (3) the trial court considers "reasonable alternatives" to closure; and (4) the trial court makes "findings adequate to support the closure."

The Supreme Court, in 1981, ruled, in *Chandler v. Florida*, that the due process rights of an accused are not, without some significant prejudice, denied by television coverage and that no constitutional rule specifically prohibits the states from permitting broadcast or photographic coverage of criminal trial proceedings. But there is no absolute, unrestricted right to record court proceedings. In *Decker v. Bales*, a 2017 Arizona federal district court case, the court stated that it was "not aware of any controlling authority that grants Plaintiff an unfettered First Amendment right to record court proceedings or meetings," but even if there were such a rule that "the Arizona Supreme Court Rules governing such recordings are reasonable time, place, and manner restrictions."

In cases in which media representatives have claimed that court rules and orders prohibiting broadcast or photographic coverage of judicial proceedings infringed upon the freedom of the press, some prohibitions have been upheld as reasonable and proper attempts to preserve courtroom decorum and to protect the rights of defendants.

Photographers are advised to consult the applicable court rules in order to determine whether photography is permitted in courthouses and during court proceedings and under which conditions.

RESTRICTIONS ON PHOTOGRAPHING PRIVATE PROPERTY

As important as the photographic subject's right of privacy is the photographer's right to take pictures. Neither of these rights is absolute. Photography may be restricted on private property when coming onto the property is required. Both rights of privacy and the property rights of owners of property may apply to restrict the right to photograph.

Property owners may restrict access to their homes, businesses, shopping centers, and privately owned housing developments. They may post signs. Even when property owners have not barred access, they have been able to obtain damages for trespass or invasion of privacy when they did not consent to a photographer's or journalist's entry onto their property.

Limitations on the right to photograph have arisen in cases involving retraining orders. A number of cases discuss balancing when the rights of photographers or videographers to photograph or record collide with the rights of others to privacy and to be free of harassment. Some issues are illustrated in two Washington State cases.

A Washington anti-harassment statute permitted a court to enter an order: (1) restraining a party from making attempts to contact another party, (2) restraining the party from making any attempts to keep the other party under surveillance (which it defined as "to keep a close watch over one or more persons"), and (3) requiring the party to stay a stated distance from the other party's residence and workplace.

In a 2000 Washington court of appeals case, *State v. Noah,* a repressed memory therapist was the victim of protests, and videotaping, by a man whose daughter had accused him, after therapy with a different therapist, of sexually abusing her when she was a child. The videotaping was all done at the edge of the therapist's property, directly in front of his office building, at the edge of his driveway entrance, or in the street in front of his building. The lower court entered a restraining order against the protestor, which among other things prohibited him from "photographing or videotaping persons entering and leaving petitioner's building." The protestor violated the order and was convicted of contempt, and he challenged the constitutionality of the order and his conviction. The court affirmed the conviction and upheld the constitutionality of the anti-harassment order, ruling that a court order could put limits on First Amendment rights to keep a party from being in contact with another.

The protestor argued that photographing the therapist in public did not amount to "surveillance," because the therapist had no expectation of

privacy. The court rejected that argument, stating that "[a]uthority for an absolute right to photograph or videotape someone is nonexistent. Even if such a privilege existed, limitations are appropriate here." Explaining that statutes with time, place, and manner restrictions were upheld where they were content-neutral and narrowly tailored to serve important government interests, the court found that the anti-harassment order was of that type and affirmed the order and the conviction.

In *Trummel v. Mitchell*, a 2006 Washington Supreme Court case, the resident of a low-income senior housing project was ordered off the project and additionally was ordered not to post on the Internet any personal identifying information, including photographs, of any other residents or project staff. The resident, among other things, forced a newsletter on other residents and harassed them in other ways. When he established an offshore website posting information about the residents and staff and then refused to modify it, he was held in contempt and was confined to jail for almost four months.

The court, despite the resident's free-speech claims, upheld the provisions of the anti-harassment order relating to his conduct in forcing his ideas on others. Citing a US Supreme Court case holding that "[n]othing in the Constitution compels us to listen to or view any unwanted communication, whatever its merit," and recognizing that "the home is the principal exception to the general rule that the burden is on the viewer to avert his or her eyes from unwanted speech," the court ruled that the order was not unconstitutional.

However, as to the prohibition on Internet postings, the court did not believe that the trial judge had the authority, under the anti-harassment statute, to enter such an order, as such posting was not the "surveillance" that the statute permitted a court to regulate.

The Washington cases involved intrusion on the privacy or property of others without their consent. Other cases have questioned whether a property owner's silence or prevailing customs have been the effective equivalent of consent. In a Florida case, in 1976, *Florida Publishing Company v. Fletcher*, an invasion-of-privacy and trespass lawsuit was brought against a newspaper for publishing a photograph of the silhouette of the body of a seventeen-year-old girl killed in a house fire. The fire marshal and a police sergeant investigating the fire invited the news media into the burned-out home to cover the story, as was common practice at the time. The court found that there was no trespass or invasion of privacy by the media because of the common practice.

However, in *Cape Publications v. Reakes*, a 2003 Florida court of appeals case, a majority of the court found that a reporter's entry into a murder suspect's apartment without permission, through an open door, was illegal and that published statements saying so were not defamation. One dissenting judge believed that the issue of whether a reporter had leeway to enter into a crime scene for newsgathering purposes remained largely unresolved based on *Fletcher*.

If the police order you not to enter an area in pursuit of news, you are risking arrest, prosecution, and liability by disregarding the order, whether or not the property in question is publicly or privately owned. In *Stahl v. Oklahoma*, a 1983 Oklahoma appeals court case, the court ruled that the First Amendment did not shield newspersons from state criminal prosecution for their conduct in news gathering. Several reporters were arrested for following antinuclear power demonstrators onto a privately owned power plant site. The owner of the land, the Public Service Company of Oklahoma, had denied both the public and the media access to the plant. The court treated the plant as a government entity because the power company's activities were heavily regulated by the state and federal government. Nonetheless, the judge fined the reporters for criminal trespass, ruling that the First Amendment does not guarantee access to property simply because it is owned or controlled by the government and that the First Amendment does not protect reporters from arrest and prosecution if they have broken the law while gathering news.

In *State v. Lashinsky*, a police officer ordered a press photographer to move away from the vicinity of an automobile accident. When he refused, the photographer was arrested for disorderly conduct after refusing to heed the officer's order. The Supreme Court of New Jersey, in 1979, held that an individual is guilty of disorderly conduct when he refuses to obey the reasonable instructions of a police officer. A similar result was reached in *Bovan v. State*, a 1997 Mississippi Court of Appeals opinion.

Agencies across the country are under pressure to develop guidelines governing their relationship with the media. If they provide guidelines governing access to crime or accident scenes and if press credentials are issued, the guidelines must not result in the arbitrary denial of access to certain journalists. In *Sherrill v. Knight*, a 1977 case in the D.C. Circuit, the court held that if an agency establishes a policy of admitting the media, even though the public is barred, media access cannot later be denied arbitrarily or for less-than-compelling reasons. It also ruled that agencies must publish the

standards that will be used in deciding whether an applicant is eligible to receive a press pass, and that journalists who are denied press passes must be provided with reasons for the denial and given an opportunity to appeal the denial. The case involved the denial by the Secret Service of a press pass to the White House.

However, the court in *Nicholas v. Bratton*, a 2016 Southern District of New York case, explained that press access may be curtailed where there is a compelling reason—or perhaps simply a rational basis—for the restriction.

When in doubt about the item to be photographed or a place to take photographs, prudence would dictate that you should err on the side of caution and obtain permission and, if possible, a release. A well-drafted document will grant you the right to photograph the item in question and commercially exploit it.

Organizing as a Business

One of the reasons—perhaps the primary reason—why photographers like their work is that they feel they have escaped the sometimes suffocating atmosphere of the dress-for-success business world—but they have not escaped it entirely. Most of the same laws, although not the same culture, that govern the billion-dollar auto industry govern the photographer. This being the case, you might as well learn how you can use some of those laws to your advantage.

Any professional person knows that survival requires careful financial planning. Yet, some photographers do not realize the importance of selecting the optimal form for their business. Most photographers have little need for the sophisticated organizational structures utilized in industry, but since photographers must pay taxes, obtain loans, and expose themselves to potential liability every time they take photographs and sell their work, it only makes sense to structure the business to minimize these concerns.

Every business has an organizational form best suited to it. Photographers, on organizing their businesses, should consider various aspects of taxes and liability in order to decide which of the basic forms is best. Consultation with a good lawyer and an accountant is advisable.

There are only a handful of basic business forms: the *sole proprietorship*, the *partnership*, the *corporation*, the *limited liability company*, and a few hybrids. Once the business form has been selected, there are organizational details, such as partnership agreements, operating agreements, or corporate papers to complete. These documents define the day-to-day operations of a business and, therefore, must be tailored to individual situations.

An explanation of some of the features of these various business organizations, including their advantages and disadvantages, follows. This book cannot, and does not, include complete coverage of all of the pertinent details about business structures and their pros and cons. Each person's personal

circumstances are different and require consideration of individually relevant factors. As previously suggested, you should consult an attorney and an accountant before deciding to adopt any particular structure. This discussion is meant to facilitate your communication with your lawyer and to enable you to generally understand the choices available.

THE AMERICAN DREAM: SOLE PROPRIETORSHIP

The technical name *sole proprietorship* may be unfamiliar to you, but you may be operating under this business form right now. A sole proprietorship is an unincorporated business owned by one person. Although not peculiar to the United States, it was, and still is, the backbone of the American dream. Legal requirements are few and simple. In many localities, professionals such as photographers are not required to have occupational licenses, while a business license is often required. If you wish to operate the business under a name other than your own, the name must be registered with the state or, in some cases, the county in which you are doing business.

There are many financial risks involved in operating your business as a sole proprietor. If you recognize any of these dangers as a real threat, you probably should consider an alternative form of organization. If you are the sole proprietor of a business, the property you personally own is at stake. In other words, if for any reason you owe more than the dollar value of your business, your creditors can force a sale of much of your other personal property to satisfy the debt. Thus, if one of your photographs is defamatory, an invasion of someone's privacy, or infringes someone else's copyright, you could find that you are personally responsible for paying any judgment entered against you.

If you have insurance that provides coverage for the type of problem with which you are faced, you may be able to shift the loss from you to an insurance company, but insurance is not always available or affordable. In any case, insurance policies have monetary limits, exclusions from coverage, premiums—sometimes high ones—and deductibles. Various hazards, as well as uncertain economic factors, could force you as a sole proprietorship into bankruptcy.

PARTNERSHIP

A *partnership* is defined by most state laws as an association of two or more persons to conduct, as coowners, a business for profit. Two photographers

can form a partnership. This arrangement can be very attractive to beginning photographers, because it allows them to pool their money, equipment, and contacts. But there are also factors that might make this a poor choice.

When a photographer and writer get together and agree to produce a manuscript accompanied by photographs, this also constitutes a partnership. No formalities are required. In fact, in some cases, people have been held to be partners even though they never had any intention of forming a partnership. For example, if you lend a friend some money to start a business and the friend agrees to pay you a certain percentage of whatever profit is made, you may be your friend's partner in the eyes of the law even though you take no part in running the business. Or, if you have no formal agreement, you may find that your collaborator is held to be entitled to one half of the income you receive, even though his or her contribution was minimal. Further, each partner is subject to unlimited personal liability for the debts of the partnership, and each partner is liable for the negligence of another partner and for the partnership's employees when a negligent act occurs in the course of business.

If you are getting involved in a partnership, you should be careful. Since the involvement of a partner increases your potential liability, you should choose a responsible partner. Additionally, the partnership should be adequately insured, if possible, to protect both the assets of the partnership and the personal assets of each partner. Perhaps of most importance, you need a comprehensive written agreement between you and your partner in order to avoid any misunderstandings or confusion in the future.

As previously mentioned, no formalities are required to create a partnership. If the partners do not have a formal agreement defining the terms of the partnership, such as control of the partnership or the distribution of profits, state law will determine the terms. State laws are based on the fundamental characteristics of the typical partnership as it has existed through the ages. The most important of these legally presumed characteristics are:

- No one can become a member of a partnership without the unanimous consent of all partners
- All partners have an equal vote in the management of the partnership, regardless of the size of their interest in it
- All partners share equally in the profits and losses of the partnership, no matter how much capital they have contributed

- A simple majority vote is required for decisions in the ordinary course of business, and a unanimous vote is required to change the fundamental character of the business
- A partnership is terminable at will by any partner; a partner can withdraw from the partnership at any time, and this withdrawal causes a dissolution of the partnership

Most state laws contain a provision that allows the partners to vary these presumptions and make their own agreements regarding the business management structure and the division of profits that best suit the needs of the individual partners. Decide how you want the business to operate and enter into a formal, written agreement. The state law presumptions may be the last thing you want.

Here are some of the things that should be considered in reaching a partnership agreement:

- How is capital to be contributed or withdrawn?
- How and when are profits to be distributed to the partners?
- How is the partnership to be managed? Who will be responsible for what?
- Who may incur debt, and will there be limits on the amounts of debt that may be incurred?
- How will a disagreement among the partners be resolved?
- Are any specific conduct or any acts by the partners to be prohibited?
- How long will the partnership last, and what will happen when it concludes?

These questions and others should be agreed upon at the outset of a partnership. You are well advised to have a detailed, written agreement prepared by an experienced business lawyer.

The Limited Partnership

The *limited partnership* is a hybrid containing elements of both the partnership and the corporation. A limited partnership may be formed by parties who wish to invest in a business and, in return, to share in its profits, but who seek to limit their risk to the amount of their investment. The law provides for

such limited risk, but only so long as the limited partner plays no active role in the day-to-day management and operation of the business. In effect, the limited partner is very much like an investor who buys a few shares of stock in a corporation but has no significant role in running the company. In order to establish a limited partnership, it is necessary to have one or more *general partners* who run the business and who have full personal liability, and one or more limited partners who play a passive role.

Each state has its own rules on how to form a limited partnership. It usually involves filing a document with the proper state office. If the document is not filed or is improperly filed, the limited partner could be treated as a general partner and lose the important protection of limited liability.

A limited partnership is a convenient business form for securing needed economic backers who wish to share in the profits of an enterprise without undue exposure to personal liability. This may be a good form to select when a corporation is not the best form for the business to take or when the business does not meet all the requirements to become an S corporation (discussed later in this chapter). A limited partnership can be used to attract investment when credit is hard to get or is too expensive. In return for investing, the limited partner may receive a designated share of the profits. From the entrepreneur's point of view, this may be an attractive way to fund a business, because the limited partner receives nothing if there are no profits. Had the entrepreneur borrowed money from a creditor, however, he or she would be at risk to repay the loan regardless of the success or failure of the business.

Another use of the limited partnership is to facilitate reorganization of a general partnership after the death or retirement of a general partner. A partnership, remember, can be terminated upon the request of any partner and will end upon the death of a partner. Although the original partnership may be technically dissolved when this occurs, it is not uncommon for the remaining partners to agree to buy out the retiring partner's share and keep the business going. Raising enough cash to buy out the retiring partner, however, could be very difficult or could jeopardize the business by forcing the remaining partners to liquidate certain partnership assets. A convenient way to avoid such a detrimental liquidation is for the retiree or the heirs of a deceased partner to step into a limited-partner status. Thus, he or she can continue to share in the profits, which, to some extent, flow from that partner's past labor, while removing personal assets from the risk of partnership

liabilities. In the meantime, the remaining partners are afforded the opportunity to restructure the partnership funding under more favorable conditions.

Limited Liability Partnerships

For businesses that have been conducted in the partnership form and desire a liability shield, or where parties decide to form a partnership and where all the partners want limited personal liability but also want to play a role in managing the partnership business, the limited liability partnership, or LLP, is available. Each state has its own rules governing if and how LLPs can be formed, and some states only allow liability protection for negligence claims. It is often used by professionals and in some states can only be formed by professionals.

THE CORPORATION

The word *corporation* may bring to mind a vision of a large company with hundreds or thousands of employees—an impersonal monster wholly alien to the world of the photographer. In fact, there is nothing in the nature of a corporation itself that requires it to be large or impersonal. In most states, even one person can incorporate a business. There are advantages and disadvantages to incorporating. If it appears advantageous to incorporate, you will find it can be done with surprising ease and little expense. However, it is advisable to use a good lawyer's assistance to ensure compliance with state formalities as well as to obtain advice on corporate mechanics and taxation.

Differences between a Corporation and Partnership

In describing the corporate form, it is useful to compare it to a partnership. There are several differences between these two forms of business, including the extent of power of the owners and the fund-raising capabilities of the business.

Liability

Like limited partners, the owners of the corporation—commonly known as shareholders or stockholders—are not personally liable for the corporation's debts. They stand to lose only their investment in the corporation, not their other assets. This is known as the *corporate shield*.

The corporate shield also offers protection in situations where an employee of the photographer has committed a wrongful act while working for the photographer's corporation. If, for example, an assistant negligently injures a pedestrian while driving to the store to buy a new memory card for the photographer, the assistant will be liable for the wrongful act and the corporation may also be liable, but the photographer who owns the corporation will probably not be personally liable.

For the small corporation, however, limited liability may be something of an illusion, because, very often, creditors will require that the owners either personally cosign for a loan or personally guarantee repayment of any credit extended. In addition, individuals remain responsible for their wrongful acts. A photographer who infringes a copyright or creates a defamatory work will be personally liable, even if he or she incorporated. The corporate shield does protect a photographer for claims of breach of contract if the other contracting party has agreed that only the corporation is responsible. Publishing contracts frequently require photographers to make certain guarantees and statements of fact. If the publisher has contracted only with the photographer's corporation and not the photographer as an individual, the corporation alone will be liable if there is a breach of the agreement.

Continuity of Existence

The many events that can cause the dissolution of a partnership do not end the life of a corporation. In fact, it is common for perpetual existence to be stated in the corporation's *articles of incorporation*, a document filed with the state when a corporation is formed. Unlike partners, under general rules, shareholders cannot decide to withdraw and demand a return of capital from the corporation. All they may do is sell their stock. This can be a problem when there are no buyers for it. However, specific agreements between shareholders may guarantee a return of capital should a shareholder die or wish to withdraw from a corporation. Shareholder agreements are more common in smaller corporations with fewer shareholders.

Transferability of Ownership

In a partnership, no one can become a partner without the unanimous agreement of the other partners unless a partnership agreement provides to the contrary. In a corporation, shareholders can generally sell some or all of their shares to whomever they wish. If the owners of a small corporation do not

want to be open to outside ownership, however, they can restrict transferability in a shareholder agreement.

Management and Control

Unlike a limited partner, a shareholder is allowed full participation in the control of the corporation, but only through his or her voting privileges. The higher the percentage of shares owned, the more significant the control. Shares may have various kinds of voting rights. Some shares may have no voting rights at all. A voting shareholder uses the vote to elect a board of directors and to create rules under which the board will operate.

The basic rules of the corporation are stated in the articles of incorporation, which are filed with the state. These can be amended by shareholder vote. More detailed operational rules, known as bylaws, must also be prepared. Shareholders and directors may have the power to create or amend bylaws. The board of directors makes operational decisions for the corporation and may delegate day-to-day control to a president and other officers and employees who must answer to the board.

Shareholders, even those who own a majority of the stock in the corporation, may not preempt a decision of the board of directors. If the board has exceeded the powers granted to them by the articles or bylaws, any shareholder may sue for a court order remedying the situation, but if the board is acting within its powers, the shareholders have no recourse except to vote for new board members or go through the process of formally removing a board member if such a process is covered in the bylaws or is permitted under state law. In a few more progressive states, a small corporation may entirely forego having a board of directors. In such cases, the corporation is authorized to allow the shareholders to vote on business decisions, just as in a partnership.

Raising Capital

Partnerships are quite restricted in the variety of means available to them for raising additional capital. They can borrow money or, if all the partners agree, can take on additional partners. A corporation, on the other hand, may sell more stock, and there are many different varieties of stock that can be sold, including: stock that is nonvoting, preferred stock, stock that is recallable at a set price, or stock that is convertible into another kind of stock. The issuance of new stock, in most cases, merely requires approval by a majority of the existing shareholders.

A means frequently used to attract a new investor is the issuance of *preferred stock*. This means the stock has some sort of preference. This can be a *dividend preference*, a *liquidation preference*, or both. A dividend preference is the corporation's agreement to pay the *preferred shareholder* some predetermined amount, known as a dividend preference, before it pays any dividends to other shareholders. A liquidation preference applies if the corporation goes bankrupt or liquidates and goes out of business. Should this occur, the preferred shareholder will generally be paid, if there is adequate money after the corporation's creditors are paid, before the other shareholders.

In addition, corporations can borrow money on a short-term basis by issuing notes or, for a longer period, by issuing long-term debt instruments known as debentures or bonds. In fact, a corporation's ability to raise additional capital is limited only by its lawyer's creativity and the economics of the marketplace.

Precautions for Minority Shareholders

Liquidating the assets of a corporation and distributing them is almost always impossible without the consent of the majority of the shareholders. Selling a minority interest in a small corporation might be difficult or impossible. If you are involved in the formation of a corporation and will become a minority shareholder, you must realize that the majority will have ultimate and absolute control unless certain precautions are taken from the start. There are numerous horror stories of what some majority shareholders have done to shareholders in the minority. Protections can be written in to a shareholder's agreement. It is advisable to retain your own attorney to represent you during a corporation's formation and not to wait until it is too late.

THE S CORPORATION

Congress has created a hybrid organizational form that allows the owners of a small corporation to take advantage of many of the corporate features described above and that avoids the double taxation problem of a regular, or C, corporation. This form of organization is called an S corporation (small business corporation). If the corporation meets certain requirements, which many small businesses do, the owners can elect to be taxed in a manner similar to that of a partnership.

The corporation owners must make an election in their corporate documents and through the IRS (IRS form 2553). If this is properly accomplished, the corporation will not be subject to federal income tax although it must file tax returns (there may, however, be state income taxes); instead, the owners will be responsible for any taxes on income (even if it is not distributed to them) and will be able to deduct losses, take deductions, and so forth, like a partnership. This can be particularly advantageous in the early years, because the owners of an S corporation can normally deduct the losses of the corporation from their personal income up to the owner's basis, which is either their stock investment or personal loans to the corporation, whereas the owners of a standard or so-called C corporation cannot.

To qualify as an S corporation, the corporation must be a domestic corporation, have less than 100 shareholders, all of whom must be individuals (with some limited exceptions such as certain trusts or estates), no shareholder may be a nonresident alien, and there can normally be only one class of stock.

There are both benefits and detriments to this form of business organization, and there are many rules and regulations that apply that are beyond the scope of this book. A good accountant can help you make a determination if an S corporation is a good choice for you based on all the circumstances.

LIMITED LIABILITY COMPANIES

Doing business as a *limited liability company* (LLC) has become a very popular way to organize a small business and to limit the liability of the business owners. The LLC business form combines the limited liability features of the corporate form with tax advantages available to the sole proprietor or partnership. A photographer conducting business through an LLC can shield his or her personal assets from the risk of the business for all situations except the individual's own wrongful acts. This liability shield is the same as that offered by the corporate form. Although it is a newer business form than partnerships or corporations, it is becoming more and more often the first choice for many businesses and is available for use even if there is a single owner. It is not a corporation, and certain rules relating to corporations do not need to be followed, allowing more flexibility in its formation and management. Much less paperwork is required than for a corporation.

A one-owner limited liability company is taxed as a sole proprietorship, and companies can be taxed as partnerships or C corporations. A limited

liability company may also be taxed as an S corporation. The correct boxes need to be checked and the right forms must be filed so that the company will be entitled to the sort of taxation model preferred. The LLC can have as many members as it wants, and there is no residency or citizenship requirement.

LLCs do not have the same restrictions imposed on S corporations regarding the number and types of owners. Corporations, sole proprietors, and partnerships can own interests in LLCs. LLCs may also have more than one class of voting ownership. If, however, an LLC elects to be taxed as an S corporation, it will be subject to certain S corporation restrictions. The LLC form can be particularly useful because of its flexibility. Virtually any internal structure for an LLC can be provided for in the LLC's operating agreement.

THE TAX CONSEQUENCES OF BUSINESS ORGANIZATION

There are differences with respect to the tax treatment of the various business entities. The tax laws and regulations are constantly changing, and the intricate details of such obviously cannot be covered in this chapter. The following information is intended to provide a general framework and to help you work with your attorney and accountant. It is not meant to provide advice with respect to your individual situation. The IRS website, www.irs.gov, also provides a wealth of useful information, examples, and access to IRS forms and free publications.

Sole Proprietorships

A sole proprietorship's profits and losses passed through to him or her are reported on his or her individual income tax return. The business is not a separate taxable entity. Sole proprietors file a Schedule C, which reports business information, and it is attached to their Form 1040s, their personal income tax returns. The business owner reports business income as personal income. Sole proprietors must pay self-employment tax and pay estimated taxes quarterly. A new deduction under the 2017 Tax Cuts and Jobs Act, for "pass through" income, effective in 2018, is discussed below.

Partnerships

Generally, partnerships are taxed in much the same way as sole proprietorships—business profits and losses "pass through" to the individual partners. Each partner pays tax on his or her share. The partnership must prepare an

annual information return on Form 1065, and K-1 schedules detail each partner's share and are filed with each partner's Form 1040, the individual tax return. Partnership tax is a very complicated body of law, so if you choose this business form, it is recommended that you consult with an accountant. A new deduction for "pass through" income available after 2017 is discussed below.

Corporations

There are two types of corporations for tax purposes: the C corporation and the S corporation. The designation "professional corporation" does not impact the tax characterization.

C Corporations

The C corporation is regarded as a separate legal entity. It is, therefore, taxed as a separate entity. The 2017 Tax Cuts and Jobs Act reduced the top federal corporate tax rate for C corporations from 35 percent to 21 percent. All corporate income is taxed at the corporate rate and then again at the shareholder level when it is distributed to the shareholders as dividends.

Congress has foreclosed the ability of corporations to avoid taxation at the shareholder level by retaining earnings and not paying them out to shareholders as dividends with imposition of an "accumulated earnings tax." Accumulated earnings are defined as retained earnings in excess of reasonable business needs. A nonexclusive list of reasonable business needs includes things like expanding operations, paying off debt, increasing working capital, and other things. Earnings cannot be retained just to avoid taxes. This tax can be assessed on retained earnings that have not been earmarked for a clear purpose. The tax may be assessed at 20 percent on sums of more than $250,000 for most businesses and $150,000 for service-related businesses.

Companies can seek exceptions to the retained earning tax but need to show there is a legitimate business justification for the earning retention.

C corporations use Form 1120 to report income and expenses, and the shareholders use form 1040 to report dividend income.

It is this double tax whammy—tax at the corporate level and again at the shareholder level—that dissuades many small businesses from opting for C corporation status. As a result, many small businesses elect to be treated as an S corporation, where shareholders are taxed much like partners in a partnership.

S Corporations

S corporations avoid double taxation because corporate profits and losses "pass through" directly to the shareholders, based on their proportionate share, and there is no federal taxation (there may be state taxes) at the corporate level. In order to be taxed as an S corporation, a special election must be made and filed with the IRS. In addition, certain requirements must be met, as discussed earlier in this chapter. The issue of retained earnings does not arise with S corporations that were originally formed as S corporations, since S corporation profits "pass through" to its shareholders, regardless of whether the money is paid to the shareholders or retained in the company. There may be exceptions to the rules noted above for C corporations that convert to S corporations.

The cost of paying taxes on profit not received should be weighed against the tax benefits of S corporation status, making consultation with a good accountant before selecting a business form advisable. S corporations file a Form 1120s (for informational purposes only), and the shareholders also file a Form 1040, Individual Income Tax Return. A new deduction for "pass through" income is discussed below.

Limited Liability Companies

Limited liability companies (LLCs) have different tax treatment. Generally, the business itself does not pay taxes; the members do. Single member LLCs are taxed as sole proprietorships. Multimember LLCs are taxed as partnerships. In some states, if such tax treatment is desired, the LLC may be taxed as a corporation. A limited liability company may also be taxed as an S corporation if it first elects to be taxed as a corporation and then elects to be taxed as an S corporation. The correct boxes need to be checked and the right forms must be filed so that the company will be entitled to the sort of taxation model preferred. But note that these federal tax treatments may not apply for state tax purposes.

THE 2017 TAX CUT AND JOBS ACT DEDUCTION FOR "PASS THROUGH" INCOME

As part of the Tax Cut and Jobs Act, commencing in 2018, income from sole proprietorships, partnerships, LLCs, and S corporations may be entitled to a new benefit that may substantially reduce their tax bills. There is a 20 percent deduction, known as the 199A deduction, that some taxpayers can apply

to "pass through" business income in certain situations. The deduction is complex and limited. With respect to its availability and the best way to take advantage of it, consultation with a knowledgeable tax professional is highly recommended. Among other limitations, the benefit phases out for workers, in what are defined as service fields, who earn more than $157,500 for individuals and $315,000 for couples, and freelancers paid as employees are not eligible for the deduction.

Although photographers are not included on the list the IRS has for service businesses, the list does include a catchall category for any trade or business where the principal asset is the reputation or skill of one or more of its employees or owners. Prominent professional photographers and even less famous photographers likely fall within this category and would be considered to be in a service business.

Taxpayers performing services for their business, as employees, cannot claim the deduction. If any of the income from the "pass through" business is wage income, that sum cannot be deducted. Also not included as eligible "pass through" business income are a number of things like capital gains or losses, some dividend or interest income, and other types of investment income. Specific and complicated regulations apply. A good accountant can help you sort this out.

TAXATION OF EMPLOYEE COMPENSATION AND BENEFITS

Business owners of "pass through" business entities, such as sole proprietorships, partnerships, LLCs, and S corporations, receive profits from their businesses. Profit, under tax law, is not employee compensation and is not deductible by the business. However, salaries paid to partners, LLC members, and S or C corporation shareholders for providing services to those businesses are compensation and may be deducted by the businesses subject to certain exceptions. Moreover, the businesses are responsible for withholding payroll taxes from the employees and paying the employer's share of such taxes, which share is deductible.

Corporate Employee Compensation

C corporations

The payment of employee compensation is actually one of the most effective ways to minimize or eliminate the double taxation that occurs when

C corporations pay dividends to owners. Rather than paying out corporate earnings to shareholder-employees as nondeductible dividends, the corporation can pay out salaries and receive a business expense deduction for the wages paid.

As this deduction provides a potentially large loophole in the tax law, Congress and the courts have limited the amount that may be deducted to only "reasonable compensation," and compensation must be an ordinary and reasonable business expense. The IRS frequently audits closely held corporations for this type of abuse. Although most challenges are to salaries and benefits for stockholders, excessive compensation paid to a non-stockholder-employees also has been successfully challenged by the IRS.

Reasonableness, as always, depends on all the circumstances of the particular case. Factors that the courts have considered include the nature of the job, the size and complexity of the business, prevailing rates of compensation, the company's profitability, the uniqueness of the employee's skills or experience, the number of hours worked, the employee's salary as compared with the salaries of coworkers, general economic conditions, and the presence, absence, and amount of dividends paid.

If a salary is found excessive, no deduction will be allowed for the part of the payment that is excessive. Even though the employer cannot deduct the full amount paid, the employee must report and pay tax on the full amount received.

Usually, a new business is more concerned with underpayment than overcompensation. Employees may work long, hard hours with little compensation in the hope of a brighter future. The IRS realizes this. In later years, when the business is profitable, employees can be compensated for the underpayment of former years by additions to their salaries. The base salaries must be reasonable, and the additional amounts also must be reasonable in light of the past services performed and the compensation already received.

Compensation also may be fixed as a percentage of profits or earnings. Contingent plans of this nature may result in low salaries in lean years and above-average salaries in good years. The IRS accepts this too, as long as, on the average, the salaries are not unreasonable. Of course, some premium is reasonable due to the risk assumed by the employee who accepts such a plan.

Contingent plans are suspect, however, when used for owner-employees, since they can be used to avoid dividends in good years. A stockholder-

employee's reward for an increase in business should be a reasonable salary and increased dividends.

S corporations

S corporation shareholders pay taxes on their share of the corporate income that is not subject to payroll taxes, so employees of S corporations generally try to minimize wage compensation and maximize their share of income—but there are rules about this. S corporations must pay reasonable compensation to a shareholder-employee in return for services that the employee provides to the company before nonwage distributions may be made to the shareholder-employee. Distributions and other payments by an S corporation to a corporate officer must be treated as wages as long as the amounts are reasonable compensation for services rendered to the corporation. The IRS may reclassify other forms of payments to a shareholder-employee as wage expenses, which are subject to employment taxes.

Other Employee Benefits

Fringe Benefits

Fringe benefits can be provided to employees, independent contractors, partners, and even owners (some benefits to owners are limited to the percentage paid to other employees). Some are taxable or partly taxable to the recipient, and others are not. Others defer income. The taxation of fringe benefits depends on the type of business entity providing them.

A C corporation can offer some benefits with tax advantages that other business entities may not. Owners of a sole proprietorship or businesses that "pass through" income, including 2 percent shareholders of S corporations, are not considered employees. They can receive benefits but do not get the same tax advantages as other employees. The law and regulations for fringe benefits and for benefit plans are extremely complex from a tax standpoint. Even though the myriad rules and regulations are tedious, the plans are worth considering.

Tax-exempt benefit plans, among other things, can provide medical long-term-care or group-term-life insurance, disability insurance, educational assistance, and child care. Each is covered by separate limits, rules, and requirements. Generally, structuring plans to favor highly compensated employees will subject the highly compensated employees to tax liability on

those benefits. This is a complicated area, and you should consult with your tax advisor or accountant before adopting any of these plans.

Retirement Plans

Retirement plans may benefit employers as well as employees. They must comply with ERISA, the Employee Retirement Income Security Act. Employers providing them may obtain significant tax advantages, and they may help with employee motivation and productivity. Additionally, the plans have tax advantages for employees. Retirement plans are either qualified or nonqualified plans. The rules for qualified pension, profit-sharing, and stock bonus plans are too numerous to summarize. Only a few features of them are discussed here.

Qualified plans meet the requirements of the Employee Retirement Income Security Act (ERISA) and the IRS Code and qualify for important tax benefits. Employers are entitled to a tax deduction for contributions to such plans, and employees do not pay tax on the amounts contributed until the money is distributed to them. Nonqualified plans do not get this tax treatment. Because of their tax advantages, most small businesses prefer qualified plans. There are particular requirements for qualified plans. Among others, a qualified plan must be permanent, must have a written program, and must be established and maintained by the employer. Generally, such a plan may not discriminate in favor of employees who are officers, shareholders, or highly compensated employees, and a certain percentage of nonhighly compensated employees must be covered. There are certain vesting and reporting requirements for qualified plans, and the help of a qualified professional is generally required to set up and administer such plans.

There are different types of retirement plans under ERISA: defined benefit plans and defined contribution plans. A defined benefit plan provides a specific monthly benefit at retirement, either a dollar amount or a benefit calculated with a formula. In a defined contribution plan, the employee or the employer or both contribute to an employee's account.

The contributions are invested, and the employee eventually receives the balance in the account.

Subcategories of plans are: Simplified Employee Pension Plans (SEPs), Profit Sharing Plans, Stock Bonus Plans, 401(k) Plans, Employee Stock Ownership Plans (ESOPs), and others.

Under a so-called "cafeteria plan," an employer may set up a menu whereby an employee is allotted a certain amount of benefit credit and allowed to choose among various amounts and combinations of plans or the receipt of additional taxable income. Amounts allocable to elected qualified benefit plans are not taxable to the employee. In this way, an employee can tailor a benefits program to best meet his or her individual circumstances. There are limits to the tax advantages for certain business owners (2 percent shareholders of S corporations) and highly compensated and key employees.

Benefits that may be offered by a cafeteria plan include, but are not limited to, accident and health benefits, dependent care assistance, group term life insurance, and health savings accounts. Other benefits may not be offered, including, but not limited to, educational assistance, cell phones, lodging and meals, and moving expense reimbursement.

Taxes to Be Aware Of and Some Ways to Keep Them Low

Photographers rarely think of themselves as being engaged in a business. Many, in fact, go to great lengths to avoid feeling like they are involved in the world of commerce. The IRS, however, treats the professional photographer like anyone else in business, so photographers have many of the same tax concerns as any other businessperson. In addition, most photographers have some special tax concerns. Photographers can, however, benefit from certain provisions of the Internal Revenue Code to reduce their income tax liability.

RECORDKEEPING

In order to take advantage of all the tax laws that may be beneficial to you, you must keep good, clear, and complete business records. The Internal Revenue Service does not require that you keep any particular type of records. They will be sufficient if they clearly and accurately reflect your income from photography and photography expenses and are consistent over time—enabling year-to-year comparisons.

You should keep a separate set of books for your business. You should also have a separate bank account for your business that you should only use for your business, and if you are a credit card user, a separate business-only credit card. Try to pay all of your business expenses by check or with your business credit card. Be sure to fill in the amount, date, and reason for each check in a check register and record the same information for credit card charges. If a check was written or a charge made for an expense related to a particular client or job, be sure to record the client's name or a job number. Finally, keep all of your canceled checks and your credit card statements and receipts.

You should also keep a cash expense diary that is similar in form to a datebook. You should use it on a daily basis, noting all cash outlays, such as business-related cab fares, tolls, tips, parking costs, and other cash expenses, as they occur, and the business purpose for the expenses.

In summary, by whatever manner, keep a complete and accurate record of all business income received and all business expenses paid. The more complete your records, the better your ability to support your claims for deductions.

QUALIFYING FOR BUSINESS DEDUCTIONS

Professional photographers may deduct their business expenses and thereby significantly reduce their taxable income. However, as with other artists and craftspeople, photographers must be able to establish that they are engaged in a trade or business and not merely pursuing a personal hobby. A dilettante is not entitled to trade or business deductions.

The Internal Revenue Service (IRS) presumes that a photographer is engaged in a business or trade, as opposed to a hobby, if he or she nets a profit from photography during three out of the last five consecutive years ending with the tax year in question. If the photographer has not had three profitable years in the last five, the IRS may contend that the photographer is merely a hobbyist, and the photographer will have to prove *profit motive* in order to claim business expenses. Proof of profit motive does not require the photographer to prove that he or she reasonably expected to make a profit, only that the photographer, in good faith, intended to make a profit.

The Department of the Treasury, Internal Revenue Service, Publication 535 (March 16, 2018), providing information for taxpayers, states:

> In determining whether you are carrying on an activity for profit, several factors are taken into account. No one factor alone is decisive. Among the factors to consider are whether:
> - You carry on the activity in a businesslike manner,
> - The time and effort you put into the activity indicate you intend to make it profitable,
> - You depend on the income for your livelihood,

- Your losses are due to circumstances beyond your control (or are normal in the start-up phase of your type of business),
- You change your methods of operation in an attempt to improve profitability,
- You (or your advisors) have the knowledge needed to carry on the activity as a successful business,
- You were successful in making a profit in similar activities in the past,
- The activity makes a profit in some years, and
- You can expect to make a future profit from the appreciation of the assets used in the activity.

Treasury regulation 1.183–2 deals with this subject in more detail. It calls for an objective standard with respect to proof of a profit motive and also lists factors to be considered in determining whether a taxpayer has a profit motive. The regulations add more detail and a number of examples. The regulations also indicate that no single factor will determine the results and that other factors may be considered.

Young v. United States, a 1971 tax case in the federal district court in Maryland, provides an example of how these factors may be applied in a particular case. Young was a psychoanalyst who also had a photography business. Although she was not a commercial photographer and had experienced what the court described as "serious large losses," the court held that she had a genuine profit motive in pursuing photography. The court was influenced, among other things, by the fact that Young did not appear to be pursuing the occupation of photography for mere pleasure or social prestige, that she was organized as a business and kept conventional business records, and that she had been trying to get a book of her work published.

In *Wilmot v. Commissioner,* a US tax court case in 2011, a taxpayer who worked primarily as an oceanographer was denied business deductions in excess of $57,000 for photography expenses (including, among many other things, foreign travel, meals, entertainment, and equipment), as the court did not believe that he pursued photography in order to make a profit. He earned no income from it and incurred increasing losses from year to year that he was unlikely to recoup. He did not conduct the activity in a businesslike manner. He did not have a separate bank account or a written business plan. Nor did he try to improve his profitability. His efforts at promotion and advertising

were meager. The court believed that he used his photography losses to offset other income and that he derived substantial recreational and personal pleasure from traveling and taking photographs. Even though the photographer had a lot of expertise in photographic techniques, and he spent a lot of time pursuing photography, the court felt that the former factors weighed more heavily than the latter ones did and denied him the ability to take business deductions for his pursuit of photography.

DEDUCTIBLE EXPENSES

Once you have established yourself as engaged in photography as a business and for profit, many of your ordinary and necessary expenditures for professional photography are deductible business expenses. This would include photographic equipment and supplies, office equipment, research, professional books and magazines, travel for business purposes, certain conference fees, agent commissions, postage, legal fees, accounting fees, and workspace. Workspace as a deductible expense—particularly space in one's home, which is a matter of concern to numerous businesspeople including photographers—is covered in the next chapter.

Many of a photographer's expenses are classified as *current expenses*—items with a useful life of less than one year. For example, postage, modeling fees, and telephone bills would be current expenses. These expenses are fully deductible in the year they were paid.

There are some business expenses, however, that cannot be fully deducted in the year of purchase but must be depreciated or amortized. These costs are *capital expenditures*. For example, the cost of professional equipment (such as cameras, tripods, memory cards, and lighting equipment) that has a useful life of more than one year is a capital expenditure and cannot normally be fully deducted in the year of purchase. Instead, the taxpayer has to depreciate, or allocate, the cost of the item over the estimated useful life of the asset. This is sometimes referred to as capitalizing or depreciating the cost. Although the actual useful life of professional equipment will vary, fixed periods have been established in the Internal Revenue Code over which depreciation may be taken.

In some cases, it may be difficult to decide whether an expense is a capital expenditure or a current expense. Repairs to equipment are one example. If you spend $200 servicing a camera, this expense may or may not constitute a capital expenditure. The general test is whether the amount spent

restoring the equipment has added to its value or substantially prolonged its useful life. Since the cost of replacing short-lived parts of equipment to keep it in efficient working order does not substantially add to the useful life of equipment, such a cost, generally, would be a current cost and would be deductible. Reconditioning equipment, on the other hand, significantly extends its useful life, and such a cost, generally, is a capital expenditure and would be depreciated.

For many small businesses, an immediate deduction can be taken under 26 U.S.C. §179 when equipment is purchased instead of depreciating the expense. This is called the "election to expense certain depreciable business assets." In order to take advantage of the provision, you must have net income of at least the amount of the deduction. The limit in 2018 is a million dollars, and there are many other requirements and limitations. For tax years 2018 to 2022, the new tax law also provides for 100 percent expensing for certain qualified business assets (known as first-year bonus depreciation) without a dollar limitation; it is mandatory for certain business assets and would need to be used first for equipment purchases unless the taxpayer makes a §179 election.

Commissions paid to agents, as well as fees paid to lawyers or accountants for business purposes, are generally deductible as current expenses. The same is true of salaries paid to assistants and others whose services are necessary for the photography business. If you need to hire help, you may wish to hire people on an individual-project basis, as independent contractors rather than as regular employees. If this is done correctly, you do not have to withhold payroll taxes from payment to the contractor, or pay the employer's share of payroll taxes. You should specify the job-by-job basis of the assignments, detail when each project is to be completed, and, if possible, allow the person you are hiring to choose the place to do and how to do the work. You must provide 1099 forms by January 31 of each year to any independent contractors you hire.

The characterization of a worker as an employee or an independent contractor is a complex legal issue. You should discuss this with your attorney or tax advisor.

Business Use of an Automobile

If you or your employees use personal vehicles for business, you may be able to deduct all (if you use the automobile only for business purposes) or part of

your automobile expense. There are two methods by which you can calculate your deductible automobile expense. The standard mileage rate may be used if you own or lease the car and:

- you operate fewer than five cars
- you have not claimed a depreciation deduction for the car using any method other than a straight-line depreciation
- you have not claimed a $179 deduction on the car
- you have not claimed the special depreciation allowance on the car
- you have not claimed actual expenses after 1997 for a car you lease
- you are not a rural mail carrier who received a "qualified reimbursement"

This method can only be used if you began using it during the first year you used the car for business. If you lease a car, you must use this method for the entire lease period. For 2018, the standard mileage rate for the cost of operating your car for business use is 54.5 cents per mile. You need to have good records to claim mileage. The IRS wants "written and contemporaneous" records. There are smartphone applications to help track such miles.

The other option is the actual expense method. To use it, you must determine what it actually costs to operate the car for the business-use portion of the vehicle's overall use, by dividing the expense based on the miles driven for each purpose. Consider gas, oil, repairs, tires, insurance, registration fees, licenses, and depreciation or lease payments (there are limitations on the total amount of lease payments that are deductible). There are special rules and limits on depreciation. To be able to take this deduction you need to keep good records to substantiate the expense. Under the new tax law, employee business expenses are no longer allowed.

Travel and Conventions

Many photographers travel abroad in order to shoot certain subjects. Even more commonly, a photographer might travel within the United States. On a US business trip (which must be temporary and generally for less than a year), "ordinary and necessary" expenses (but nothing luxurious or extravagant), including travel and lodging, are generally deductible if your travel

is entirely for business purposes. As of 2018, any deduction for business entertainment has now been eliminated. Instead of keeping records of your meal expenses and deducting the actual cost, you can generally use a standard meal allowance, which varies depending on where you travel. The IRS has a list of rates and locations for the United States and abroad. The deduction for business meals is generally limited to 50 percent of the cost. If you are traveling for an employer, there are special rules for how much you can deduct depending on your employer's reimbursement procedure. Special rules apply to "luxury water travel" and cruise ship travel and to foreign travel.

If the trip involves primarily a personal vacation, you can deduct business-related expenses at the destination, but you may not deduct the transportation costs. If the trip is primarily for business but part of the time is spent on a personal vacation, you must record which expenses are for business and which are for pleasure.

For foreign travel, the amount of expense that can be deducted depends in part on how much of the trip was business related. The trip may be entirely for business or primarily for business. The IRS presumes that a trip is entirely for business if you fall within certain exceptions (such as being abroad for no more than a week or spending less than 25 percent of your time on personal activities) even if you spend time doing other things.

If a trip is only primarily for business, you must allocate business and nonbusiness days and apply a fraction to determine deductibility, and there are other technical rules. If your foreign travel is primarily for vacation, the entire cost of the trip is a nondeductible personal expense. However, if you attend professional seminars or a continuing education program, depending on the circumstances, you may be able to deduct your registration fees and other expenses directly related to your business.

The IRS also has rules for deducting expenses incurred while attending conventions and conferences both inside and outside the United States. You can generally deduct transportation expenses for conventions in the US if you can prove that your attendance benefits your trade or profession. If a convention is for investment, political, social, or other purposes unrelated to your trade or business, your expenses are not deductible. There are stricter rules for conferences outside the United States.

Keeping a logbook or expense diary is probably the best line of defense for the photographer with respect to business expenses incurred while traveling.

If you are on the road, keep these things in mind. With respect to travel expenses, it is a good idea to:

- Keep proof of the costs
- Record the time of departure
- Record the number of days spent on business
- List the places visited and the business purposes of your activities

With respect to the transportation costs:

- Keep copies of all receipts
- If traveling by car, keep track of mileage
- Log all other expenses in your diary

Similarly, with meals, tips, and lodging, keep receipts and make sure to record all less expensive items in your logbook.

Charitable Contribution Deductions

Historically, photographers and others have donated either money or property to qualified charities in order to take a tax deduction for the donation. The deduction is still available, but it may be more difficult to take advantage of it after passage of the Tax Cuts and Jobs Act. You need to itemize your deductions to claim it, and with the increase in the new standard deduction (now $12,000 for an individual and $24,000 for a married couple), and as you must have deductions in excess of this amount to make itemization worthwhile, fewer people are expected to itemize deductions.

For those who itemize, the deduction is still available up to certain limits. To be deductible, donations must be made to qualified organizations. The IRS has a list of which organizations qualify. For donations of money, you must keep a bank record of the contribution or obtain a written communication from the donee organization with its name, the amount, and the date of the contribution. For contributions of over $250, the written communication is mandatory or no charitable deduction will be allowed. You can also deduct the cost or the fair market value of any property, depending on what it is that you donate, but you cannot deduct the value of your time or services. Determining fair market value is not always an easy process. Since this area

can be quite technical, you should consult with your tax advisor before making any charitable donations of property.

SPREADING INCOME AMONG FAMILY MEMBERS

Another strategy for photographers in high tax brackets is to divert some of their income directly to members of their immediate family who are in lower tax brackets by hiring them as employees. Putting dependent children on the payroll can result in tax savings for professional photographers, because their salaries can be deducted as a business expense. The child can earn up to the amount of the standard deduction without incurring tax liability, but the following must be true:

- The salary must be reasonable in relation to the child's age and the work performed.
- The work performed must be a necessary service to the business.
- The work must actually be performed by the child.

Family Partnerships

A second method of transferring income to members of your family is the creation of a family partnership. Each partner is entitled to receive an equal share of the overall income, unless the partnership agreement provides otherwise. The income is taxed once as individual income to each partner. Thus, the photographer with a family partnership can break up and divert income to the family members, where it will be taxed to them according to their respective tax brackets. The income received by children may be taxed at a significantly lower rate, resulting in more net income reaching the family than if it had all been received by the photographer, who is presumably in a higher tax bracket than the children.

But a photographer must be vigilant to avoid the *Kiddie Tax* that applies to a child's unearned income (not to a child's wages from working), such as income received from income-producing or investment types of property. This effects children under the age of nineteen, and those between nineteen and twenty-three who are full-time students and whose earned income does not exceed half of the annual expenses for their support. Prior to the Tax Cuts and Jobs Act, the Kiddie Tax taxed their unearned income over a

threshold amount at their parents' highest income rate, but the new law taxes such unearned income at rates between 10 and 37 percent depending on the amount of income. These rates may be higher than the rates applied under the old law and may make this income-shifting procedure inadvisable.

Additionally, although the IRS allows family partnerships, it may subject them to close scrutiny to ensure that the partnership is not a sham. Unless the partnership capital is a substantial income-producing factor, and unless partners are reasonably compensated for services performed on the partnership's behalf, the IRS may deny the shift in income. One section of the tax code deals with distribution of partners' shares and family partnerships and provides that a person owning a capital interest in a family partnership will be considered a partner for tax purposes, even if he or she receives the capital interest as a gift. However, the gift must be genuine and it cannot be revocable. Only if you intend to permanently give a partnership interest to a child is this method of shifting family income permissible.

Incorporating

In the past, some families incorporated in order to take advantage of favorable corporate tax rates. If the IRS questioned the motivation for such an incorporation, the courts examined the intent of the family members. If the sole purpose of incorporating was tax avoidance, the scheme was disallowed. There may not be a substantial tax benefit to be derived by incorporating a business, but there may be other reasons for incorporating, such as limiting personal liability. If the photographer employs a spouse and children, legitimate salaries paid to them will be considered business deductions, thus reducing the photographer's taxable income. When the spouse and children are made owners of the corporation by being provided with shares of stock in it, then all of the benefits discussed will be available. Unearned income from the corporation that is received by a child to which the Kiddie Tax applies follows the same rule as for a family partnership.

CAPITAL GAINS

The tax on capital gains is something to be aware of and likely something to attempt, with the help of a good accountant, to reduce or avoid. The key to a working understanding of the capital gains tax is the definition of a *capital asset*. For individuals, capital assets are generally anything the

individual owns for personal or investment purposes. This includes things like buildings, stocks, bonds, and even collectibles and art. Some things, among others, that are not capital assets are property held for sale in the normal course of business (like inventory), money received from the sale of that property, supplies of a type regularly used or consumed by the taxpayer in the ordinary course of a trade or business, depreciable personal property used for business, and some protected creative works (such as copyrights and patents).

There are two types of capital assets, long-term and short-term. Long-term capital assets are those that you have held for more than a year before selling them. Short-term capital assets, with some exceptions, are those held for less than a year.

A capital gain may occur when you sell capital assets for more than you paid for them. When a capital asset is sold, the amount received minus the *adjusted basis* of the asset (the purchase price plus other costs minus depreciation) and minus selling expenses is a capital gain or loss.

Long-term capital gains are taxed more favorably than short-term gains, which are taxed at the same rate as ordinary income. In 2018, long-term capital gains (other than for a few exceptions including capital gains from selling collectibles, which are taxed at 28 percent) are taxed at one of three rates—0 percent for taxpayers in the 10 and 15 percent tax brackets; 15 percent for taxpayers in the 25, 28, 33, and 35 percent tax brackets; and 20 percent for taxpayers in the 39.6 percent bracket. There is also an additional 3.8 percent bump for couples with $250,000 in income. There is an exception for taxpayers who sell their principal residences. Gains of up to $250,000 (or $500,000 for married taxpayers filing jointly) are tax free.

Other sections of the tax code cover assets that are not capital assets. Section 1231 of the tax code covers taxation of gains and losses on the sale or exchange of real or depreciable property used in a trade or business and held over one year whether it is one piece of property or your entire business. A gain under this section (§1231) is taxed at the lower capital gain rates, and a loss under this section is deductible as an ordinary loss. A capital loss not governed by section 1231 is only deductible up to $3,000 a year with the balance carried over to other tax years unless offset by other gains.

Section 1245 of the tax code covers depreciation recapture rules applicable to gains from dispositions of certain depreciable property—for example, business equipment, furniture, and fixtures.

The technicality of the tax treatment, as to which assets are capital assets and which assets are not, and as to capital gains and losses, serves to illustrate the immense complexity of the Internal Revenue Code. The code is full of pitfalls for the unwary. However, with the aid of a competent tax advisor, hopefully you can avoid big blunders or substantially reduce the pinch that you might feel if you find yourself in this taxing situation.

OTHER TAXES

There are several state and local taxes to which a photographer might be subject. Many states collect statewide sales taxes. Local sales taxes are collected in a variety of states. There are often also, depending on your location, other taxes such as personal income and corporate income taxes, occupational or business taxes, use and occupancy taxes, personal and real property taxes, gross receipts taxes, excise taxes, and inventory taxes, to name a few.

In most states and in some cities, photography is a business subject to sales tax when photographs are sold. You should contact your state and city sales tax bureaus, if any, to ascertain their requirements. If applicable, a taxing authority will issue you a taxpayer identification number after you fill out necessary forms. Usually, purchases by businesses that later resell goods are not taxed. These businesses are issued a "resale certificate" by the taxing authority, which, when provided to the seller of goods with the explanation that the item is for resale, exempts the purchase from sales tax. If sales tax is applicable to sales you make, you will be responsible, as an agent of the state, for collecting sales tax from your clients and paying it to the taxing authority. You should be aware that, if you do not collect sales tax from your customers but you should have collected it, you will be liable for paying it.

Sales taxes vary from state to state and from city to city, so be sure to find out which sales taxes apply in your area and if there are other taxes specific to your business. Sales taxes are generally imposed on the retail sales of goods, but they may also be imposed on other kinds of sales, such as leases or rentals or taxable services. Sales taxes customarily are levied on the last sale—those where the merchandise reaches the consumer. The manufacturer, distributor, and others earlier in the production chain generally do not pay sales tax. Some states require an out-of-state seller to collect tax for the state in which the goods are delivered. When selling your work across state lines, it is important to know the sales tax regulations in those states in which you

do business. Some states impose a sales tax when transporting goods outside of the state, whereas others do not. In states where sales tax is charged on goods, but not on services, a photographer may be confronted with complicated issues, as a photographer often sells a service as well as photographs. This is an area where employing a good accountant to keep you out of trouble is particularly appropriate.

NOTE

The scope of this chapter and the information contained in it is not intended to offer tax advice specific to your circumstances. Its purpose is to point out issues and areas of concern or opportunity to enable you to obtain further information. It is highly recommended that you locate, and retain, a good tax accountant to give you advice pertinent to your particular situation.

Tax Deductions for the Office at Home

It is quite common for photographers to have offices or studios at home for a variety of reasons. The most common reason may be economic. The cost of renting a separate space is such that many photographers prefer to work at home. Others, of course, choose to work at home because it enables them to juggle work and family obligations.

To be able to claim a deduction for use of part of your home for your business, as with other business deductions, you must have a trade or business. A decision denying the office-at-home deduction was the 1983 Federal Circuit Court of Appeals case of *Moller v. United States*. The taxpayers were a husband and wife who claimed a deduction for the area of their home used to manage their investments from which they earned their income. The court held that in order to qualify as a trade or business, the business must consist of the active buying and selling of securities, from which income was derived. The Mollers, however, derived their income from the dividends and interest resulting from holding securities for a long time. The court considered them investors as opposed to traders and ruled that their investment activity did not rise to the level of a trade or business.

If you qualify as a business and use part of your home for your photography business, you may be able to take the home office deduction. This deduction is available to both homeowners and renters. Certain requirements must be met before you are entitled to the deduction:

- You must use part of your home exclusively and regularly as your principal place of business; or

- You must use part of your home exclusively and regularly as a place where you meet with clients or customers in the regular course of your trade or business; or
- You have a separate structure apart from your home that you use for your business; or
- You must use part of your home on a regular basis for storage of inventory or product samples.

There are further rules with respect to the above categories. A generalized, summarized discussion follows. It is necessarily incomplete as to smaller details and exceptions. The advice of a qualified professional is advisable if you are considering taking this deduction.

EXCLUSIVE AND REGULAR USE AS YOUR PRINCIPAL PLACE OF BUSINESS

To qualify for the deduction under the first category, part of your home must be used *exclusively* and *on a regular basis* as your *principal place of business*.

Regularly means that the space is consistently used for business purposes, meaning that occasional use does not qualify. *Exclusively* means that the area is used only for the business purpose.

In the 2015 US Tax Court case of *Savulionis v. Commissioner*, a taxpayer claimed a deduction for the business use of his living room. The court, explaining that deductions are "a matter of legislative grace" and that the taxpayer bears the burden of establishing with adequate records an entitlement to one, denied the deduction. The court refused to conclude that a living room, in a three-person home, into which people had to enter and exit the home, and through which they had to pass to get into the other rooms of the home, was exclusively used for business.

To qualify as your principal place of business, it need not be your only business location. You may use it for more than one business, but not for nonbusiness uses. Factors to consider include the importance of the activities you perform there and the amount of time spent there as compared to other locations. The IRS will consider your home office to be your principal place of business if you use it exclusively and regularly to perform administrative and management activities for your business and if you have no other fixed location for performing them.

The phrase "principal place of business" has been interpreted different ways at different times depending on the language of the tax code and any amendments. In *Meiers v. Commissioner*, a case that ended up in the Seventh Circuit Court of Appeals in 1986, a couple owned a self-service laundromat and sought a home office deduction. The wife managed the business, supervised the five part-time employees, and performed other managerial and bookkeeping functions. She spent only about an hour a day at the laundromat and two hours a day in her office at home. The office was used exclusively for administrative work related to business. The tax court disallowed the deduction, stating that the laundromat was the "focal point" of the business. The Seventh Circuit disagreed with the tax court's analysis, explaining that a "focal point" test was inappropriate, as it looked at where work was more visible, not the place where more work was accomplished. A major factor to consider, according to the court, was the length of time spent in different locations, but other factors were also important, such as the importance of the work done in each location, the business necessity of having a home office, and the cost of establishing it. After considering those factors, the court reversed the tax court's ruling denying the deduction.

In *Hawk v. Commissioner*, a 2015 Tax Court decision, the court, citing Section 280A(c)(1) of the US Code (the provision applicable to the home office deduction), stated:

> The Supreme Court has laid out a two-part test to determine whether such a "home office" constitutes a taxpayer's principal place of business: (1) the relative importance of the activities performed at each business location, and (2) the amount of time spent at each place. *Commissioner v. Soliman*, 506 US 168, 175, 113 S. Ct. 701, 121 L. Ed. 2d 634 (1993). However, Congress adjudged the *Soliman* standard too rigid and enacted flush language following section 280A(c)(1)(C) designed to liberalize it. The Taxpayer Relief Act of 1997, Pub. L. No. 105–34, sec. 932(a), 111 Stat. at 881; see H.R. Rept. No. 105–148, at 407 (1997), 1997–4 C.B. (Vol. 1) 319, 729. This flush language provides that
>
>> the term "principal place of business" includes a place of business which is used by the taxpayer for the administrative or management activities of any trade or business of the taxpayer if there is no other fixed location of such trade or business where the

taxpayer conducts substantial administrative or management activities of such trade or business.

The taxpayer, an accountant, was denied a deduction for two home offices, as the court determined that neither was her principal place of business. She performed 50 percent of her work for one tax year, and 75 percent of her work for a subsequent tax year, at another office that she rented. She saw no clients at either home office. The court concluded that the accountant was entitled to no home office deduction for either tax year for either home office. Both home offices failed the time spent test as well as the importance of the work test.

EXCLUSIVE AND REGULAR USE AS A PLACE TO MEET CLIENTS OR CUSTOMERS

To qualify for a deduction under the second category—the meeting with clients category—the requirements of regularity and exclusivity apply, but you may also carry on business at a different location, and your home does not need to be the principal place of your business. However, you must physically meet with clients of customers at your home, and their use of your home must be substantial and integral to the conduct of your business. Occasional meetings and telephone calls are insufficient.

The US Tax Court, in 2015, in *Burke v. Commissioner*, denied a deduction for use of a home office to a land use consultant, finding that the deduction failed to qualify as a principal place of business and also on the alternate ground that it was regularly used as a place to meet clients. The consultant had an office at another location, most often met clients at their properties, and only met with clients in his home between five and ten times a year. The court found this to be an incidental or occasional use, as opposed to a regular use, and denied the deduction.

SEPARATE STRUCTURE

You may be entitled to a deduction if you have a separate freestanding structure on your property, such as a studio, workshop, garage, or barn. You must use it exclusively and regularly for your business, as was required for the other categories, but it does not need to be your principal place of business, nor do you need to meet with clients or customers there.

STORAGE OF INVENTORY OR PRODUCT SAMPLES

You may be entitled to a deduction under this category if you use part of your home to store inventory or product samples. The area does not need to be used exclusively for this purpose, however. But there are other requirements:

- Your business or trade must be selling products at wholesale or retail
- You store your business inventory or product samples in your home
- Your home is the only fixed location for your business
- The storage space is used as such on a regular basis
- The space is separately identifiable and suitable for storage

DETERMINING THE DEDUCTION

The home office deduction allows various home expenses to be deducted against the net business income. Depending on the calculation method used, expenses that fall into this category may include, but are not limited to:

- mortgage interest (up to a limit under the new Tax Cuts and Jobs Act);
- real estate taxes (also up to a limit under the new tax law;
- home repairs/maintenance;
- rent;
- utilities;
- insurance;
- security system; and
- depreciation.

The expenses for a home office are broken down into two categories—indirect expenses and direct expenses. Indirect expenses are those that benefit both the business and the personal use portions of the home. The business portion of the expense is taken as a percentage of the total spent. The business use percentage is determined by dividing the square footage of the business use of the home by the total square footage. Direct expenses are those that were made to improve only the business use portion of the home. These amounts are allowed in full.

As of tax year 2013, there are now two ways to calculate the deduction for business use of a home—the regular method and a simplified method. The simplified method makes the calculation and recordkeeping requirements easier. The taxpayer can choose either method for any taxable year. Once you have chosen one method for a particular year, you cannot change to the other method for that year. If you use the simplified method one year and change to the regular method in a subsequent year, there are rules about how you must calculate the depreciation deduction. The depreciation rules for the regular method of calculation are beyond the scope of this book. It is wise to consult a good accountant to be sure that you do this properly. For both methods, you can deduct a portion of the residence for home office use *only if* that portion is used *exclusively* and on a *regular basis* for business purposes.

Under the simplified method of calculation:

- determine the square footage of the home that is used for business (not to exceed 300 feet);
- apply the standard $5 per square foot to determine the deduction;
- home-related itemized deductions are to be claimed in full on Schedule A;
- there is no depreciation deduction;
- there is no recapture of depreciation on the sale of the home
- the deduction cannot exceed the gross income from the business use of the home less the business expenses;
- any amount in excess of the gross income limitation may not be carried over to subsequent years; and
- any loss carryover from the use of the regular method of computation in prior years may not be claimed.

Under the regular method of calculation:

- determine the percentage of the home used for business;
- the actual expenses must be determined and good records maintained;
- home-related itemized deductions must be apportioned between Schedule A and a business Schedule—Schedule C or Schedule F;

- a depreciation deduction for the portion of the home used for business must be taken;
- the depreciation is recaptured on any gain from the sale of the home;
- the deduction cannot exceed the gross income from the business use of the home less the business expense;
- any amount in excess of the gross income limitation may be carried over in subsequent years; and
- any loss carryover from using the regular method in prior years may be claimed if the gross income test is met in the current year.

An allocable portion of mortgage interest and property taxes can be deducted against the business income. These would be deductible as personal itemized deductions anyway if itemization were performed. The advantage of deducting them against the business, in the regular method, is that the business profit subject to self-employment taxes is reduced. A taxpayer who lives in a rented house and otherwise qualifies for the office-at-home deductions may deduct a portion of the rent that would not otherwise be tax deductible. The primary tax advantage for both renters and owners comes from a deduction for an allocable portion of repairs and utility bills and, for owners using the regular method of computation, depreciation. Otherwise, these would not be deductible at all.

Remember, a home office deduction may not be permitted for certain expenses if by taking the deduction, the taxpayer ends up with a net loss from the business to which the deduction relates. While mortgage interest and real estate tax that would be deductible as an itemized deduction are allowed in full as a home office deduction even if there is a business loss, other expenses for the home office would not be allowed and would carry forward. The assistance of a good accountant in determining whether it makes economic sense to take a home office deduction, as well as in determining how to calculate one, is well worth the price.

Having good records to support your claimed deduction is critical. Courts have emphasized the fact that taxpayers bear a heavy burden in proving their eligibility for a home office deduction. In *Morten v. Commissioner*, a 2018 case in the District of Columbia Court of Appeals, the court upheld the tax court's allowance of only a 10 percent home office deduction rather than the

25 percent deduction requested by the taxpayer. At trial, when asked about the size of her home office, the taxpayer responded, "I would say the office was maybe, you know, 300 square feet I think," and there was no further substantiation of size or use. Three hundred square feet would have represented 15 percent of her home, but, based on her testimony, the appellate court felt that the reduction to 10 percent was well within the tax court's authority and noted that the Tax Court could have denied the deduction altogether based on the paucity of evidence.

What to Know about Leases

Photographers may work out of their homes, own the office buildings they use, or rent commercial space. Purchasing commercial real estate is quite complex and beyond the scope of this book. Before embarking on this course, you should retain an experienced real estate lawyer for assistance.

At some time in your professional life as a photographer, you may be in a position where you will have to evaluate the terms and conditions of a commercial lease. You may also have to examine a residential lease, although these are customarily more tightly regulated by state law than are commercial leases. The relationship between a landlord and a tenant varies from state to state, and it is important for you to consult with an attorney who has some expertise in dealing with this body of law before signing such a lease. As a photographer, however, you may wish to call your attorney's attention to some specific items in a commercial lease that could be of great concern to you.

DESCRIPTION OF PROPERTY

One of the most important terms in any lease is the description of the property to be rented. Be sure that the document specifies, in some detail, the area that you are entitled to occupy. If you will be renting a studio in a building with common areas, you should have the responsibilities for those common areas spelled out. Will you be responsible for cleaning and maintaining them, or will the landlord? If you are not responsible for physically maintaining them, will the cost or a pro rata share of the cost of doing so be passed on to you? When will the common areas be open or closed? What other facilities are available to you, such as restrooms, storage, and the like?

COST

Another important item is the cost of the leased space. Will you be paying a flat monthly rental or one that will change based on your earnings at the location (percentage rent)? Will you be responsible for paying a pro rata share of property taxes and insurance in addition to the rent? In order to evaluate the cost of the space, you should compare it with other similar spaces in the same locale. Do not be afraid to negotiate for more favorable terms.

Care should be taken not to sign a lease that will restrict you from opening another facility close to the one being rented. A clause such as this is often included in a lease with percentage rent. In addition, find out if there is an escalator clause that will automatically increase your rent based on some external standard, such as the Consumer Price Index.

LENGTH OF THE LEASE

It is also important to consider the period of the lease. If you intend to rent a studio for a year or two, it is a good idea to try to get an *option* to extend. This gives you the right—but not the obligation—to extend the term of the lease for one or more set periods, usually on the same terms, other than that an extended term may come with an increase in rent. It is likely you will want to advertise and promote your business, and if you move on an annual basis, customers may feel that you are unstable. In addition, occasional customers who return on an irregular basis may not know where to find you after the lease period ends. Besides, moving can result in real headaches with respect to mail and for many other reasons.

Long-term leases are recordable in some states. Recording, where permitted, is generally accomplished by filing the lease in the same office where a deed to the property is filed, usually the county clerk's office. Check with a local title company or attorney for the particulars in your state. If you are in a position to record your lease, it is probably a good idea to do so, since recording the lease will then entitle you to receive legal and other notices related to the property. If receiving such notices is important to you and your landlord does not want the lease recorded, discuss the option of recording a memorandum of lease (a summary of the lease) with your landlord.

If you enter into a long-term lease, you should attempt to obtain the right to assign or sublet the space so that you are not locked in if your situation should change. Landlords often impose restrictions on these rights, which

range from preapproving the assignee or subtenant to paying the landlord a fee for exercising the right.

RESTRICTIONS TO WATCH OUT FOR

It is essential for you to determine whether there are any restrictions on the particular activity you wish to perform at the leased premises. For example, do you use film and develop your own photographs? The area may be zoned so that you are prohibited from discharging developing chemicals into the sewer system. It is a good idea to insist on a provision that puts the burden of obtaining any necessary permits or variances on the landlord or, if you are responsible for them, allowing you to terminate the lease without penalty if you cannot get those permits or variances.

It is also quite common for zoning laws to prohibit certain forms of commercial activities in dwellings when the area is zoned residential and vice versa. You can seek to have a clause inserted in the lease whereby the landlord represents that the premises are zoned for your particular use. If the place you wish to rent will be used as both your personal dwelling and studio, some special problems may arise.

Some states have enacted legislation that permits individuals to live in certain industrially zoned buildings, such as warehouses and the like. This type of legislation began in New York City's SoHo district in the late 1960s and has spread throughout the country. Some states also permit limited commercial activity to occur in residentially zoned areas. These activities are customarily restricted to light manufacturing, such as photographers' and artists' studios, and professional services, such as those of lawyers, doctors, and accountants. Rarely will these zoning exceptions permit ongoing retail activities. You should consult with your attorney before attempting to operate out of your home or to live in your commercial space.

Many leases prohibit the use or storage of hazardous materials. If you still use photography chemicals, you will need to make sure that there is an express exception for those. Be aware that smoking is now prohibited in many buildings as well as the area within a specified number of feet from the building. Learn the lease rules and about any smoking legislation pertinent to the lease area.

Be sure that the lease permits you to display any signage or advertising used in connection with your business. It is not uncommon, for example, for

historic landmark laws to regulate signs on old buildings. Can you put a sign in your window or in front of your building? Some zoning laws prohibit this.

REMODELING AND UTILITIES

Photographers should also be aware that extensive remodeling may be necessary for certain spaces to become useful studios. This remodeling, also known as "tenant improvements," may be designated as "TIs" in the lease documents. If remodeling will be required, it is important for you to determine who will be responsible for the costs. This should be expressly stated in the lease, or you may find that you are responsible for a lot more renovating than you anticipated. In addition, it is essential to find out whether it will be necessary for you to restore the premises to their original condition when the lease ends. This can be extraordinarily expensive and, in some instances, impossible to accomplish.

The Americans with Disabilities Act (ADA) of 1990 requires places of public accommodation to be reasonably accessible. The law is broadly interpreted and includes virtually every form of business. The term *reasonable accommodation* is not precise, and thus it is important to determine what must be done in order to fulfill the requirements of this federal statute. Typically, approximately 25 percent of the cost of any covered remodel must be allocated to items that aid accessibility. These would include, among other things, levered door openers, braille signs, larger bathroom stalls, wheelchair ramps, approved disability-accessible doors, elevators, and the like. You should determine whether the cost of complying with the ADA will be imposed on the landlord, the tenant, or divided.

If you need special hookups, such as water or electrical lines, find out whether the landlord will provide them or you have to bear the cost of having them brought in. If the leased premises already have the necessary facilities, question the landlord regarding their cost. Are they included in the rent, or are they to be paid separately?

Most commercial leases require the tenant to pay and be responsible for all utilities. You should make these arrangements directly with the utility companies. The landlord need not be involved. Because public utilities are tightly regulated, it is highly unlikely that any negotiation between you and the public utility will be fruitful regarding deposits, rates, fees, or contractual arrangements.

In some locations, garbage pickup is not a problem because it is one of the services provided by the municipality. On the other hand, it is not uncommon for renters to be responsible for their own trash disposal. In commercial spaces, this can be quite expensive and should be addressed in the lease.

You should also inquire about the availability of high-speed Internet access.

SECURITY

A good lease will also contain a provision dealing with security. If you are renting an internal space in a shopping center, it is likely that the landlord will be responsible for external security. This is not universally the case, though, so you should ask. Many buildings have security guards and surveillance cameras. If you are renting an entire building, it is customarily your responsibility to provide whatever security you deem important. Does the lease permit you to install locks or alarm systems? If this is something in which you are going to be interested, you should get an answer to that question.

DELIVERIES

Many photographers have materials delivered to their studios at off-hours so as to avoid disturbing potential customers. Does the lease have any restrictions regarding time or location of deliveries? If you are dealing with large, bulky items and are accepting deliveries or making them, put a provision in your lease that will give you the flexibility you desire.

INSURANCE COVERAGE IN THE LEASE

Customarily, the landlord will be responsible for the exterior of the building. It will be the landlord's obligation to make sure that the building does not leak during rainstorms and that it is properly ventilated. Nevertheless, it is important that the lease deal with the question of responsibility if, for example, the building is damaged and some of your photographs are damaged or destroyed. Will you have to take out insurance for the building as well as its contents, or will the landlord assume responsibility for such building insurance?

Similarly, find out whether you will have to obtain liability insurance for injuries that are caused in portions of the building not under your control, such as common hallways and the like. In any case, you should, of course, have your own liability policy for accidental injuries or accidents that occur on your premises, as well as coverage for your own belongings. It is a good idea to have your insurance agent review all of the lease requirements relating to insurance before you sign the lease. (See chapter 10 for more information about insurance.)

SECURITY DEPOSITS

When the lease is first executed, landlords will often require new tenants to pay the first month's rent, the last month's rent, and a security deposit. Some state laws require landlords to keep security deposits in a special trust account during the term of the lease. These funds are available to the landlord if the tenant causes an injury to the property during the lease or fails to leave the premises in proper condition. Tenants who fulfill all of their obligations under the lease should be entitled to refunds of their deposits when their leases expire.

LATE RENT

Most leases require the tenant to pay rent at the beginning of each month. Customarily, a lease will impose a penalty on the tenants for a late rent payment. You should try to negotiate for a fairly long grace period—ten or fifteen business days—before your rent is deemed late and a requirement that the grace period start running only after you are notified by the landlord. Generally, the late charges are called *service charges* or something similar to avoid their being characterized as penalties or interest, either of which is subject to specific rules regarding disclosure and amount.

GET IT IN WRITING

Finally, it is essential to make sure that every item agreed upon between you and the landlord is reduced to writing. This is particularly important when dealing with leases, since many state laws provide that a long-term lease is an interest in land and can be enforced only if it is in writing.

The writing may consist of several documents. For example, some shopping malls use a *master lease*, which governs the rights and responsibilities of all tenants, as well as an individual lease, which deals only with the issues unique to the specific rental space. In addition to leases, landlords may also add rules and regulations to the lease that are binding on all tenants regarding, for example, parking, waste disposal, rules for common areas, and the like.

The writing may consist of several documents. For example, some shopping malls use a master lease, which governs the rights and responsibilities of all tenants, as well as an individual lease, which deals only with what is unique to the specific rental space. In addition to leases, landlords may also add rules and regulations to the lease that are binding on all tenants regarding, for example, parking, waste disposal, rules for common areas, and the like.

What to Know about Insurance

One of the early instances of modern shared-risk business insurance originated in a London coffeehouse called Lloyd's sometime in the late seventeenth century. Lloyd's was a popular gathering place for seamen and merchants engaged in shipping and foreign trade. As Shakespeare pointed out in *The Merchant of Venice*, great profit can come from a successful sea voyage, but financial disaster can follow, just as surely, from a loss of ships at sea. The merchants congregating at Lloyd's knew that, as shipping news was circulated there. They understood that, despite their greatest precautions, disaster could strike any one of them at any time.

Through their dealings with the Italians, who already had a system of insurance, the merchants had become familiar with the notion of insurance, and it became a custom at Lloyd's to arrange for mutual insurance contracts. Before a ship embarked, information was provided about the ship, its captain and crew, its destination, and the nature of its cargo. Merchants who wished to be insurers of that particular ship would sign or initial a document indicating the extent to which they could be held liable in the event of a loss. The document was circulated until the entire value of the ship and cargo was covered. This method of creating insurance contracts was called *underwriting*.

Today, the term *underwriting* describes the agreement of an insurance company to pay if a certain loss occurs. Lloyd's of London still uses a method similar to the one that originated in the coffeehouse, but most other insurance companies insure against loss with their own financial holdings. The risks covered by insurance have also changed. The original Lloyd's insurers dealt in maritime insurance only. Now, almost anything can be insured—from a pianist's hands to an old master painting.

Although your business may not be as perilous as that of the seventeenth-century merchant, it is not altogether free of risks. Even in rural areas,

you may become the victim of burglary, and the forces of nature—fire, flood, earthquake—are undiscriminating in their targets. If you operate out of your home, you may already have homeowner's insurance, but your homeowner's insurance likely will not cover your professional activities.

As a photographer, you probably will need several types of insurance. While it is theoretically possible to insure virtually everything, as a practical matter, there are some risks that are not worth insuring. This section discusses some of the more common forms of insurance and identifies some of the issues that should be considered when obtaining insurance. The following information is necessarily limited and is very general. For specific information about insurance, you should carefully investigate the various providers of insurance in your area, learn what coverages may be available, and evaluate your specific needs. The more information you have, the better decisions you can make. Consider contacting your state insurance commissioner, enlisting the help of trustworthy insurance advisors, and retaining an experienced attorney.

WHAT IS INSURANCE?

All insurance is based on a contract between the insurer and the insured—that contract is detailed in a *policy* that defines the type and amount of insurance purchased by the insured. The insurer assumes a specified risk for a fee, which is called a *premium*. The insurance contract, or policy, must contain at least the following:

- A description of whatever is being insured (the subject matter)
- The nature of the risks insured against
- The maximum possible recovery
- The duration of the insurance
- The due date and amount of the premiums

When the total amount you can collect in the event of a loss has been set in the insurance contract, it is called a *valued* policy. Should a loss occur, the insurer pays a specified sum, regardless of the actual value of what was lost. For example, the state of Minnesota has a valued policy law. As was explained in *Auto-Owner Insurance Co. v. Second Chance Invs., LLC*, a 2013 Supreme Court of Minnesota case, such laws were enacted to stop insurance companies

from collecting high premiums for excessive amounts of coverage and then paying lesser amounts if fires occurred. As the insurer must pay the insured value in the event of a loss, over-insurance is prevented. The parties must agree on the value of property in advance of a loss, and, in the absence of fraud, the valuation is binding and must be paid by the insurer. An *unvalued* or *open* insurance policy covers the full value of property, which must be ascertained in some manner at the time of the loss, up to a specified policy limit.

There are generally two amounts for which property may be insured— *actual cash value* (ACV) and *replacement cost value*. Actual cash value is the cost it would take to replace the property lost or damaged, minus depreciation at the time of the loss. This is sometimes described as the price for which the property could be sold, which is almost always less than what it would cost to replace it. Replacement cost is the amount at which the property lost or damaged, in the condition it was in at the time of loss, could be replaced. Some policies require that an item actually be repaired or replaced before the insurer is required to pay for it.

Insurance companies spread the risk among insureds through the amount of premium paid by them. Insurance companies use data and statistics to predict levels of risk for various individuals or groups. An insurance company may, for example, charge higher premiums for drivers with many accidents than for drivers with few. A premium is set for each individual in proportion to the likelihood that a loss will occur to him or her. Things like age, where you live, the value of what you are insuring, and any loss history you may have are considered, and your premium is determined.

Each state has an agency responsible for regulating insurance companies that operate in that state. Insurance laws are different from state to state and cover such things as which companies can write insurance policies in each state, which kinds of coverages or limits of insurance must be offered by insurance companies, which certain kinds of policies must provide if they sell a certain type of insurance, which policy language may be prohibited in that state, methods of determining premiums, rules on cancellation and similar matters, and the licensure and training necessary for insurance agents and brokers.

THE CONTRACT

The documents that a company can use to make insurance contracts are regulated. Sometimes the state requires a standard form from which the company

may not deviate, especially for fire insurance. A growing number of states have statutes or regulations that say that all forms must be in "plain English." It may be required that insurance policies contain short words, sentences, or paragraphs; that there are no overly technical terms or obscure words; that there is a table of contents and individual sections with bold headings; and that the language in the policy must pass a reading ease test. More and more, insurance companies are being forced to write contracts that an average person can understand.

One issue that may arise is when the language of an insurance policy differs in some respects from what the agent who sold the policy told the insured person to expect. Generally, courts rule that people have a duty to read their insurance policies and that they will be charged with knowing the contents of the policy whether they read it or not. This rule may be mitigated, however, depending on the circumstances under which the issue arises. If the agent lied or negligently misrepresented the policy's coverage, or if he or she failed to obtain the requested coverage, depending on a multitude of factors, either the agent or the company or both may be liable.

In *Morrison v. Allen*, a 2011 Tennessee Supreme Court case, the court ruled that an insurance agent could be held personally liable for failing to obtain the right kind of life insurance policy. Such an action was permissible, according to the court, if:

- there was an agreement by the agent to procure insurance;
- the agent failed to use reasonable diligence in attempting to place the insurance and failed to notify the client promptly of the failure to obtain it; and
- the agent's actions warranted the client's assumption that he or she was properly insured.

Moreover, the court explained, an action would be permissible if insurance was obtained but did not include coverage promised by the agent.

Similarly, in a 2011 Supreme Court of Minnesota case, *Graff v. Robert M. Swendra Agency, Inc.*, an agent was held responsible for failing to obtain a million-dollar umbrella policy providing extra automobile liability insurance. The court explained that even though the insurance company did not have to pay (it had been released from liability by the insured), the insured could sue the agent individually.

But to succeed in such a case, an insured must be able to prove the promises made by an agent or what specific requests for insurance he or she made, and this may be difficult or impossible. The best idea is to be careful. When you buy insurance, go through your requirements with the agent and, if possible, have the agent put his or her promises in writing. Then, when you receive the policy, make sure that it includes the coverage you want and need. You may need the help of an attorney experienced in insurance law to make such a determination.

Because there is ambiguity in an insurance contract, courts generally require the insurer to provide the coverage that a reasonable person, after reading the contract, would expect to receive. And while an insured generally bears the burden of proving that coverage is provided by an insurance contract, the insurer generally has the burden of proof as to whether an exclusion applies.

Insurance law is quite complex, and the help of a good lawyer, if you have specific questions or need information pertinent to your own circumstances, is highly advisable.

What May Void an Insurance Contract?

An insurer may claim that an insurance contract is void and that it has no obligation to pay because the insured omitted or misstated important information when obtaining the insurance. For an insurer to be absolved of liability under an insurance contract, generally the omission or misstatement must be *material*—that is, it must be so important that the insurer should be excused from living up to its promises. If the insured had supplied the insurer with the true facts and if the insurer would not have insured had it known the facts, or if knowing the facts would have affected the conditions the insurer would have demanded or would have significantly increased the premium charged, the omission or misstatement would likely be considered material.

Exclusions in Insurance Contracts

Injuries caused by intentional bad conduct by the insured are generally excluded from coverage. In *American Guarantee & Liability Co. v. 1906 Co.*, a 1997 case in the Fifth Circuit Court of Appeals, a photography studio, which photographed and videotaped young women for modeling portfolios and advertisements and practiced "glamour photography," was sued when women learned that they were videotaped, by a studio employee, dressing

and undressing in the studio's dressing rooms. The court found that there was no coverage for the studio employee, as there was an exclusion in the policy prohibiting coverage for persons engaging in deliberate wrongful acts. A later appeal followed in the same case, in 2001, and coverage was found for the company that owned that building in which the offenses occurred, and for another party who was not personally involved in the videotaping.

American Family Mut. Ins. Co. v. M. B., a 1997 Minnesota court of appeals case, involved a photographer who sexually harassed and assaulted models. The photographer's employer was not covered, as there was an "expected injury" exclusion in the policy, and the employer knew or should have known of the sexual advances.

In *Kennedy v. Lumbermans Mut. Casualty Co.*, a 1991 New York case, an insurance company sought to avoid paying a claim made by its insured for the loss of his son's camera that was stolen from his car. Since the son, an avid photographer, worked as a salesman for upscale sound systems in vehicles and homes and occasionally took photographs of his work, the insurer tried to avoid paying for the camera, claiming that the policy excluded "business" property. The court determined that the insurer was obligated to pay, however, stating:

> The undisputed facts before this court attest clearly to a nonbusiness purpose for this equipment. It was not required for his job, nor was the equipment or any part of it purchased for use on his job. The equipment was purchased and utilized for leisure and recreational photography, and an occasional photo taken of his work product cannot change the essential character of the items, or their recreational purpose.

Had the son been a professional photographer, however, coverage would have been properly denied. Photographers should be aware that such an exclusion is often included in homeowner's and automobile policies and should select their insurance, and determine what is covered and what is not, very carefully.

Many standard business insurance policies exclude coverage for liability arising from contractual obligations. If, in your photography business, you are obligated under a lease to *indemnify* (pay or reimburse another for sums they have to pay as a result of something you did) your landlord, it might be

wise to add your landlord to your insurance policy as an additional insured. Usually this added coverage will cost little or even nothing.

There are a myriad of exclusions in most policies, and it is important to be aware of the kinds of things for which coverage is not provided.

TYPES OF INSURANCE

You may have some coverage for your camera if you have homeowner's or renter's insurance, and there are also basic types of insurance often purchased by small businesses like photographers—professional liability insurance, general liability insurance, business or commercial property insurance, and business interruption coverage, among others. Product liability insurance is also available but may not be required by photographers. Some types of insurance may be mandated by law. For example, photographers who are employers are often required to purchase worker's compensation insurance and unemployment insurance. Some potential policies that you may consider include:

Homeowner's or Renter's Insurance

You may be surprised to learn, if you are not a professional photographer, that you have some protection for your photography equipment under your homeowner's or renter's insurance if your equipment is stolen, damaged, or destroyed by certain hazards while at your home. There may be limits or exclusions, however, and it might make sense to *schedule* (value and list specific property to be insured at an additional cost) such property. While it may cost more, you may find that any standard homeowner's or renter's coverage is far too limited. Moreover, homeowner's and renter's insurance policies often exclude coverage for loss or damage to property used in a business.

Professional Liability Insurance

Professional liability insurance, also known as malpractice insurance or errors and omissions insurance, protects against financial loss due to errors or negligence on the part of a business or its employees. Not all businesses are required to carry this coverage, but it is a good idea for businesses providing personal services.

General Liability Insurance

General liability insurance covers such risks as claims for injuries to others during the normal course of operations, whether due to the negligence of the business owner or his or her employees, or for some other reasons. This insurance will often pay for the injured party's medical expenses and will pay for legal expenses if you are sued for accidents occurring at your business or because of your business operations. Sometimes risks such as copyright infringement, libel or slander, and invasion of privacy are protected against under such policies if they have "personal and advertising injury" coverage. Personal injury coverage is broader than advertising injury coverage, which is limited to certain situations. As the court in *Boehm v. Scheels All Sports, Inc.*, a 2017 case in a federal district court in Wisconsin, explained:

> To put these provisions in plain English, the policy provides coverage for advertising injury. But advertising injury does not include claims for copyright infringement generally. Claims of copyright infringement are covered only if the infringement occurs in the insured's advertisement.

Sometimes these types of coverages are excluded from general liability policy, and such coverage must be added.

General liability coverage is important to have if you injure someone while driving your car for your photography business, as many personal automobile policies exclude coverage for accidents when you are using your car for business.

Business or Commercial Property Insurance

Business property insurance covers your building, if you own one, and its contents in the event of a loss because of certain risks. The insurer will pay an amount up to the amount of insurance you purchase. There are policies available that cover only certain risks, such as fires, floods, or vandalism, and there are policies known as *all risk* policies that cover a broader range of risks but may include exclusions for certain types of risks.

If you are in the photography business, you may wish to obtain a business policy specific to photography (these are often available through professional photographer's associations) and may include both property and liability insurance.

Camera Riders

If you are not a professional photographer, the theft of or damage to your camera equipment by fire or certain other hazards may be covered by your homeowner's or renter's insurance. Determine, however, whether you also need to add a *rider* (extended coverage for certain listed pieces of property) to your policy to cover your cameras and other photography equipment. If you are a professional photographer, you may need to purchase a rider for camera and other photographic equipment to attach to a business policy.

Transit Insurance

This type of insurance covers property moving from one place to another over land. Homeowner's insurance generally covers property at the home, and business insurance often covers only property at the business premises. Transit insurance often covers the packing and loading and unpacking and offloading of items, and their transportation and storage during a move, if the items are damaged or lost due to fires, accidents, theft, or vandalism.

Business Interruption Coverage

Business interruption insurance or business income insurance helps replace lost income if you are out of business as a result of the type of risk for which you have purchased coverage. If you have a fire, for example, this insurance may pay for the rent for a new workspace until you can return to your old location.

Bailee's Customer Insurance

This kind of insurance covers loss to someone else's property while temporarily in the possession of the insured. If you are photographing priceless art objects owned by a collector in your studio, for example, this insurance could protect you from loss of or damage to the art for things like fire damage, theft from your premises, and damage from certain other hazards.

WHAT AND WHEN TO INSURE

Numerous factors should be weighed to determine whether or not to obtain insurance. Here are a few:

- Consider the value of what you are considering insuring. If you keep a large inventory of hard-to-replace prints or if

you own expensive equipment, as most photographers do, it should probably all be insured if possible. The most elementary way to determine whether the value is sufficiently high to necessitate insurance is to rely on the pain factor. If it would hurt to lose it, insure it.

- Estimate the chances that a given calamity will occur. An insurance broker can tell you which risks are prevalent in the photography business or in your neighborhood. You should supplement this information with your personal knowledge. For example, you may know that your studio is virtually fireproof, or that only a massive flood would cause any real damage. Although these facts should be weighed in your decision, you should not tempt fate. If the odds are truly slim but some risk is still present, the premium will be correspondingly smaller in most cases.

- Consider the cost of the insurance. Bear in mind that insurance purchased to cover your business is tax deductible.

- Determine whether you are legally obligated to obtain certain insurance. For example, commercial leases customarily require the tenant to maintain liability insurance in specific amounts, with the landlord as an identified insured party. There may be a comparable provision in your mortgage.

WHAT TO DO IF YOU ARE SUED

If you are served with a complaint in a lawsuit, immediately contact an experienced attorney. The case should then be promptly *tendered* (submitted) to your insurance carrier for coverage. If your policy covers the claims in the complaint, the insurance will hire an attorney for you, fund the defense, and be responsible for any recovery against you up to the *limits of liability* (the highest amount of insurance coverage purchased).

In addition to providing coverage for covered claims, most insurance policies also cover situations where a counterclaim is filed against you. This means that if, for example, you sue someone in order to recover your fees for work performed and they file a counterclaim against you alleging that you defamed them, the counterclaim may also be covered. If you have the proper insurance coverage, the insurance company will be required to fund the cost

of the defense, as well as pay any possible recovery up to the limits of your policy.

In situations where it is not clear whether there is coverage under an insurance policy, the company may agree to pay for the defense of a case but may not agree, at the outset, to pay any judgment entered against you. This is known as a *reservation of rights*. The insurer may later seek a judicial decision ruling that it is not liable to pay the judgment. In this situation, it is especially important that you have a good attorney looking out for your interests. Some courts have held that an insured, faced with a reservation of rights, in a case where the interests of the insurer and the insured conflict, has a right to choose his or her own lawyer who will be paid for by the insurer and is not obligated to accept a lawyer selected by the insurance company.

Insurance law varies from state to state, and in the event that an insurance company denies a claim that you have filed, refuses to defend you in a case filed against you, or agrees to defend but reserves rights in a case filed against you, a good lawyer can provide help that is well worth the cost.

FINDING THE RIGHT INSURANCE

It pays to shop around for insurance. Seeking a policy with a higher-than-average deductible may save you a considerable amount on your premium. Because a photographer's insurance needs tend to be complicated and tend to vary with the type of photography done, do try to find an insurance broker experienced in serving photographers. That agent is more likely to be able to predict your particular needs and find the right kind of policy for you. If you are unable to locate such a qualified agent in your area, try consulting with one of the professional organizations, such as the American Society of Media Photographers (ASMP) or the Professional Photographers of America (PPA). These organizations should be able to give you information on insurance providers in your area and may even be able to provide you with specific referrals.

Contracts and Remedies

In the normal course of business, photographers enter into contracts with magazines, agents, other photographers, customers, and photo and printing labs. The contractual terms may vary with the kind of service or image contracted for, but in every case, the nature of a legally binding agreement is the same.

The word *contract* commonly brings to mind a long, complicated document replete with legal jargon, but this need not be the case. A simple, straightforward contract can be just as valid and enforceable as a complicated one—although, depending on the number of issues to be covered, it may still be long.

WHAT IS A CONTRACT?

A contract is defined as a legally binding promise or set of promises. The law requires the participants in a contract to perform the promises they have made to each other. In the event of *nonperformance*—usually called a *breach*—the law provides remedies for the injured party. For the purposes of this discussion, we will assume that the contract is between two people, although contracts may involve any number of individuals or business entities.

Every contract contains three basic elements:

1. The offer
2. The acceptance
3. The consideration

Suppose, for example, you show a potential customer a variety of family portraits taken in your studio and suggest what you think would be the best arrangement for photographing her family (the offer). The customer says she

likes the way you have photographed other families and wants you to do it the same way for her (the acceptance). You agree on a price and the specific work to be performed (the consideration).

That is the basic framework, but there may be a great many variations.

TYPES OF CONTRACTS

A contract need not be a formal written document. Contracts can be express or implied, oral or written, formal or informal.

Express or Implied

Contracts may be *express* or *implied*. An express contract is one in which all the details are spelled out. Suppose, for example, you make a contract with a sculptor to deliver twenty photographs of his work, to be delivered on or before October 1, at an agreed-upon price, which will be paid thirty days after the photographs are delivered.

That is fairly straightforward. If either party fails to live up to any material part of the deal, a breach has occurred, and the other party may stop performing his part until he or she receives assurance that the breaching party will perform. In the event no such assurance is forthcoming, the aggrieved party may have reason to sue for breach of contract.

If the photographs are delivered on October 15 but the sculptor needed them by October 10 to get them to the judges for a juried exhibit, the delivery time was an important or *material* part of the contract, and the sculptor would not be required to accept the late delivery. But if the delivery time was not a material part of the contract, then the tardy delivery in most jurisdictions would be considered *substantial performance*, and the sculptor would be required to accept the delivery in spite of the delay.

Express contracts can be either oral or written, though if you are going to the trouble of expressing in detail the contractual terms, you should put your understanding in writing to avoid disputes or different recollections of the terms in the future.

Implied contracts are not in writing but include terms that would normally be expected based on the circumstances. Suppose you call a printer to order 1,000 sheets of glossy photographic paper without making an express statement that you will pay for it. The promise to pay is implied when the order is placed, and payment must be made when the paper is picked up.

With implied contracts, things can often get complicated quickly. Suppose an acquaintance asks you, a well-known wildlife photographer, to deliver one of your recent large prints of a nesting eagle to see how it will look in her living room. She asks if you will leave it there for a few days. Two months later, she still has it, and you overhear her raving to others about how marvelous it looks over the fireplace. Is there an implied contract that she will pay for the photograph under these circumstances? That may depend on a number of factors. Are you normally in the business of selling your work? Or do you usually loan your work for approval? If you do, for how long do you loan it before payment must be made?

The issue of whether an implied contract existed was confronted in *Faulkner v. National Geographic Society*, a 2006 federal district court case in New York. The case was brought by freelance photographers for *National Geographic* who sold their photographs for use in original articles and then sought additional payment for the use of their work in a digital archive. One of their claims was that there was an implied contract to pay the additional sums. While the court recognized that, in the absence of an express contract, a court may infer an implied contract from the conduct of the parties, it did not find that one existed in that case. While *National Geographic* paid the photographers when it used their contributions in contexts different from the magazine, it did not pay for reuse in the same context, including use in microfilm, microfiche, and bound compilations. And, when it did not pay in such earlier instances, the photographers had not complained. Under those circumstances, the court refused to imply a contract for additional payment.

In *Psihoyos v. Pearson Educ., Inc.*, a 2012 federal district court case in New York, the court could not, on the information before it, determine whether or not photographers had granted an implied license to publishers to publish certain of their images or whether or not the publication infringed the photographers' copyright in the photographs, stating that the determination would have to be made by a jury after a trial. The issue came up because, although under the Copyright Act an exclusive license must be in writing, courts have held that a nonexclusive license may be granted orally or may be implied by conduct. After acknowledging that "[t]he law in the area of implied licenses shows a measure of conflict," the court found the evidence inconclusive and contradictory and found that the publisher defendants might be able to persuade a jury that the course of conduct between the parties had created an implied license.

Obviously, it makes sense to avoid being placed in the inherently difficult position of having to try to prove an implied contract. Enter into a specific and detailed written contract, carefully setting out all of the terms and conditions and promises in the contract.

Possible Contract Scenarios

Some examples follow of the principles of offer, acceptance, and consideration in the context of several possible situations for a hypothetical freelance photographer, Smith. Smith has had works accepted in local and regional exhibitions, has won several prizes, and is getting assignments from large national corporations. In a word, Smith is developing quite a reputation. Under the following situations, we determine whether there is an enforceable contract:

- At a cocktail party, Jones expresses an interest in hiring Smith to photograph Jones's family. "It looks like your work will go up in price pretty soon," Jones tells Smith. "I'm going to hire you while I can still afford you."

 Is this a contract? If so, what are the terms of the offer—the particular work, the specific price? No, this is not really an offer that Smith can accept. It is nothing more than an opinion or a vague expression of intent.

- Brown offers to pay $800 for one of Smith's photographs that she saw in a show several months ago. At the show, it was listed at $900, but Smith agrees to accept the lower price.

 Is this an enforceable contract? Yes. Brown has offered, in unambiguous terms, to pay a specific amount for a specific work, and Smith has accepted the offer. A binding contract exists.

- One day, Gray shows up at Smith's studio and sees a photograph that she would like to use in her book. She offers $200 for the exclusive publication rights in the photograph. Smith accepts and promises to deliver the photograph to Gray's publisher next week, at which time Gray will pay for the rights. An hour later, Brown shows up. She likes the same photograph and offers Smith $300 for the exclusive publishing rights in it.

 Can Smith accept the later offer? No. A contract exists with Jones. An offer was made and accepted. The fact that

the rights have not yet been exercised or paid for does not make the contract any less binding.

- Green agrees that Smith will photograph Green's wedding and present Green with an "acceptable" wedding album for $2,000. It is understood that Smith will take a variety of shots throughout the festivities. After Smith presents Green with the proofs, Green indicates that he is disappointed and will not accept any of them.

Green is making the offer to purchase in this case, but the offer is conditional upon his satisfaction with the completed work. Smith can accept the offer only by producing something that meets Green's subjective standards—a risky business. There is no enforceable contract for payment until such time as Green indicates that the completed album is satisfactory.

Now, suppose Green came to Smith's studio and said that the completed album was satisfactory but then, when Smith delivers it, says it does not look right when Green reexamines it at home. Must Green accept the album? Yes. It is too late for Green to change his mind. The contract became binding at the moment he indicated that the album was satisfactory. If he then refuses to accept it, he will be breaching the contract.

Oral or Written Contracts?

A contract is enforceable only if you can prove what the terms of it were. A great deal of detail may be lost over time, and parties may have very different recollections about what was said in a particular conversation. The best practice, of course, is to put the contract in writing. A written contract generally functions as a safeguard against subsequent misunderstanding or forgetful minds, and written contracts are usually easier to enforce.

Some people are adamant about doing business strictly on a handshake, particularly where photography is concerned. The assumption seems to be that the best business relations are those based upon mutual trust, and some business people believe that any agreement other than a gentlemen's agreement belies this trust.

Although there may be some validity to these assumptions, people who own small businesses, such as photographers, would nevertheless be well

advised to put all of their oral agreements into writing. Far too many people have suffered adverse consequences because of their reliance upon the sanctity of oral understandings.

Even if there is no question that an oral contract was made, it may not always be enforceable. There are some agreements that the law requires to be in writing.

The Statute of Frauds

An early law that was designed to prevent fraud and perjury, known as the Statute of Frauds, provides that any contract that, by its terms, cannot be fully performed within one year must be in writing. This rule is narrowly interpreted, so if there is any possibility, no matter how remote, that the contract could be fully performed within one year, the contract need not be reduced to writing.

For example, assume that a customer and a photographer have entered into a contract in which the photographer has agreed to produce five pictures. Assume further that the agreement requires that the photographer submit one set of proofs per year for five years. In this situation, the terms of the agreement make it impossible for the photographer to complete performance within one year—the contract must be put in writing to be enforceable. If, however, the photographer agrees to submit five sets of proofs within a five-year period, it is possible that the photographer could submit all five sets in the first year. Therefore, the Statute of Frauds would not apply, and the agreement need not be in writing. The fact that the photographer might not actually complete performance within one year is immaterial. So long as complete performance within one year is possible, the agreement may be oral.

The Uniform Commercial Code

Certain agreements relating to the sale of goods must also be in writing to be enforceable. This rule has been incorporated into the Uniform Commercial Code (UCC), a compilation of commercial laws, versions of which have been adopted in all states. Louisiana has not, however, adopted the specific provisions of the UCC discussed in this chapter.

The UCC provides that a contract for the sale of goods for $500 or more is not enforceable unless it is in writing and is signed by the party against whom enforcement is sought. There is no such restriction on service contracts,

however. Regardless of the sum to be paid, a contract for the sale of services that can be completed within one year need not be in writing.

Distinguishing Sale of Goods from Sale of Services

Obviously, it is important to know whether a particular contract is regarded as involving the sale of goods or the sale of services. The UCC defines *goods* as being all things that are movable at the time the contract is made, with the exception of the money (or investment securities or certain other types of documents) used as payment for the goods. This definition is sufficiently broad to enable most courts to find that the transactions between a photographer and a supplier of such items as film, paper, cameras, and tripods involve goods. Unfortunately, the distinction is not so clear in the case of agreements between a photographer and a customer.

In *Carpel v. Saget Studios, Inc.*, a 1971 federal court case in Pennsylvania, the court ruled that a particular photographer-customer contract, a contract to deliver wedding pictures, was for the sale of goods. The Fifth Circuit Court of Appeals, in 2004, agreed in *Propulsion Techs. v. Attwood, Corp.* and stated:

> Even where the production of goods is labor-intensive and the cost of goods is relatively inexpensive, such as for wedding photographs or custom computer software, jurisprudence has considered the contracts for production and delivery to be transactions predominately in "goods." This contract would have to be much more service oriented for its "essence" or "dominant" factor to be the furnishing of services.

A different result occurred in *Whalen v. Villegas*, a 2013 district court case in New York, which involved the loss of wedding pictures during a transfer of the images from a camera to a computer. The court commenced by explaining that an agreement to shoot wedding photographs imposes a contractual obligation on the photographer to shoot the photographs in a skillful and workmanlike manner and to provide the photographs agreed upon. The court then had to determine if the agreement was one for the sale of goods or for the sale of services. It stated that it had to determine the predominant purpose of the agreement and stated:

The agreement in question is an agreement in which the provision of photographic services predominates. No goods, wedding pictures, would be available for sale or could be provided to Whalen, their parents or guests unless and until the photographic services are properly and timely performed.

The court in *Elbe v. Adkins*, a 1991 a federal district court case in Ohio, also found that a contract to shoot wedding photographs was a service contract as opposed to a contract for the sale of goods and was not governed by the UCC. It stated:

> Thus, just as an artist's labor is intimately involved in a contract to paint a picture, so too is a photographer's labor intimately involved in a contract to photograph a wedding. Thus the Elbe-Adkins contract was a service contract.

In 2008, in *Flying Double B, LLC v. Doner Int'l Ltd.*, a federal district court in Michigan determined that a photographer's provision of photographic transparencies to a potential customer did not amount to a "sale of goods," as the transaction contemplated a licensing agreement rather than sale of goods.

As the position a court would take as to whether contracts to photograph people or events involve the sale of goods or the sale of services is uncertain, it is wisest to have written contracts for sales of $500 and over and not a bad idea to have a written contract when the amount of a sale is even less.

Determining the Contract Price of Goods

Assuming for the moment that the various agreements entered into by the photographer involve a sale of goods, a second matter to be determined is whether the price of the goods is or exceeds $500. In most cases, the answer will be clear—but not always.

A photographer, for example, might contract to purchase several camera accessories from a wholesaler. The price for the total purchase exceeds $500, but the price for the individual accessories does not. Which price determines whether or not the statute applies?

Or suppose a photographer sells pictures to a gallery. The gallery will offer the pictures at a price that exceeds $500, but the price the photographer gets

is less than $500. Again, which price is used to determine whether the statute applies?

Obviously, a photographer will not in every case be able to ascertain whether the financial terms of a given contract exceed $500, any more than one can always be certain whether a given agreement involves the sale of goods or of services. Given the differences in interpretation by various courts, the best way to ensure that a contract will be enforceable is to reduce it to an unambiguous writing.

No-Cost Written Agreements

At this point, you might claim, with reason, that your profession is taking photographs, not writing legal documents. Where are you going to find the extra time, energy, or patience to draft contracts? Fortunately, you as a photographer will not always need to do this, since the supplier or customers you deal with may be willing to draft satisfactory contracts. However, be wary of someone else's all-purpose contracts—they will almost invariably be one-sided, with all terms drafted in favor of whoever paid to have them prepared.

As a second alternative, you could employ an attorney to draft your contracts, but this may be worthwhile only where the contract involves a substantial transaction or where you will use the contract in numerous transactions. With smaller transactions, the legal fees may be larger than any benefits you would receive. The book titled *Business and Legal Forms for Photographers*, by Tad Crawford, copublished with the American Society of Media Photographers, is an excellent resource and contains many useful forms and documents.

The Uniform Commercial Code provides a third alternative in most states. You need not draft a contract at all or rely on a supplier, customer, or attorney to do so. The UCC provides that where both parties are "merchants" and one party sends to the other a written confirmation of an oral contract within a reasonable time after that contract was made—and the recipient does not object to the confirming memorandum within ten days of its receipt—the contract will be enforceable.

A merchant is defined as any person who normally deals in goods of the kind sold or who, by occupation, represents himself as having knowledge or skill peculiar to the practices or goods involved in the transaction. Thus, professional photographers and their suppliers will be deemed merchants. Even an amateur photographer may be considered a merchant, since adopting the

designation "photographer" may be seen as a representation that one has special knowledge or skill in the field. The rule will, therefore, apply to many oral contracts you might make as long as there is also a "merchant" on the other side of the contract.

It should be emphasized that the sole effect of the confirming memorandum, if no timely objection to it is made, is that neither party can use the Statute of Frauds as a defense. The party sending the memorandum must still prove that an oral contract was made. Its advantage is that it may often be used effectively without the active participation of the other contracting party.

It might suffice to show that a contract was made to simply state: "This memorandum is to confirm our oral agreement." However, since the writer still has to prove the terms of the agreement, it is a good idea to provide a bit more detail in the confirming memorandum, such as the subject of the contract, the date it was made, and the price or other consideration to be paid. For example:

> This memorandum is to confirm our oral agreement made on July 3, 2020, pursuant to which [Photographer] agreed to deliver to [Magazine Editor] on or before September 19, 2020, five photographs and the right to use each of them one time only in the December issue of [Magazine] for the price of $200.

The advantages of providing some detail to the confirming memorandum are twofold. First, in the event of a dispute, the photographer may introduce the memorandum as proof of the terms of the oral agreement. Second, the recipient of the memorandum would be precluded from offering any terms contradicting those contained in the memorandum. The editor in the above example would be precluded from claiming that the contract called for delivery of six photographs because the quantity was stated in the memorandum and he did not object to it in a timely manner. However, the editor would be permitted to testify that the original contract required the photographer to package the pictures in a specific manner, as this testimony does not contradict the terms detailed in the memorandum.

In summary, no one in business should rely solely on oral contracts, since they offer little protection in the event of a dispute. The best defense is afforded by a written contract that includes all terms and agreements. It is a truism that oral contracts are not worth the paper on which they are written. Where a complete written contract is too burdensome or too costly, the

photographer, when dealing with another merchant, should at least submit a memorandum in confirmation of an oral contract to surpass the barrier raised by the Statute of Frauds.

Summary of Essentials to Put in Writing

A contract need not be and should not be a complicated document written in legal jargon. A contract should be written in simple language that both parties can understand and should spell out, in enough detail, all of the terms of the agreement.

A photography contract, at a minimum, should include:

- The date of the agreement
- Identification of the parties
- A description of the work being sold or, if a service, the service to be performed
- The price
- The signatures of the parties

To supplement these basics, the agreement should spell out whatever other terms might be applicable: the time a service is to be performed, the time payment is due or payments are to be made, the method of delivery, copyright ownership, use rights, licenses, and so on.

Finally, it should be noted that a written document that leaves out essential terms presents many of the same problems of proof as an oral contract. Contract terms should be well conceived, clearly drafted, conspicuous (i.e., not in tiny print that no one can read), and in plain English so that everyone understands what each party is to do.

QUESTIONABLE CONTRACTS

Obviously, you do not want to find yourself involved in contracts of questionable validity, nor do you want to find yourself stuck with a contract that you cannot enforce.

Capacity to Contract

Certain classes of people are deemed by law to lack the capacity to contract. The most obvious class is minors, a fact of particular relevance to

photographers, since a photographer might wish to use a minor as a model. Note that some states have strict laws surrounding photography or videography and minors, so you should check with an attorney if you are not sure about the rules in your state.

A person is legally a minor until the age of majority, generally eighteen. A contract entered into by a minor is not necessarily void but generally, depending on what the contract concerns, is voidable. This means that the minor is free to reject the contract up until he or she reaches the age of majority (or until some period shortly thereafter), but that the other party is bound by the contract if the minor elects to enforce it. In most states, a minor, shortly after reaching the age of majority, loses his or her ability to void a contract if he or she has not done so by then. Also in most states, a minor cannot get out of a contract for certain necessary items, like food or shelter.

In some states, a minor must return what he or she received as a result of the contract if he or she decides to reject it. Some states allow a parent to sign on behalf of a minor. Other states have a procedure for enabling minors to sign binding contracts that cannot be rejected. This generally requires the approval of a judge.

Other people who lack the capacity to contract include insane and incompetent persons. Since the requirements for contracting with such persons are highly technical and generally must be done through people like guardians, the photographer who wishes to enter into a contract with such people is well advised to consult a lawyer.

Illegal Contracts

Contracts are illegal if either entering into them or performing them is against the law. Courts will generally not enforce them. As a matter of public policy, neither party can ask the court to force the other party to perform or to award money for the other party's failure to perform. This problem will not often arise in photography contracts, but it is possible that a photographer could unwittingly become a party to an illegal contract. A few situations where this issue may arise follow.

A photographer may become a party to an illegal contract if the work he or she agrees to produce is obscene or libelous, for example. Moreover, the federal government and many states have enacted statutes, popularly known as Son of Sam laws, that prohibit criminals from receiving financial compensation from the exploitation and commercialization of their crimes. A

number of these statutes, in New York in 1991, in Rhode Island in 1997, in California in 2002, and in Nevada in 2004, for example, have been held to be unconstitutional as a violation of the First Amendment right of free speech. In response, a number of state legislatures have amended their statutes in order to try to survive a constitutional challenge. This is a rapidly evolving area of the law, and photographers should be aware that there is some danger in entering into contracts with criminals.

Although illegal contracts are generally not enforced, there may be cases where a court may grant an innocent party some sorts of relief, like the return of what was paid by that party, for example, although the party performing illegal acts would not be entitled to relief. Sometimes courts may even permit an illegal actor to get some kinds of relief, but these cases and circumstances are relatively rare. If you have even the slightest doubt as to whether you may be a party to an illegal contract, or if you are thinking about entering into a contract that may be questionable, it is worth the time and trouble to consult an attorney.

Federal Trade Commission Regulation

There are rules and regulations under the Federal Trade Commission Act about which you should be aware. The Federal Trade Commission (FTC) oversees and regulates advertising and marketing in the United States. Section 5 of the Federal Trade Commission Act provides that "unfair or deceptive acts or practices in or affecting commerce, are hereby declared unlawful." A photographer should use care not to enter into contracts that would run afoul of FTC requirements. A few areas that might impact you as a photographer follow. State laws also may contain similar rules and regulations.

The Cooling-Off Rule

The FTC's cooling-off rule gives purchasers the right to cancel a sale made at their home, workplace, dormitory, or at a seller's temporary location like a hotel, convention center, fairground, or the like. The seller must advise a buyer of this right at the time of a sale and give the buyer two copies of a cancellation form containing certain required information—one to keep and one to return in the event of cancellation. The buyer has a three-day right to cancel, and, if he or she does so, the seller has ten days to refund any sums paid or return any check and to notify the buyer when any now-unwanted products transferred to him or her will be picked up. The seller must pick up

any such products within twenty days or agree to pay the buyer for mailing the items back if the buyer will agree to do so.

The rule does not apply to sales made at the home of the buyer if they are under $25; sales made at temporary locations under $130; sales for goods or services not intended primarily for personal, family, or household purposes; sales made entirely online or by mail or telephone; sales made as a result of prior negotiations at the seller's permanent place of business; and in some other situations. Sales of arts and crafts at locations like fairs, malls, or schools are also exempted from the rule.

This rule could apply to sales you might make. You should determine if it applies to a sale you intend to make and comply with the rule if it does.

Advertising, Influencers, and Endorsements

Photographers are often hired to take pictures for social media marketing or other advertisements. FTC rules may apply to how the photographs are taken and how they are used if they are considered an endorsement or they are intended to influence purchasers. Advertising that is false or deceptive is illegal. Truth in advertising rules apply, and endorsements must reflect the honest opinions, findings, beliefs, or experiences of the endorser.

In 2016, it was reported that the department store chain Lord & Taylor agreed to settle with the FTC for deceptive marketing on Instagram. It paid fifty "fashion influencers" up to $4,000 each to post a picture of themselves wearing a paisley dress in the company's inventory, which resulted in the dress selling out quickly. FTC rules were broken, according to the article, as the photographers did not indicate that the photos were in fact paid advertisements.

Section 12 of the Federal Trade Commission Act regulates false or misleading advertising with respect to "food, drugs, devices, or cosmetics." In an American Bar Association article about advertising food products, the author, Timothy Ernst, stated:

> the law requires that photographs, pictures or models used in an advertisement accurately reflect the product being represented. Colors should not be enhanced, product consistency should not be modified, and quantity or concentration of ingredients should not be adjusted so as to make the product appear more attractive in the advertisement. So while it is appropriate to use care and effort to

ensure that a product presents its best face to the cameras, the product should not be manipulated to misrepresent its actual appearance.

As to what constitutes an unfair or deceptive act or practice, in *FTC v. Affiliate Strategies, Inc.*, a 2011 federal district court in Kansas stated:

> To establish an unfair or deceptive act or practice, the FTC must show "that the representations, omissions, or practices likely would mislead consumers, acting reasonably, to their detriment." The Tenth Circuit has explained:
>
> > The primary purpose of § 5 is to lessen the harsh effects of caveat emptor. Such rule can no longer be relied upon as a means of rewarding fraud and deception and has been replaced by a rule which gives to the consumer the right to rely upon representations of facts as the truth. Because the primary purpose of § 5 is to protect the consumer public rather than to punish the wrongdoer, the intent to deceive the consumer is not an element of a § 5 violation. Instead, the "cardinal factor" in determining whether an act or practice is deceptive under § 5 is the likely effect the promoter's handiwork will have on the mind of the ordinary consumer.
>
> In determining whether a claim is deceptive, the Court is not limited to express claims, but may also look to the overall net impression of the promotional statements by the defendant.

Closely examine what it is that you are expected to do once you enter into a contract and avoid agreeing to things that might put you in conflict with FTC rules.

Unconscionable Contracts

The law generally gives the parties involved in a contract complete freedom to contract. Thus, contractual terms that are unfair, unjust, or even ludicrous will generally be enforced if they are legal, but this freedom is not without limits. The parties are not free to make a contract that is *unconscionable*. Unconscionability is an elusive concept, but there are certain guidelines.

A given contract is likely to be considered unconscionable if it is grossly unfair and the parties lack equal bargaining power. Photographers who are

just starting out are typically in a weaker bargaining position than advertising clients or owners of stock photography businesses and might have a better chance of winning a lawsuit claiming that a contract was unconscionable, but the unfairness would need to be quite egregious. This might occur if the photographer signed a magazine's extremely one-sided form contract, which he or she was required to sign, unchanged; was rushed and did not read the contract; and needed to get the work to survive. A court could throw out the contract entirely or strike the unconscionable clauses and enforce the remainder. But be aware—unconscionability is generally used as a defense by someone sued for breach of contract, and the defense is rarely successful, particularly where both parties are businesspeople.

In *Passelaigue v. Getty Images (US), Inc.*, a 2018 federal district court case in New York—the model release case mentioned previously—the model tried to void the photographic release that she signed, claiming that it was unconscionable. She objected to a $500 limitation on damages as well as to the clause prohibiting her from objecting to unflattering or embarrassing uses of her photographs. The court described an unconscionable contract as one that "is so grossly unreasonable as to be unenforceable because of an absence of meaningful choice on the part of one of the parties together with contract terms which are unreasonably favorable to the other party." As the model was unable to prove that her bargaining power, experience, or education was limited, or that she was under duress or pressured to sign it without reading it, and since the release was short and simple, her claim of unconscionability failed, and she was held to the terms of the release.

In *Fotomat Corp. of Florida v. Chanda*, a 1985 case in the Florida Court of Appeals, the issue arose as to whether a photoprocessor's order form, which limited its liability in the event of the loss of film to the film's replacement cost, was unconscionable. The court ruled that it was not. The limitation on liability was reasonable, and the photographer had voluntarily agreed to it.

In *Mieske v. Bartell Drug Co.*, a Supreme Court of Washington case in 1979, a drug store/photoprocessing company destroyed a customer's home movie film and attempted to avoid liability by relying on a receipt, given to the customer at the time the film was accepted, that provided that it assumed no responsibility beyond the retail cost of the film unless there was a written agreement to the contrary. The appellate court agreed that the trial court had properly found the clause to be unconscionable and invalid, as it had considered all of the necessary factors, such as the conspicuousness of the clause,

any prior course of dealings between the parties, any negotiations about the clause, and other similar factors. It mattered to the court that the customer had never read the document, which she thought was only a receipt, and never discussed the clause with the drugstore manager.

These types of cases are resolved by the courts based on the individual circumstances presented, and success in claiming that a clause is unconscionable is more difficult for a professional or business person.

WHAT HAPPENS WHEN THE TERMS OF A CONTRACT ARE DISPUTED OR UNENFORCEABLE?

If the parties disagree about the terms of the contract or whether certain terms are enforceable, a court is required to first determine what was agreed upon, and next decide whether certain terms, if they were agreed upon, should be enforced. Disputes can arise in many areas relating to photography contracts. Only two are discussed here.

Delivery Memorandums

It is a practice of some photographers, and a good idea, to prepare a delivery memorandum when providing images to customers for review or approval, in advance of payment or a specific agreement with respect to use, and to provide the memorandum along with the images. Ordinarily, such memorandums contain clauses saying that the customer will be liable for any loss of, or damage to, the prints or images. Some contain clauses establishing an amount to be paid for lost or damaged prints or images. Some contain restrictions on use, expectations of payment, and other requirements. A number of legal issues, including whether or not the Uniform Commercial Code is applicable to them, can arise with respect to such memorandums.

Courts have ruled differently as to whether such memos are enforceable depending on the circumstances of the cases before them. In *Propet USA, Inc. V. Shugart*, a 2007 federal district court case in Washington State, the court found the terms contained in a photographer's delivery memo to be enforceable and upheld a jury verdict of $303,000 in his favor when his photographs were lost or stolen. The photographer testified that he regularly sent film delivery memos with all of his copyrighted images that limited the use of the images and required that they be returned to him. The defendant argued that there was no evidence that it had agreed to the terms in the memo, so

the court should not find that the earlier oral contract, which did not contain such provisions, had been modified to include them. The court explained that mutual agreement to the terms could be shown through either the words or the conduct of the parties. As the jury heard evidence about the actions of the parties over a number of years, including the fact that the photographer sent a delivery memo with each invoice he sent to the defendant, and the fact that the defendant paid each of the invoices, its verdict in the photographer's favor was supported by the evidence.

The terms included in his delivery memo were used against a photographer in *Senisi v. John Wiley & Sons, Inc.*, a 2015 federal district court case in New York. A photographer sued a textbook publisher for using her photographs in its textbooks, claiming that the publisher had exceeded the license she granted to it. The textbook company insisted that the case should be resolved through arbitration, and not in court, because the invoices for the license provided by the photographer, which contained various clauses including the terms and conditions of the licenses, contained an arbitration clause. The court dismissed the case and sent it to arbitration after rejecting the photographer's argument that the arbitration clause, which she included on her own invoice, was unconscionable.

Courts in other cases have found the terms contained in delivery memos unenforceable. For example, in *Ryan v. Aer Lingus*, a 1994 federal district court case in New York, the court considered the effect of a clause in a letter accompanying transparencies sent by a photographer to an airliner to be considered for a brochure that the airline was having designed. It set a $1,500 price for each lost or damaged transparency and requested that the airline sign and return the letter evidencing its receipt. No one at the airline signed or returned the letter, and 140 transparencies were ultimately lost. The court determined that the clause was not binding on the airline, as the parties did not discuss damages in the event of a loss, let alone the sum the photographer wanted. Because the additional term included in the letter materially altered the original agreement, it was not enforceable. Although the photographer was entitled to damages for the lost transparencies, she was not entitled to $1,500 for each one lost.

Delivery memorandums make sense, but it is a better practice to insist on terms, applicable in the event of acceptance, prior to the delivery of photographs or images.

Promises Implied by Law

Even though a written contract may not contain certain promises on the part of a photographer, courts recognize some implied promises. In *Andreani v. Romeo Photographers & Video Prods.*, a 2007 New York trial court case, the plaintiffs, a couple about to get married, hired a professional photography studio to photograph and videotape their wedding. The plaintiffs were unhappy with the pictures they received, finding them unacceptable and amateurish. They complained that, although 360 pictures were taken, many were duplicates, there were no photos of the bride's family, no special effects shots, no collages, no black-and-white photos, no photos of the groomsmen, and about other failures. The photographer argued that the contract did not provide for special effects, or collages of black-and-white photos, or specify a specific number of photos to be taken. Nevertheless, the court found that the plaintiffs had a case for breach of contract. Although there was no provision in the contract for how the photos were to be taken, the court noted that New York law recognized an implied promise in a contract to perform the contract in a skillful and workmanlike manner and to use the care, skill, and diligence generally used by practitioners in the field. The court found that the photographs were of poor quality, with dark and gray backgrounds and very poor lighting, had distorted colors, and that many were unfocused. The court found that the photographer had breached the contract, as the pictures were not skillfully taken and did not comport with the reasonable standards and practices in the trade of professional photography.

In *Roberto v. Star Photo & Video*, in 2008, another New York trial court case, a bride complained about wedding pictures that had been taken by a photographer. There were no full body shots of the bride and groom, and no shots of the groom with the bridal party, among other things. The court refused to return the bride's money for the photographs. The photography contract provided that "photographers will use their own creative judgment unless otherwise told in writing by client," and the bride had expressed no specific preferences. Although the court found that a few of the 355 photographs that were taken were poorly focused, poorly framed, or generally worthless, it thought that the majority were clear and professional. The photographer performed his duties with the necessary skill and professionalism required and was entitled to the contract price.

WHAT HAPPENS WHEN A CONTRACT IS BREACHED?

When a contract is breached, the principle underlying all remedies for breach of contract is to satisfy the wronged party's expectations. The courts will attempt to place the injured party in the position in which the party would have been had the contract been fully performed. Courts and the legislatures have devised a number of remedies to provide aggrieved parties with the benefit of their bargains. Generally, this will take the form of monetary damages, but where monetary damages fail to solve the problem, the court may order *specific performance.*

Specific performance means that the breaching party is ordered to perform as promised. This remedy is generally reserved for cases in which the contract involves unique goods or property. In photography, a court might specifically enforce a contract to deliver wedding pictures by compelling the photographer to deliver the photographs to the customer, but only if the photographs had already been taken and printed and qualified as goods. A court would not be likely to compel a photographer to shoot a wedding (to perform a service) as a means of satisfying the aggrieved customer. The Thirteenth Amendment of the Constitution prohibits one from being forced to perform labor against one's will. Thus, for breach of a personal service contract, monetary damages are generally awarded. What kind of damages may be awarded and how they are to be determined vary from case to case.

Valuing Damages in Lost Image Cases

Photographs, films, transparencies, and even digital images may be lost due to the fault of a contracting party. Courts have often had to attempt to value such losses in cases brought by photographers and in cases against them. In *Whalen v. Villegas* (also discussed on page 183), a federal district court case in 2013, a couple that contracted to have wedding photos taken asked for damages as a result of the loss of some images when the photographer failed to properly transfer all of the photographs from the memory card in his camera to a computer. The couple wanted the return of the money paid to the photographer in addition to the cost of renting the venue, a limousine, and the significant other expenses that would be required to permit a reshooting of the wedding ceremony. The court did not feel that the couple was entitled to that relief for multiple reasons and posed the question of whether posed wedding photos taken a year and a half later would be worth taking, as the couple would always know that the photographs were not really of the wedding.

The couple was entitled to damages for breach of contract, but not a staged re-creation and reshoot of the wedding.

The court did make note of damages that had been awarded in other New York cases where professional photographers sought compensation when their photographs or slides were irretrievably lost. In such cases, the court explained, a determination of the proper damages amount might include consideration of the cost of reshooting the lost images.

There are various ways in which courts determine the damages a photographer may receive when his or her images are lost. As a first step, the court will attempt to calculate the market value of any photographs that would have been made from the lost or damaged images. Market value is determined by the prior use made of the images, the current price for use of such images, and a number of other factors. Some might have historical importance, and certain subjects are more salable than others. Further, courts may consider the ease or difficulty with which pictures may be retaken.

In 1998, in *Raishevich v. Foster*, a federal district court case in New York, the court stated, with respect to the loss of a collection of photographic transparencies of marijuana plants, that the measure of damages was their market value at the time they were destroyed and their potential for licensing during the life of the copyright on them. Important things to consider were their uniqueness (both subject matter and the cost of replacement) and the photographer's earning potential from their use. Factors bearing on earning potential were whether there had been past earnings from the transparencies, the expertise and reputation of the photographer, the market demand for the photos, the extent and nature of the photographer's efforts to exploit their value, and potential competition or alternate sources for similar photographs. After that analysis, the court determined that the photographer was entitled to $24,000 in damages as a result of the destruction of 347 transparencies that occurred when the government arrested him and seized the transparencies and they were destroyed in police custody.

The Second Circuit Court of Appeals, in 2007, in *Grace v. Corbis-Sygma*, suggested a methodology for determining damages in a case where a photographer's agent failed to return photographs to him, explaining that other methodologies might also be appropriate. It stated that the New York rule for valuing lost photographs depended on the uniqueness of the images and the photographer's earning potential. It suggested that the trial court first determine the number of lost images and then take that number and divide it by

the total number of the images delivered to the agent. The resulting percentage could then be multiplied by the highest earnings the photographer had received in a year during the time the agent had the images. Next, the trial court could determine the number of years the lost photographs would have commercial value and multiply that number by the annual earning potential. Then the present value of the earning stream could be calculated.

There are certainly a myriad of ways by which the value of lost images may be determined and a host of factors to consider when doing so, but hopefully, in this digital age, the loss of images resulting from entrusting them to others is less likely to arise than in the past.

Liquidated Damages

Cases involving damages estimates set in delivery memos, before a loss, have been discussed previously. Similar damage provisions, known as liquidated damage provisions, have arisen in other cases. *Photography by Brett Mathews, Inc. v. Solomon*, a 2013 New York case, involved a clause in a photography contract that provided for the full outstanding balance due under a contract to photograph a wedding if the customer canceled within six months of the event. The court explained that a liquidated damages provision is an estimate, made by parties at the time they enter into an agreement, of the extent of injury that would likely be sustained as a result of a breach of contract. Such clauses will be enforced if the sum bears a reasonable relationship to the probable loss that would occur when the actual loss would be hard or impossible to estimate. The court found that the clause was not enforceable. It was unreasonable, as the actual damages would only be the profit to be made if the contract were performed—that is, the contract price less the photographer's expenses.

In *Baker v. International Record Syndicate, Inc.*, a Texas court of appeals case in 1991, the court upheld a liquidated damages clause in favor of a photographer who took pictures of a musical group for a record syndicate. Photographic chromes were returned to him damaged. A provision printed on the photographer's invoice stated: "reimbursement for loss or damage shall be determined by a photograph's reasonable value which shall be no less than $ 1,500 per transparency." The following evidence convinced the court that valuing the worth of a photograph is extremely difficult:

Baker testified that he had been paid as much as $14,000 for a photo session, which resulted in twenty-four photographs, and that several

of these photographs had also been resold. Baker further testified that he had received as little as $125 for a single photograph. Baker also testified he once sold a photograph for $500. Subsequently, he sold reproductions of the same photograph three additional times at various prices; the total income from this one photo was $1,500. This particular photo was taken in 1986 and was still producing income in 1990. Baker demonstrated, therefore, that an accurate determination of the damages from the loss of a single photograph is virtually impossible.

Because of this, and because the amount was not unreasonable, the court found that the liquidated damages provision was enforceable and allowed the photographer to collect the amount set in the contract.

You may wish to insert a *liquidated damages* clause in your contracts. Such a clause should provide that, because of the difficulty in ascertaining actual damages, the parties have agreed on a per item value and that the specified value is reasonable. It would also be helpful to state that the photographer would not sell the rights to any of the items for less than the stated amount.

Damages for Sentimental Value of Lost or Unprofessional Photographs

The answer to whether courts will award damages for sentimental value or mental anguish for lost or unprofessional photographs is generally no—with some exceptions. In 1976, in the Court of Appeals for Louisiana, in *Grather v. Tipery Studios, Inc.*, the court allowed an award of general damages "for mental anguish and embarrassment" when it found wedding photographs were "of less than professional quality," depriving the wedding couple of the full enjoyment of their wedding and reception.

On the other hand, in *Carpel v. Saget Studios, Inc.* (also discussed on page 183), a federal district court case in Pennsylvania, in 1971, a married couple sued a studio that failed to deliver photographs of their wedding. The court stated that, because there was not a market or replacement value for such photographs, the only arguable measure of damages was the estimated cost to restage and reshoot the wedding, which would have amounted to less than the amount that had to be reached for the court to have jurisdiction to hear the matter. Since lost sentimental value was too speculative an issue to go

to a jury, and since mental suffering was not permitted as damages under Pennsylvania law, their case was dismissed.

Other courts have awarded damages that appear to be of that sort while at the same time stating that they are not damages for sentimental value or mental anguish. In 2008, in *Edmonds v. United States*, a federal district court for the District of Columbia discussed the value of a lost photo when an employee of the FBI was terminated and she was not permitted to retrieve her personal property, including family photos, from her job site. The court noted that when property is lost, generally, a court must determine the fair market value of the property at the time of loss. The court adopted another rule that was reached, it said, in a majority of jurisdictions, applicable if the item is something like a family portrait that cannot be replaced—in such cases the owner should be compensated for the "special value" to him or her, not including "sentimental" value. After consideration of a number of factors, the court awarded the employee $5,005.00 for the loss, as certain photos of her father had special significance to her. The court did not explain how "sentimental value" and "special value" were different.

In 1996, the Supreme Court of Alaska, in *Landers v. Municipality of Anchorage*, examined a case where the plaintiff sued a city for the loss of family photographs and videotapes when it disposed of them in connection with a criminal case involving a marijuana growing operation. The trial court had instructed the jury that it could award the fair market value of the property, but not "sentimental, emotional, or fanciful value." The jury returned a minuscule verdict for the plaintiff. On appeal, the court found that the trial judge had applied the wrong standard for evaluating damages. It summarized what it believed were the three different standards for evaluating damages for lost property that were applied by courts at that time. First was fair market value. Second, the court recognized that some courts allowed a value-to-the-owner standard when the lost property had no market value or when the value to the owner was more than any market value. That value, the court explained, was the "actual monetary loss" to the owner not including any "sentimental or fanciful" value—such things as "the cost of replacement, original cost, and cost to reproduce." That would mean, in that particular case, the cost of purchasing and developing film for the photographs, in addition to the cost of purchasing blank videotapes. The third standard, which the court described as a minority view, was that sentimental value could be considered in calculating damages. The court adopted the

value-to-the-owner standard so that damages would not be based on consid-
erations that were difficult to measure.

Whether or not a plaintiff may recover for the sentimental value for
the loss of photographs may depend on whether the case in which they are
sought is a contract case or a tort (civil wrong, such as negligence) case. In
Bond v. A.H. Belo Corp., a Texas appellate court case, in 1980, the court
reversed the lower court's judgment, which awarded an injured party only
what was determined to be the "actual" value of certain family papers and
photographs lost while in the possession of a writer who planned to write an
article about that party. The case was brought under a tort theory, alleging
negligence on the part of the writer. No contract was involved. The court
ruled that the correct measure of damages was "the reasonable special value
of such articles to their owner taking into consideration the feelings of the
owner for such property."

In another case brought under a tort theory, *Ahrens v. Stalzer*, a 2004
New York federal district court case, a family was even awarded $100,000 in
punitive damages (a sum meant to punish rather than to compensate) and
compensatory damages when the defendant stole six family photo albums
and intentionally and maliciously destroyed four of them.

THE ASSIGNMENT AGREEMENT

Whenever you contract with a client for an assignment, whether it is a one-
time shoot or a long-term assignment, there is always the possibility that
someone will change his or her mind or that circumstances will change such
that you, as the photographer, are left with no assignment, having already
perhaps incurred some expense in preparation. In order to protect yourself
against this happening, it is best to enter into an assignment agreement that
details the consequences for either party's breach:

- First, be sure to be clear on how you expect to be paid, i.e.,
 whether it is per day or per photograph, and detail the time at
 which payment is to be made.
- You should include clauses on travel, preparation, and weather
 days. It is often considered standard practice and may be
 acceptable to receive one-half your standard fee for travel
 and weather cancellations.

- If you are being paid per day, specify how overtime is to be considered—whether by the week or by the day. This is especially important if you are going to be expected to put in long days.

- You should also predetermine whose responsibility it is to rent the space you will be using, if space is rented, and who is to pay for it.

- Include the amount of expenses you are anticipating, along with an ability to exceed the budget by 10 percent without prior approval. This will protect you in the event of unanticipated overages.

- The contract should, of course, specify the number and size of photographs requested, as well as a brief description of their content.

- A cancellation policy will most likely vary according to the type of assignment. If it is possible to schedule a reshoot in the near future that will not interfere with the result or your schedule, you may decide to waive a cancellation charge, providing your client gives you reasonable notice. However, if you do not get fair notice, try to provide for one-half fees, along with an additional one-half fee plus expenses for any reshoot if this is a reasonable estimate of the damage you would sustain as a result of a cancellation and reshoot. This is an area in which you will most likely need to rely on all of your tact and negotiating skills when dealing with your client.

- If you are presented with a contract by your client, read it carefully to determine whether it states that the work is a "work made for hire." If so, the copyright in the work will belong to the client, not to you. Any assignment contract should explicitly state that the copyright in the work belongs to you or that rights not granted to the customer are reserved to you.

- Ownership of the original images should also be discussed. Will the client receive the original images or only be given a license of limited permission to reproduce the images?

- You should require your client to obtain any necessary releases and to indemnify you for any costs you incur as a result of the client's not doing so.
- Depending on how the photograph is to be used, you may also wish to specify the credit line, if any, to be used when the images are published.

Stock Photography

Many photographers are successful in selling their own work, either directly to clients or to intermediaries, such as galleries. Other photographers are employed on a regular basis—for example, as staff photographers for newspapers. A third group of photographers are independent and depend on stock photography vendors to make their work available to the largest possible number of potential buyers.

These days, those who want to locate an image to use for one purpose or another go through an online photograph and video archive. Stock agencies maintain large banks of photographs classified by subject. Now searches by keyword, type of image, number of people, image format, and other factors can be conducted online and high-resolution images transferred over the Internet.

Getty Images (www.gettyimages.com) and Alamy (www.alamy.com) are what are known as *macrostock* agencies. They sell photographs from professionals at high rates. Most macrostock sites have a very stringent vetting process for photographers, requiring, for example, that the photographer complete a profile, pass a test about the site's guidelines, and provide superior sample photographs.

Microstock agencies, such as iStockphoto (www.istockphoto.com), Shutterstock (www.shutterstock.com), Fotolia (www.fotolia.com), Dreamstime (www.dreamstime.com), and Deposit Photos (www.depositphotos.com), sell images at much lower rates (the photographer generally gets some percentage of the price per download) and typically accept images from amateurs and professionals alike, although not all submissions are accepted. There are a multitude of such sites. You can find helpful reviews of the various companies' prices and policies in many places on the Internet.

Many photographers believe that the availability of such a large pool of photography for purchase, much of which is often quite inexpensive, has led

to a decrease in the prices they can get for their work. Some photographers make only enough income to pay for their camera equipment, but others can and do make significant income from participating in stock photography.

In fact, in *Groobert v. President and Directors of Georgetown College*, a 2002 wrongful death case in the federal district court for the District of Columbia, the court considered the issue of what a photographer would have made had she worked full-time in the stock photograph industry. She had previously specialized in various forms of photography, including portraits, assignments, and stock photography. She took some time off when she had a child, but, before she died, she had plans to go back to work full-time pursuing only stock photography. The court had to decide if it would permit the testimony of expert witnesses for the spouse of the deceased photographer, as the defendant argued that their opinions were not reliable and should not be allowed. The court decided to permit their testimony, which was based on their experience in, and knowledge of, stock photography. The experts for the photographer's spouse claimed she would have made $250,000 a year within three to four years, ultimately earning between $250,000 to $400,000 a year before expenses. One defense expert testified that she would make only $90,000 per year, and another testified that she would make only $60,000 per year. The court ruled that the experts could present their opinions, and the basis for their opinions, to the jury.

Photographers retain copyrights on their work when submitting it to stock agencies. The photos are to be licensed for use by purchasers, but not sold. Buyers may not resell the images or claim ownership of them.

Some sites or agencies require photographers to deal with them exclusively, prohibiting photographers from submitting images to other stock sites. Some sites permit photographers to determine whether they wish to establish an exclusive arrangement or not. An exclusive arrangement generally means more money to the photographer but reduces the number of marketing avenues available to the photographer. An agreement being exclusive or nonexclusive may determine whether or not the agency has the ability to bring a lawsuit for infringement of a copyright.

In *DRK Photo v. McGraw-Hill Global Educ. Holdings, LLC*, a 2017 Ninth Circuit Court of Appeals case, the court held that a stock photography agency could not sue for copyright infringement when a licensee exceeded the rights granted to it by the license. As a nonexclusive licensing agent for the photographs at issue, it failed to demonstrate enough of an interest in

the photographs that would permit it to sue. If the agreement between the agency and the photographer who had shot the images had been a different kind of representation agreement, one that gave the agency an exclusive right to license the photographs, the result would have been different. An agency was permitted to sue in *Minden Pictures, Inc. v. John Wiley & Sons, Inc.*, a 2015 Ninth Circuit Court of Appeals case, where the agreement between photographers and the agency included appointing the agency "as sole and exclusive agent and representative with respect to the Licensing of any and all uses" of certain photographs that were the subject of an infringement suit, even though the photographer retained some rights in the photographs. The Second Circuit Court of Appeals, in 2018, in *John Wiley & Sons, Inc. v. DRK Photo,* drew the same distinction and adopted the same rule.

Many photographers prefer to place their work with more than one stock agency when they have nonexclusive agreements. However, enough legal problems have resulted from this practice that many advise photographers to shoot slightly different views of important subjects when selling to different agencies.

Different agencies pay photographers different percentages of sales and calculate the basis for payment in different ways.

CONTRACTING WITH A STOCK VENDOR

Most agencies will require a written agreement before dealing with a photographer. Such an agreement is likely to be a "click-through" agreement accessed online. Agreements can vary greatly, so be sure to carefully and thoroughly review the contracts. Some agencies may require exclusivity, so be sure you are clear on what it is to which you are agreeing. Most agencies require captions and keywords, and model or property releases are generally necessary if the image is not for *editorial* (a true representation that is not advertising or an endorsement) use.

There are two basic types of licensing agreements: *rights-managed* agreements and *royalty-free* agreements.

Rights-Managed Licensing

Rights-managed licensing involves negotiation of separate licenses for uses of images. A license is given for specific types of use—such as whether the image will be used for advertising or for news, and whether it will be in magazines

or on billboards or will be otherwise distributed. Pricing is based on factors such as the type of use, size, placement, duration of use, geographical distribution of use, and whether the purchaser wishes to buy the exclusive use of the image. Purchasers may want to pay an additional sum so they may be confident that they will not see the same image in a competitor's advertisement. This is the traditional form of licensing, whereas royalty-free licensing (discussed below) is relatively new.

Many photographers prefer to license their work under a rights-managed model, since the photographer retains more control over how the images are used. This model is most often used by macrostock agencies working with better-known photographers.

Royalty-Free Licensing

Buyers of royalty-free stock photography generally pay once and are licensed to use an image multiple times for multiple purposes, although there are certain restricted uses. While there is generally no time limit on when the buyer can use the photograph, there is also no exclusivity, and the image may be sold by the photographer or agency to other buyers. Microstock agencies generally use this model of licensing. Pricing for royalty-free images is generally based on the file size. Frequently, buyers purchase a subscription for royalty-free stock photos.

Professional photographers, whether experienced or not, are likely to become involved at some point with online stock vendors. You should pay attention to the ever-changing landscape of this dynamic marketing vehicle. Compare the terms and conditions offered by the different companies and be sure to read carefully and understand any contract that you sign.

The Photographer's Estate

Awareness of estate planning issues can be especially important to photographers. Proper planning ensures that the ownership of his or her photographic images, and his or her intellectual property rights to them after his or her death, will end up in safe and knowledgeable hands. A carefully drafted estate plan affords the opportunity to direct distribution of these items. For example, a photographer who wants to donate certain items to a library or university, but only if certain conditions are adhered to, can specify these conditions in the legal documents that constitute his or her estate plan.

In addition to giving the photographer significant posthumous control over his or her work and associated property rights, an estate plan can greatly reduce the overall amount of estate tax paid at death. Because valuations of photographic images and the ownership rights in them, for estate tax purposes, are not precise, estate taxes may turn out to be significantly higher than might have been anticipated. It is very important for photographers to reduce their taxable estate as much as possible.

An estate plan may be generally either will-based or trust-based. Each type has advantages, but both are legitimate forms of estate planning. Estate laws and probate procedures vary throughout the United States, and a plan that works well for one person in one state may be inappropriate in other situations. Proper estate planning requires a knowledgeable lawyer and often the assistance of other professionals, such as life insurance agents, accountants, and trust officers, depending on the nature and size of the estate.

THE WILL

A *will* is a legal instrument by which a person directs the distribution of property in his or her estate upon death. The maker of the will is called the

testator. Gifts given by a will are referred to as *bequests* or *devises* generally based on the state in which you live. Certain formalities are required by state law to create a valid will. Most states require that the instrument be in writing and signed by the testator in the presence of two or more witnesses. In these states, the witnesses swear, by their signatures, that the testator declared the will to be genuine and signed it in their presence. Some of these and other states permit unwitnessed wills, known as *holographic wills,* if they are entirely handwritten and signed by the testator.

When carefully prepared, wills not only address how the assets of the estate will be distributed, but can also ensure better management of the assets. Those persons responsible for administering an estate are known as *executors* in some states and *personal representatives* in others. It may be a good idea for photographers to appoint joint executors so that one has experience with the technical and industry issues of photography and the other has business or financial expertise. In this way, the financial decisions can have the benefit of at least two perspectives. If joint executors are used, it will be necessary to make some provision in the will for resolving any deadlock between them. It is also advisable to define the scope of the executor's power by detailed instructions.

A lawyer's help generally will be necessary to set forth all of these important considerations in legally enforceable, unambiguous terms. It is essential to avoid careless language that might be subject to attack by survivors unhappy with the will's provisions. For example, in *In Re Estate of Ramer*, a 1995 probate court case in Pennsylvania, the court had to attempt to determine whom a well-known local photographer meant by the phrase "my surviving relatives," in his handwritten will. As the clause was not defined in the will, the court had little choice but to apply the statutory definition for "heirs" and "next of kin" in the Pennsylvania probate laws, which was those who would take the photographer's property under state law if he did not have a will, even though the court recognized that that might not have been what the photographer wanted to do with his property.

A will is a unique document in two respects. First, if properly drafted, it is *ambulatory,* meaning it can accommodate change, such as applying to property acquired after the will is made. Second, it is revocable.

Revocation

A will is *revocable,* meaning that the testator has the power to change or cancel it before death. Even if a testator makes a legally enforceable agreement

not to revoke the will, he or she still has the power to revoke it, although he or she could be liable for breach of contract. Generally, courts do not consider a will to have been revoked unless it can be clearly shown that the testator either:

- performed a physical act of revocation, such as burning or tearing up a will, with the intent to revoke it; or
- executed a valid superseding will that revokes the earlier one.

Most state statutes also provide for automatic revocation of a will in whole or in part if the testator subsequently divorces. To change a will, the testator may execute a supplement, known as a *codicil,* which has the same formal require-ments as those for creating a will. To the extent that the codicil contradicts the earlier will, those contradictory parts of the earlier will are revoked. A testator may also execute a completely new will that takes the place of the old one.

Distributions

There is a certain order in which matters proceed when the property in an estate is distributed under a will. Before the property can go to those entitled to it, all outstanding debts and taxes owed by the testator must be paid. When they have been paid, and what is left is insufficient to satisfy all the bequests in the will, some or all of the bequests must be reduced or even eliminated entirely. The process of reducing or eliminating bequests is known as *abate-ment.* The priorities for reduction are set according to the category of each bequest. The ones at the top of the list are paid first.

The legally significant categories of gifts are generally as follows:

- specific bequests or devises, meaning gifts of a particular kind or uniquely identifiable items (*I give to X all the framed photo-graphs in my home*);
- demonstrative bequests or devises, meaning gifts that are to be paid out of a specified source, unless that source contains insufficient funds, in which case the gifts will be paid out of the general assets (*I give to Y $1,000 to be paid from my shares of stock in ABC Corporation*);
- general bequests, meaning gifts payable out of the general assets of an estate (*I give Z $1,000*); and

- residuary bequests or devises, meaning gifts of whatever is left in the estate after all other gifts and expenses are satisfied (*I give the rest, residue, and remainder of my estate to X*).

These rules and others must be kept in mind when a will is prepared, and a reasonable estimate of the assets that may be included in an estate at the time of the testator's death should be made. If assets are insufficient to cover all of the bequests under a will, the parties whom the testator particularly wishes to benefit may be left in the cold.

INTESTATE DISTRIBUTIONS

When a person dies without leaving a valid will, this is known as dying *intestate*. When a person dies intestate, his or her property is distributed according to state laws of intestate succession, which specify who is entitled to which parts of the estate. These rules vary from state to state. An intestate's surviving spouse will always receive a share, generally at least one third of the estate, most often more. An intestate's surviving children likewise may get a share, in some states depending on whether the children were children of the surviving spouse or of a former spouse. If some children do not survive the intestate, the grandchildren of the intestate may be entitled to a share by *representation*. Representation allows the surviving children of a deceased parent to stand in the shoes that parent, generally dividing the deceased parent's share equally.

If there are no direct descendants surviving, the intestate's surviving spouse may take the entire estate or may share it with the intestate's parents. If there is neither a surviving spouse nor any surviving direct descendants, the estate may be distributed to the intestate's parents, or if the parents are not surviving, to the intestate's brothers and sisters. If there are no surviving persons in any of these categories, the estate may go to surviving grandparents and their direct descendants. In this way, the family tree is constantly expanded in search of surviving relatives. If none of the persons specified in the law of intestate succession survive the decedent, the intestate's property ultimately goes to the state. This is known as *escheat*.

These rules vary from state to state. A good estate plan will avoid a situation where the state, rather than you, determines who will inherit your property.

DISTRIBUTIONS TO A SPOUSE LEFT OUT OF THE WILL

State law will often provide a testator's surviving spouse with certain benefits from the estate even if the spouse is left out of the testator's will. Historically, these benefits were known as *dower*, in the case of a surviving wife, or *curtesy*, in the case of a surviving husband. In place of the old dower and curtesy, modern statutes give the surviving spouse the right to elect against the will and receive a certain share, such as one-fourth of the estate. This is generally called the spouse's *elective share*.

Here again, state laws vary. For example, in some states, the surviving spouse's elective share is one third. The historical concepts of dower and curtesy are, in large part, a result of the law's traditional recognition of an absolute duty on the part of a husband to provide for his wife. Modern laws are based on the notion that most property in a marriage should be shared because the financial success of either partner is due to the efforts of both.

DISTRIBUTING PROPERTY OUTSIDE THE WILL

Another aspect of estate planning is distributing property outside the will. This can be done by making gifts to individuals during your lifetime (known as *inter vivos gifts*) or by placing the property in *trust* prior to death. Thought should also be given to other methods of transferring property before or after death, such as joint bank accounts that go to the survivor on the death of one of the account owners, or POD (payable on death) or TOD (transfer on death) designations that may be permitted for bank accounts or investment accounts, or through beneficiary elections available for things like retirement accounts. Married people should hold title to real property as *tenants by the entirety*, so that the property passes to the surviving spouse on death without the necessity for probate. Some states, by statute, now allow a TOD deed for real estate. Title to vehicles may be held by "x or y"—instead of by either, individually; or by "x and y," so that the surviving party may hold or dispose of the property without the need for probate or the signature of the other party. Be cognizant of the fact, however, that having joint bank accounts during the life of both parties, or owning vehicles by two parties with the "or" designation while they both live, entitles either party to spend, sell, or otherwise deal with the property without the consent of the other.

The main advantage to distributing property outside of the will is that the property escapes the delays and expense of *probate,* the court procedure by which a will is validated and administered.

Gifts

In order to qualify as an inter vivos gift for tax purposes, a gift must be complete and final. Control is an important issue. For example, if a photographer retains the right to take a gift back, the gift may be found to be testamentary (occurring on death) in nature, even if the right was never exercised. The gift must also be delivered. An actual, physical delivery is best, but a symbolic delivery may suffice if there is strong evidence that the giver intended to make a gift he could not take back. An example of symbolic delivery is when the giver puts something in a safe and gives the intended recipient the only key.

One advantage to making an inter vivos gift is that if the gift appreciates in value between the time the gift is made and the death of the giver, the appreciated value will not be taxed. If the gift were made by will, the added value would be taxable, since the gift would be valued as of the date of death (or six months after). This value difference can represent significant tax savings for photographers who have recently realized fame and whose works are rapidly gaining in value.

Another advantage to making an inter vivos gift is that the giver can take advantage of the yearly exclusion from gift taxes. The general rule is that any gift is taxable to the giver, not the recipient, but fortunately, there are exclusions from the rule. The major exceptions are tuition or medical expenses paid for someone else, and gifts to a spouse, political organization, or charity. There is also an annual exclusion amount that applies on a per recipient basis. In 2018, the yearly exclusion was $15,000 per recipient. For example, if $18,000 worth of gifts were given to an individual in 2018, only $3,000 worth of gifts would actually have been taxable to the giver. Married couples can combine their gifts and claim twice the yearly exclusion per recipient.

Gift Tax Returns

Gift tax returns must be filed by the donor for any year in which gifts made to any one recipient exceed the exclusion amount. It is not mandatory to file returns when a gift is less than the exclusion amount. However, if the value of the gift may become an issue with the IRS, it is a good idea to file a return

anyway. Filing the return starts the three-year statute of limitations running. Once the statute of limitations period has expired, the IRS will be barred from suing for tax it claims is due because the gift was more valuable than the taxpayer said it was. If a taxpayer fails to disclose gifts that should have been included on the return, however, the statute of limitations is extended, and there is no statute of limitations for fraudulent returns filed with the intent to evade tax.

TRUSTS

Another common way to transfer property outside the will is to place the property in a trust that is created prior to death. A trust is simply a legal arrangement by which one person holds certain property for the benefit of another. The person holding the property is the trustee, and those who benefit, or receive the property, are the *beneficiaries.*

To create a valid trust, a photographer must identify the trust property, make a declaration of intent to create the trust, transfer property to the trust (this is often a step that is missed and can create a multitude of problems), and name identifiable beneficiaries. Failure to name a trustee will not defeat the trust, since if no trustee is named, a court will appoint one. The photographer may name himself or herself as trustee, and, if so, segregation of the trust property satisfies the transfer requirement. Trusts can be created by will, in which case they are called *testamentary trusts,* but these will be probated along with the rest of the will. To avoid probate, a person must create a valid inter vivos or living trust.

Generally, in order to qualify as an inter vivos trust, a valid interest in property must be transferred before the death of the trust creator. The creator of the trust is known as the *settlor.* If the settlor fails to name a beneficiary for the trust property or transfer the property to the trustee before death, the trust will likely be considered testamentary. Such a trust will be deemed invalid unless the creator complied with all of the formalities required for making a valid will.

However, a trust will not be considered testamentary simply because the settlor retained significant control over the trust, such as the power to revoke or modify it. If a person makes a deposit in a savings account in his or her own name as trustee for another, for example, but reserves the power to withdraw the money or revoke the trust, the beneficiary is still able to claim the

money in the account upon the death of the depositor provided that the trust has not been revoked. Many states allow the same type of arrangement in authorizing joint bank accounts with "rights of survivorship" or "payable on death" designations as valid will substitutes. Property transferred this way is passed outside the will and need not go through probate.

However, even though such an arrangement escapes probate, the trust property may be counted as part of the settlor's gross estate for tax purposes, since he or she retained significant control over it. Additionally, if a deceased settlor created a revocable trust in order to decrease the elective share of a surviving spouse, the trust will not be enforced in some states. In such cases, the surviving spouse is granted the elective share from both the probate estate and the revocable trust.

Advantages of Using a Trust

The use of trusts in estate planning will, in certain situations, have significant advantages over will-based plans. For example, carefully drafted trusts can avoid probate, which, in some states, is a lengthy and expensive process. Similarly, the execution of a trust-based plan can ensure a level of privacy not possible for wills that must be probated. However, trusts cannot adequately substitute for a will if they are not carefully drafted or if they are used haphazardly. Professional assistance is strongly recommended, and it is important not to miss the step of legally transferring the property to be included in the trust to the trust.

Life Insurance Trusts

Irrevocable life insurance trusts (ILITs) can be used to avoid estate taxes and to provide their beneficiaries with liquid sums to pay estate taxes on other property in the deceased's estate. Federal estate taxes are quite expensive and must be paid in cash, usually within nine months after death. Under the Tax Cuts and Jobs Act of 2017, if you had died in 2018, estate taxes would be due if your net estate exceeded $11.18 million or $22.36 million per couple. The top federal estate tax rate for 2018 is 40 percent. States may have much lower thresholds after which estate taxes are due, and their rates vary. For example, the Washington State estate tax threshold is $2.193 million per person. Oregon has one of the lowest thresholds for 2018 of $1 million per person. New York's was $5.25 million for 2018, and Connecticut's was $2.6 million for 2018.

While the receipt of death benefits from life insurance policies is not subject to income tax, they could be counted as part of your taxable estate for estate tax purposes if they were paid to your estate or if you retained control over them. Properly transferring life insurance policies to a ILIT can remove them from your estate. Their value will not be subject to estate tax if the life insurance trust is irrevocable and the trustee is someone other than the insured.

There are some drawbacks, however:

- Such trusts are irrevocable. You cannot remove your insurance from the trust, although you can surrender it, or it may lapse.
- You cannot change the beneficiary of the policy, amend it, or borrow against it, as you will not be considered the owner of the policy.
- The death benefit is taxable for three years after the transfer if you transfer an existing policy to the trust.
- You may not directly pay the premiums for the policy. You may annually make gifts to the trust (be sure the gifts are under the exempt amount) so that the trust may pay the policy premiums. The trust beneficiaries, however, will be notified that they can withdraw the gift sums within thirty days, but the idea is that they will not withdraw the sums within that time period, and the sums will then be used to pay the policy premiums.
- The establishment of a life insurance trust is a complex legal matter and can be expensive. Whether or not an ILIT accomplishes what you want it to do requires that the necessary documents be properly drafted.
- Care must be taken in naming the trustee of in ILIT. Be sure to select someone who is knowledgeable and can perform the trustee's duties. A professional trustee such as a bank or trust company may be a good choice.

Life insurance trusts can not only avoid estate tax, but they can provide funds to pay estate taxes and other expenses relating to the probate of an estate, so that liquidation of other estate assets to get the money to pay them,

sometimes at fire sale prices, would not be necessary. The proper use of such trusts will allow more of your property to go to your loved ones.

ESTATE TAXES

As was mentioned previously, the 2017 Tax Cut and Jobs Act significantly increased the threshold for federal estate taxes, at least through the end of 2025, unless Congress extends it. While the increase in the federal exclusion amounts will reduce the concerns about estate taxes for many photographers, it is still useful to understand how estate taxes are assessed and the relationship between estate and gift taxes. Remember, state thresholds are often significantly less. It is also important to understand how issues such as valuation of assets can lead to higher-than-necessary tax burdens.

The Gross Estate

The first step in evaluating an estate for tax purposes is to determine the *gross estate*. The gross estate includes all property in which the deceased had an ownership interest at the time of death and before the will is administered. The key element in determining ownership is control. Thus, the gross estate will include all property over which the deceased retained significant control at the time of death. Examples would include real estate, personal property, life insurance proceeds paid to the insured or his or her estate, bank and retirement accounts, annuities, jointly held interests, and revocable transfers.

Under current tax laws, the executor of an estate may elect to value the property in the estate either as of the date of death or the date six months after death. All of the estate property must be valued at the time chosen. If the executor elects to value the estate six months after death and certain pieces of property are distributed or sold before then, that property will be valued as of the actual date of distribution or sale.

Assets are to be valued for estate tax purposes, generally, at their *fair market value*. Fair market value is defined as the price at which property would change hands between a willing buyer and a willing seller, when both buyer and seller have reasonable knowledge of all relevant facts. Such a determination is often very difficult to make, especially when photographic images and the rights associated with them are involved.

Disagreements with the IRS on Value

Although the initial determination of fair market value is generally made by the executor when the estate tax return is filed, the Internal Revenue Service (IRS) may disagree with the executor's valuation and assign assets a much higher fair market value and claim that additional tax is due. Such cases must be settled or litigated. The majority of them are settled out of court. The fair market value of fine photographs with significant artistic merit could certainly be a disputed issue in tax court.

The Estate of David Smith case, a 1975 case in the Second Circuit Court of Appeals, is often cited as an example of the valuation of artistic assets for estate tax purposes. Smith was a sculptor, and the controversy was over the value of his creations. When he died, there were 425 works in his estate. The market for his sculptures was limited, since most pieces were large and abstract, but prior to Smith's death, each of the 425 pieces had been photographed and marked with an estimated sales price. When the executors of the estate figured fair market value of the pieces, they first reduced the figure representing the sum of all the estimated prices ($4,284,000) by 75 percent to account for the devaluing effect that the sudden availability of so many sculptures had on the limited market. They then reduced that figure by one third to account for the gallery's commission, as set out in the agency contract between the deceased and the gallery that had the exclusive right to sell his work. The executors' final figure representing fair market value on the tax return was $714,000. The IRS determined fair market value for the sculptures by simply adding up the one-at-a-time prices in Smith's gallery contract, claiming that the simultaneous availability factor would have no adverse impact on the market value. The IRS, thus, set the total value at $4,284,000 and sued the estate for the tax deficiency.

When the case went to court, the court allowed a 50 percent reduction for sudden availability but refused to deduct the gallery's commission, holding that the measure of value is the amount received, not retained, from a sale. Thus, the court's final figure was $2,700,000—a compromise between the executors' listed value of $714,000 and the IRS figure of more than $4,000,000. Notwithstanding the reduction, the additional tax was devastating for the estate.

Another interesting case was *Mauldin v. Commissioner,* a tax court case in 1973. In *Mauldin*, the IRS claimed a tax deficiency based on disagreement over the value of artistic assets. At question was a series of cartoons and an

original manuscript and sketches donated to the Smithsonian. Mauldin used experts provided by the Smithsonian to arrive at this valuation of the works. The interesting part of this case is that the court ruled that when one government agency (the Smithsonian) makes an appraisal in order to induce a charitable donation, another government agency (the IRS) should not challenge or disregard the appraisal after the contribution has been made.

Again, when a photographer's executor and the Internal Revenue Service disagree as to value of photographic prints or images or the rights associated with them, and the parties cannot negotiate an agreed value, a court will decide the matter. In most cases, the burden will be on the taxpayer to prove the value of the asset. Expert testimony and evidence of sales of the same or similar images will be helpful. Valuation is not a precise science. As a probate court in New York in 1994 stated in attempting to determine the value of the estate of Andy Warhol, which included photographs, drawings, paintings, and prints:

> The value of any art collection is "inherently imprecise and capable of resolution only by a Solomon-like pronouncement." How much is Andy Warhol's art worth? It is difficult, if not foolhardy, to attempt an answer.

With respect to tax deductions for charitable donations and gift and estate taxes, a panel of art experts, known as the Art Advisory Panel of the Commissioner of Internal Revenue, reviews the taxpayers' appraisals for art items with a claimed value of $50,000 or more. The panel may agree with the taxpayer's appraisal or may disagree and suggest a different value. It offers advisory recommendations to the Art Appraisal Services (AAS) division of the IRS. According to a 2017 annual report, the panel accepted the taxpayers' values for only 39 percent of the appraisals submitted to it. The AAS adopted 67 percent of the panel's recommendations.

The Net Estate

The next major step in figuring the taxable estate is to evaluate the *net estate*. Typical deductions from the gross estate include funeral expenses, certain estate administration expenses, debts and enforceable claims against the estate, mortgages and liens, and, perhaps most significant, the marital deduction and the charitable deduction.

The *marital deduction* allows the total value of any interest in property that passes from the decedent to the surviving spouse to be subtracted from the value of the gross estate. The government will eventually collect the tax on this property when the surviving spouse dies, but only to the extent such interest is included in that spouse's gross estate at the time of death. This deduction may occur even in the absence of a will making a gift to the surviving spouse, since state law generally provides that the spouse is entitled to at least one-third of the overall estate, regardless of the provisions of the will.

The *charitable deduction* is the tax deduction allowed when property is transferred from an estate to a recognized charity. In effect, the fair market value of donated items is excluded from the taxable estate. Of course, the same issues with respect to fair market value discussed previously may arise if the IRS and the photographer's executor disagree about the permissible value of a charitable deduction. Since the definition of charity for tax purposes is quite technical, it is advisable to insert a clause in the will providing that, if the institution specified to receive the donation does not qualify for the charitable deduction, the bequest will go to a substitute qualified institution at the choice of the executor.

Once deductions are figured, the remainder—the *taxable estate*—is taxed at the rate specified by the *Unified Estate and Gift Tax Schedule*. The unified tax imposes the same rate of tax on gifts made by will as on gifts made during life. It is a progressive tax, meaning the percent paid in taxes increases with the amount of property involved.

Paying Estate Taxes

Generally, estate taxes must be paid when the estate tax return is filed within nine months of the date of death, although arrangements may be made to spread payments out over a number of years, if necessary.

PROFESSIONAL ESTATE PLANNING

All photographers should give some thought to estate planning and make the effort to address these issues adequately. Without a soundly prepared plan, there is simply no way to control the disposition of your property.

Ansel Adams made careful plans for the disposition of his work, which included both a charitable organization and a profit-making trust. Adams sold his negatives to the Center for Creative Photography (CCP) for a modest

sum. When Adams died in 1984, he left detailed instructions about how his negatives could be used by CCP for educational purposes only. His fine prints and other works he had collected were donated to museums. However, Adams's estate retained the copyrights to exploit his work for the purpose of establishing the Ansel Adams Publishing Rights Trust, which retains control of all publishing, licensing, and reproduction rights. The trustees of this trust also supervise the archives where the negatives are stored. Profits from the trust are split two ways: part goes to support the archives at the CCP, and part goes to the Ansel Adams family trust, which manages the gross estate and personal property.

While you might not have all of the same options that Ansel Adams did for estate planning, you should clarify your wishes for the use of your work and any income that may be derived from it. Who will retain the artistic control over printing, and who will own any copyright or licensing rights? It makes a great deal of sense to consult with an experienced professional to develop a comprehensive plan rather than to rely on form documents. The generally modest added expense associated with professional estate planning will most likely be recouped when the plan is finally executed.

How to Find a Lawyer and an Accountant

Most photographers expect to seek the advice of a lawyer only occasionally for counseling on important matters, such as whether to incorporate their business, the purchase of a new building, or when they have been sued for something like defamation or invasion of privacy. If this is your concept of the attorney's role in your profession, you should reevaluate it. If you are a serious photographer, you should establish a relationship with an attorney before you have a problem. An attorney experienced in intellectual property, art, and photography law should be able to give you important information regarding areas of liability exposure unique to your work, such as portrayal of someone in a false light, invasion of privacy, pornography and obscenity, libel, copyright infringement, issues arising from photographer-customer contracts, and the like. Such an attorney will also be aware of many statutes, both state and federal, applicable to the practice of photography.

Most photographers could avoid problems if they had a relationship with a lawyer more like that between a family doctor and a patient—an ongoing relationship that would allow the attorney to get to know the photographer and his or her business well enough to engage in preventive legal counseling and to assist in planning, making it possible to prevent costly mistakes before they occur. As a photographer, you are no doubt anxious to keep costs down and probably do not relish the idea of paying an attorney to get to know you or your business if you are not involved in an immediate crisis. However, it is a good bet that a visit with a competent lawyer right now will alert you to issues vital to the future success of your operations. There is a good reason why larger, successful businesses employ one or more lawyers full-time as

in-house counsel. Ready access to legal advice is something you should not deny yourself at any time, for any reason.

If you have employees, or use independent contractors, you should also get advice on your legal relationship with them and your obligations toward them, and you should be aware of the issues that can develop with other persons or entities with whom you have business dealings. Each state has its own laws covering certain business practices. Ignorance about critical matters and violations of statutory rules and regulations can result in financially devastating lawsuits and even criminal penalties. A competent local attorney is, therefore, your best source of information on many issues that will arise in your practice of photography and the running of your business. If legal issues arise in other locations, many law firms have attorneys who are licensed in several jurisdictions, and others have relationships with attorneys in other locales.

Most legal problems cost more to solve or defend after they arise than it would have cost to prevent their occurrence in the first place. Litigation is notoriously inefficient and expensive. You do not want to sue or be sued if you can avoid it.

FINDING AND EVALUATING A LAWYER

Photographers should understand that the intellectual property issues inherent in photography (the rights to your images) are specialized and involve legal issues that may be unfamiliar to most general business lawyers. To get legal advice that is specific to the intellectual property issues in your practice of photography, it is recommended that you consult with an attorney with expertise in art and intellectual property law. A good tip is to find out who is in the art and intellectual property law section of the state or local bar association or who has served on special bar committees in this area. Find out if any books or articles have been published, in scholarly journals or publications, discussing areas of legal interest to you. It may also be useful to see if there are articles by attorneys in any photography industry publications in print or on the Internet. You could start by contacting the authors for assistance or recommendations.

While it is true that you may pay more per hour for an expert, you will not have to pay for the attorney's learning time. Experience is valuable. In this regard, you may wish to keep in mind that it is uncommon for a lawyer to specialize in art and intellectual property matters and also in criminal matters.

Thus, if you are faced with a criminal prosecution, you should be searching for an experienced criminal defense lawyer. The advantage of an art and intellectual property attorney is to avoid the need for a criminal attorney.

If you do not know any attorneys, ask other photographers if they could recommend a good one. Finding the lawyer who is right for you may require that you shop around a bit. You may wish to contact one of the state-based lawyers for the arts organizations listed on this website: www.vlaa.org/get-help/other-vlas/. These nonprofit organizations vary in terms of the clientele they are able to serve. For example, some provide referrals only for pro bono clients based on income eligibility, while others serve artists of all income levels. Many of these organizations also offer affordable educational programs on intellectual property and other legal issues; some also offer mediation services that are tailored for the needs of photographers and other artists.

Most local and state bar associations have referral services. Consult the information contained in lists of lawyers online at sites like www.martindale.com, www.lawyers.com, lawyers.findlaw.com, www.legalmatch.com, or other such sites containing lists or ratings of lawyers. The mere fact that an attorney's name does not appear in a database should not be given too much weight. Some lawyers will not be listed there because these listings may be expensive or unwanted. In addition, you should check Yelp, Avvo, Google, or similar Internet information providers for reviews and recommendations.

Many law firms have established websites. The larger firms usually include extensive information about the firm, its practice areas, and its attorneys. The best recommendations, however, are those made by your friends and colleagues who have firsthand experience with a lawyer.

After you have obtained several recommendations for attorneys, it is appropriate for you to talk with them for a short period of time to determine whether you would be comfortable working with them. Do not be afraid to ask about their background, experience, and whether they feel they can help you.

USING A LAWYER

Once you have completed the interview process, select the person who appears to best satisfy your needs. One of the first items you should discuss with your

lawyer is the fee structure. You are entitled to an estimate. However, unless you enter into an agreement to the contrary with the attorney, the estimate is just that—your expense may exceed the estimate depending on the course your problem takes or the difficulty of its resolution. Lawyers generally charge by the hour, though you may be quoted a flat rate for a specific service, such as incorporation or a simple will.

Contact your lawyer whenever you believe a legal question has arisen. Your attorney should aid you in identifying which questions require legal action or advice and which require business decisions. Generally, lawyers will deal only with legal issues, though they may help you to evaluate business problems in a way that will facilitate your decisions.

The attorney-client relationship is such that you should feel comfortable when confiding in your attorney. This person is prohibited from disclosing your confidential communications. A violation of this rule applicable to attorneys, depending on the circumstances, can be considered an ethical breach that could subject the attorney to disbarment or professional sanctions. If you take the time to develop a good working relationship with your attorney, he or she may well prove to be one of your more valuable assets.

FINDING AN ACCOUNTANT

In addition to an attorney, many photographers will need the services of a competent accountant to aid with tax planning, the filing of periodic reports, and annual tax returns. Finding an accountant with whom you are compatible is similar to finding an attorney. You should ask around and learn which accountants are working for other photographers and if the other photographers are satisfied with the services being provided. State professional accounting associations may have referral services or can point you to a directory of accountants in your area. You should interview prospective accountants to determine whether you feel you can work with them and whether you feel their skills will be compatible with your needs.

Like your attorney, your accountant can provide valuable assistance in planning for the future of your business or avocation. It is important to work with professionals you trust and with whom you are able to relate on a professional level.

Books and Resources

The publications below cover some aspects of photography, art, and the law. Note that the Internet is in constant flux and publications are appearing and going out of print with some regularity. Please verify that any publications below are still available and search for new books, magazines, and periodicals online or at your library.

BOOKS

Art Law: Cases and Materials, 2nd ed. (2017)
By Leonard D. DuBoff and Michael D. Murray
Wolters Kluwer
PO Box 990, Frederick MD 21705
WEBSITE: https://lrus.wolterskluwer.com/store

Art Law Deskbook, 3rd ed. Volume One (2017)
By Leonard D. DuBoff, Christy O. King, Michael D. Murray, and James
 A. R. Nafziger
LexisNexis
230 Park Avenue, Suite 7, New York, NY 10017

Art Law Deskbook, 3rd ed. Volume Two (2018)
By Leonard D. DuBoff, Christy O. King, Michael D. Murray, and James
 A. R. Nafziger
LexisNexis
230 Park Avenue, Suite 7, New York, NY 10017

Art Law Deskbook, 3rd ed. Volume Three (2019)
By Leonard D. DuBoff, Christy O. King, Michael D. Murray, and James
 A. R. Nafziger
LexisNexis
230 Park Avenue, Suite 7, New York, NY 10017

Art Law in a Nutshell, 5th ed. (2017)
By Leonard D. DuBoff, Christy A. King, and Michael D. Murray
West Academic Publishing
444 Cedar Street, Suite 700, St. Paul, MN 55101
WEBSITE: www.store.westacademic.com

ASMP Professional Business Practices in Photography, 7th ed. (2008)
Edited by the American Society of Media Photographers
Allworth Press
307 West 36th Street, 11th Floor, New York, NY 10018
WEBSITE: https://www.skyhorsepublishing.com/allworth-press/

Best Business Practices for Photographers, 3rd ed. (2017)
By John Harrington
Rocky Nook
1010 B Street, Suite 350, San Rafael, CA 94901
WEBSITE: https://rockynook.com

Business and Legal Forms for Photographers, 4th ed. (2009)
By Tad Crawford (2009)
Allworth Press, co-published with the American Society of Media
 Photographers
307 West 36th Street, 11th Floor, New York, NY 10018
WEBSITE: https://www.skyhorsepublishing.com/allworth-press/

The Law (in Plain English)® for Collectors (2018)
By Leonard D. DuBoff and Sarah J. Tugman
Allworth Press
307 West 36th Street, 11th Floor, New York, NY 10018
WEBSITE: https://www.skyhorsepublishing.com/allworth-press/

The Law (in Plain English)® for Publishers (2019)
By Leonard D. DuBoff and Amanda Bryan
Allworth Press
307 West 36th Street, 11th Floor, New York, NY 10018
WEBSITE: https://www.skyhorsepublishing.com/allworth-press/

The Law (in Plain English)® for Small Business, 5th ed. (2019)
By Leonard D. DuBoff and Amanda Bryan
Allworth Press
307 West 36th Street, 11th Floor, New York, NY 10018
WEBSITE: https://www.skyhorsepublishing.com/allworth-press/

Legal Handbook for Photographers: The Rights and Liabilities of Making and Selling Images, 4th ed. (2017)
By Bert P. Krages
Amherst Media
PO Box 586, Buffalo, NY 14226
WEBSITE: www.amherstmedia.com

The Photography Law Handbook (2015)
By Steven M. Richman
American Bar Association
321 North Clark Street, Chicago, IL 60654
WEBSITE: https://www.americanbar.org/products/inv/book/138458842/

GOVERNMENT WEBSITES AND PUBLICATIONS

Copyright Registry Online
https://copyrightregistry-online-form.com/

Internal Revenue Service
www.irs.gov/

Small Business Handbook
US Department of Labor (OSHA) Small Business Management Series
WEBSITE: https://www.osha.gov/Publications/smallbusiness/small
 -business.html

US Copyright Office
https://www.copyright.gov

US Small Business Administration
www.sba.gov/

OTHER SOURCES

"The Photographer's Right" (2016)
By Bert P. Krages
WEBSITE: http://www.krages.com/phoright.htm

"The Role of Permission in Photography" (2014)
By Bert P. Krages
WEBSITE: https://www.photovideoedu.com/Learn/Articles/the-role-of-
 permission-in-photography.aspx

To obtain other books on photography and the law, it is recommended that
you try book vendors on the Internet, such as:

Amazon
www.amazon.com

**American Booksellers
 Association**
www.bookweb.org

Barnes & Noble
www.barnesandnoble.com

Books-a-Million
www.booksamillion.com

eBay
www.ebay.com

Powell's Books
www.powells.com

Organizations That Offer Help

PHOTOGRAPHERS' ORGANIZATIONS

Your best source for finding the professional who can help you may be a friend whose needs have been the same as yours. In addition to those sources, consider asking the photography or art department of your local college or university for the names of people or groups who might be of help, but if you are not able to receive a referral this way, you may refer to the chapter on finding a lawyer.

The following are some of the best-known and largest of the photographers' organizations:

In the United States

American Photographic Artists
5042 Wilshire Boulevard, #321, Los Angeles, CA 90036
EMAIL: info@apanational.org
WEBSITE: www.apanational.org

American Society for Photogrammetry and Remote Sensing (ASPRS)
425 Barlow Place, Suite 210, Bethesda, MD 20814–2160
PHONE: 301-493-0290
FAX: 301-493-0208
EMAIL: asprs@asprs.org
WEBSITE: www.asprs.org

American Society of Media Photographers, Inc. (ASMP)
PO Box 31207, Bethesda, MD 20824
MEMBERSHIP AND DUES: PO Box 1810, Traverse City, MI 49685
PHONE: 877-771-2767
FAX: 231-946-6180
EMAIL: ASMP@vpconnections.com
WEBSITE: www.asmp.org

American Society of Photographers
3120 N. Argonne Drive, Milwaukee, WI 53222
PHONE: 414-871-6600
WEBSITE: https://asofp.com

BioCommunications Association (BCA)
220 Southwind Lane, Hillsborough, NC 27278–7907
PHONE: 919-245-0906
EMAIL: office@bca.org
WEBSITE: www.bca.org

Boston Press Photographers Association (BPPA)
EMAIL: info@bppa.net
WEBSITE: www.bppa.net

Commercial Industrial Photographers of New England (CIPNE)
PO Box 124, Tewksbury, MA 01876
EMAIL: mail@cipne.org
WEBSITE: www.cipne.org

Connecticut Fire Photographers Association
PO Box 1181, Hartford, CT 06143–1181
EMAIL: CTFirePhoto@gmail.com
WEBSITE: www.ctfirephoto.org

Evidence Photographers International Council, Inc. (EPIC)
229 Peachtree Street NE 2200, Atlanta, GA 30303
PHONE: 866-868-3742
FAX: 404-614-6406
EMAIL: csc@evidencephotographers.com

Florida Professional Photographers, Inc.
13804 Lake Village Place, Tampa, FL 33618
PHONE: 813-760-1933
EMAIL: fpp1933@gmail.com
WEBSITE: www.fpponline.org

Graphic Artists Guild
31 W. 34th Street, 8th Floor, New York, NY 10001
PHONE: 212-791-3400
EMAIL: admin@graphicartistsguild.com
WEBSITE: www.graphicartistsguild.org

Gravure Association of the Americas
PO Box 25617, Rochester, NY 14625
PHONE: 201-523-6042
FAX: 201-523-6048
EMAIL: gaa@gaa.org
WEBSITE: www.gaa.org

Houston Center for Photography
1441 West Alabama, Houston, TX 77006
PHONE: 713-529-4755
FAX: 713-529-9248
EMAIL: info@hcponline.org
WEBSITE: www.hcponline.org

Illinois Press Photographers Association (IPPA)
2638 N. Troy Street, Unit 1, Chicago, IL 60647
PHONE: 217-245-4178
EMAIL: mailippa@gmail.com
WEBSITE: www.ippaonline.org

The Imaging Alliance – Photo Marketing Alliance
7600 Jericho Turnpike, Suite 301, Woodbury, NY 11797
PHONE: 516-802-0895
FAX: 516-364-0140
WEBSITE: www.theimagingalliance.com

Indiana News Photographers Association
WEBSITE: www.indiananewsphotographers.org
TWITTER: @indianaphotoj

International Alliance of Theatrical Stage Employees (IATSE)
General Office, 207 W. 25th Street, 4th Floor, New York, NY 10001
PHONE: 212-730-1770
FAX: 212-730-7809
West Coast Office, 10045 Riverside Drive, Toluca Lake, CA 91602
PHONE: 818-980-3499
FAX: 818-980-3496
WEBSITE: www.iatse.net

International Association of Panoramic Photographers (IAPP)
Church Street Station, PO Box 3371, New York, NY 10008
WEBSITE: www.panoramicassociation.org

Inter-Society Color Council
7820B Wormans Mill Road, Suite 115, Frederick, MD 21701
EMAIL: iscc@iscc.org
WEBSITE: www.iscc.org

National Association of Government Communicators
400 South 4th Street, Suite 754e, Minneapolis, MN 55415
PHONE: 888-285-8556
EMAIL: info@nagc.com
WEBSITE: www.nagc.com

National Press Photographers Association (NPPA)
120 Hooper Street, Athens, GA 30602
WEBSITE: www.nppa.org

New Jersey Press Photographers Association (NJPPA)
WEBSITE: www.njppa.org

New York Press Photographers Association (NYPPA)
Church Street Station, PO Box 3346, New York, NY 10008
PHONE: 212-889-6633
FAX: 212-889-6634
EMAIL: office@nyppa.org
WEBSITE: www.nyppa.org

Ohio News Media Association
1335 Dublin Road, Suite 216B, Columbus, OH 43215
PHONE: 614-486-6677
FAX: 614-486-6373
WEBSITE: www.ohionews.org

Oklahoma Press Association
Attn: Photography
3601 North Lincoln Boulevard, Oklahoma City, OK 73105
PHONE: 405-499-0020
PHONE (TOLL-FREE): 888-815-2672
WEBSITE: www.okpress.com

Ophthalmic Photographers Society
1887 West Ranch Road, Nixa, MO 65714
PHONE: 417-725-0180
FAX: 417-724-8450
EMAIL: ops@opsweb.org
WEBSITE: www.opsweb.org

Photo Marketing Association International
1717 Pennsylvania Avenue NW, Suite 1025, Washington, DC 2006
PHONE: 202-559-9044
FACEBOOK: https://facebook.com/photomarketingassociation
WEBSITE: www.pmai.org

Photographic Historical Society
PO Box 10342, Rochester, NY 14610
EMAIL: tphs@rochester.rr.com
WEBSITE: www.tphs.org

Photographic Society of America
8241 S. Walker Avenue, Suite 104, Oklahoma City, OK 73139
PHONE: 405-843-1437
PHONE (TOLL-FREE): 888-772-4636
WEBSITE: www.psa-photo.org

Press Photographers Association of Greater Los Angeles
501 W. Glenoaks, #655, Glendale, CA 91202
WEBSITE: www.ppagla.org

Professional Photographers of America (PPA)
229 Peachtree Street, NE, Suite 2200, Atlanta, GA 30303
PHONE: 404-522-8600
PHONE (TOLL-FREE): 800-786-6277
EMAIL: csc@ppa.com
WEBSITE: www.ppa.com

Professional Photographers of Greater Bay Area, Inc. (PPGBA)
PO Box 5583, San Mateo, CA 94402
WEBSITE: www.ppgba.org

Society for Photographic Education
2530 Superior Avenue E, Suite 407, Cleveland, OH 44114
PHONE: 216-622-2733
FAX: 216-622-2712
EMAIL: membership@spenational.org
WEBSITE: www.spenational.org

Society of Motion Picture and Television Engineers (SMPTE)
White Plains Plaza, 445 Hamilton Avenue, Suite 601, White Plains, NY 10601
PHONE: 914-761-1100
FAX: 914-206-4216
WEBSITE: www.smpte.org

Society of Photo Technologists
11112 Spotted Road, Cheney, WA 99004
PHONE: 509-710-4464
WEBSITE: www.spt.info

SPIE (International Society for Optics and Photonics)
PO Box 10, Bellingham, WA 98227
PHONE: 360-676-3290
PHONE (TOLL-FREE): 888-504-8171
FAX: 360-647-1445
EMAIL: customerservice@spie.org
WEBSITE: www.spie.org

University Photographers Association of America
Auburn University Photographic Services, PO Box 433, Califon, NJ 07830
PHONE: 732-754-0609
WEBSITE: www.upaa.org

White House News Photographers Association
WEBSITE: www.whnpa.org

Wisconsin Professional Photographers Association
WEBSITE: www.wppa-online.com

Outside the United States
Canadian Association of Photographers and Illustrators
60 Atlantic Avenue, Suite 200, Toronto, Ontario, Canada M6K 1X9
PHONE: 416-462-3677
PHONE (TOLL-FREE): 888-252-2742
EMAIL: info@capic.org
WEBSITE: www.capic.org

International Alliance of Theatrical Stage Employees (IATSE)
Canadian Office, 22 St. Joseph Street, Toronto, Ontario, Canada M4Y 1J9
PHONE: 416-362-3569
FAX: 416-362-3483
WEBSITE: www.iatse.net

Professional Photographers of Canada
209 Light Street, Woodstock, Ontario, Canada N45 6H6
EMAIL: info@ppoc.ca
WEBSITE: www.ppoc.ca

Royal Photographic Society
Fenton House, 122 Wells Road, Bath, England, United Kingdom BA2 3AH
PHONE: 44 (0)1225–325733
EMAIL: reception@rps.org
WEBSITE: www.rps.org

Société Française de Photographie
71 rue de Richelieu, Paris, France 75002
PHONE: 33-(0)1-42-60-05-98
WEBSITE: www.sfp.asso.fr

OTHER ORGANIZATIONS

Federal Trade Commission
WEBSITE: www.ftc.gov

Library of Congress
WEBSITE: www.loc.gov

National Institute of Occupational Safety & Health
WEBSITE: www.cdc.gov/niosh/index.htm

PLUS Coalition
EMAIL: info@useplus.org
WEBSITE: www.useplus.org

Small Business Administration (SBA)
WEBSITE: www.sba.gov

United States Copyright Office
WEBSITE: https://copyright.gov

United States Department of Labor
WEBSITE: www.dol.gov

United States Department of Labor—Occupational Safety and Health Administration
WEBSITE: www.osha.gov

Volunteer Lawyers and Accountants for the Arts
WEBSITE: www.vlaa.org/get-help/other-vlas/

About the Authors

Leonard D. DuBoff is an art lover and enthusiast with over thirty years' experience studying, teaching, writing, and breathing art and crafts law. Known as one of the leading authorities on art law, DuBoff's works are frequently referenced by judges, lawyers, and anyone interested in knowing about the law in this field. He has served on numerous advisory boards and received several accolades for his work and devotion, including the Oregon Governor's Art Award.

DuBoff began his renowned career teaching law at Stanford Law School. He then taught as a Professor of Law at Lewis & Clark College in Portland, Oregon, for more than twenty-three years. In addition to teaching such courses as "The Law and the Arts," DuBoff served "of counsel" to three Portland area law firms before founding the DuBoff Law Group. DuBoff is licensed to practice in both New York and Oregon, as well as admitted to over fifteen federal courts—including the United States Customs Court, the United States Court of International Trade, and the United States Supreme Court. His major practice areas include art law, crafts law, international law, copyright and trademark law, and business law. DuBoff's influence is immense. He is the author of over fifteen books directly related to art, crafts, galleries, photographers, and publishing, as well as countless articles on the subject. In addition to authoring *The Antique and Art Collector's Legal Guide*, DuBoff is a frequent contributor to *Art Trends Magazine, Communication Arts, Glass Craftsman, Picture Magazine, Woodshop News,* and *Critical Issues.*

DuBoff shares his passion for art with his wife and three children. He currently lives in Portland, Oregon.

Sarah J. ("Sally") Tugman grew up in Walla Walla, Washington, and attended Mount Holyoke College in South Hadley, Massachusetts. She graduated from Lewis & Clark Law School in Portland, Oregon, in 1983, magna cum laude, at the top of her class. She practiced for almost thirty-five years in Anchorage, Alaska, and will continue to practice in Oregon "of counsel" with the DuBoff Law Group, PC, with an office in Lincoln City. She is licensed to practice in Alaska, in Oregon, in various federal courts, and in the US Supreme Court. Coming from a long line of lawyers and newspaper people, she is an avid reader and has a great appreciation of fine writing, and she collects art and antiques.

Index

Books from Allworth Press

The Artist-Gallery Partnership
by Tad Crawford and Susan Mellon (6 × 9, 216 pages, paperback, $19.95)

The ASMP Guide to New Markets in Photography
Edited by Susan Carr (6 × 9, 304 pages, paperback, $24.95)

Business and Legal Forms for Photographers (Fourth Edition)
by Tad Crawford (8½ ×11, 208 pages, paperback, $29.95)

The Business of Being an Artist (Fifth Edition)
by Daniel Grant (6 × 9, 244 pages, paperback, $19.99)

The Copyright Guide (Fourth Edition)
by Lee Wilson (6 × 9, 312 pages, paperback, $19.99)

The Education of a Photographer
Edited by Charles H. Traub, Steven Heller, and Adam B. Bell (6 × 9, 256 pages, paperback, $19.95)

Fair Use, Free Use, and Use by Permission
by Lee Wilson (6 × 9, 256 pages, paperback, $24.95)

Fine Art Publicity
by Susan Abbott (6 × 9, 192 pages, paperback, $19.95)

How to Shoot Great Travel Photos
by Susan McCartney (8½ ×10, 160 pages, paperback, $14.95)

How to Succeed in Commercial Photography
by Selina Maitreya (6 × 9, 240 pages, paperback, $19.95)

How to Survive and Prosper as an Artist (Seventh Edition)
by Caroll Michels (6 × 9, 368 pages, paperback, $24.99)

The Photographer's Guide to Marketing and Self-Promotion (Fifth Edition)
by Maria Piscopo (6 × 9, 280 pages, paperback, $24.99)

The Photographer's Guide to Negotiating
by Richard Weisgrau (6 × 9, 208 pages, paperback, $19.95)

Photography: The Art of Composition
by Bert Krages (7¾ × 9¼, 256 pages, paperback, $24.95)

The Photography Exercise Book
by Bert Krages (7¾ × 9¼, 216 pages, paperback, $24.99)

The Profitable Artist (Second Edition)
by the New York Foundation for the Arts (6 × 9, 288 pages, paperback, $24.99)

Starting Your Career as a Freelance Photographer
by Tad Crawford and Chuck Delaney (6 × 9, 352 pages, paperback, $19.99)

Top Ten Secrets for Perfect Baby & Child Portraits
by Clay Blackmore (5½ × 8½, 112 pages, paperback, $16.95)

To see our complete catalog or to order online, please visit *www.allworth.com*.